Ancient Ecuador

Culture, Clay and Creativity
3000-300 B.C.

El Ecuador Antiguo

Cultura, Cerámica y Creatividad
3000-300 A.C.

text by
Donald W. Lathrap

catalogue by
Donald Collier and Helen Chandra

Field Museum of Natural History

Catalogue of an exhibit organized by Field Museum of Natural History
April 18 - August 5, 1975.

Participating institutions:
Center for Inter-American Relations, New York,
September 23 - November 18, 1975.
William Rockhill Nelson Gallery and Atkins
Museum of Fine Arts, Kansas City.
January 15 - February 29, 1976.
Krannert Art Museum, Urbana,
September 5 - October 3, 1976.
Minneapolis Institute of Arts,
March 8 - May 8, 1977.
Museo Arqueológico del Banco Central del Ecuador, Quito;
Museo Arqueológico del Banco Central del Ecuador, Guayaquil,
after July, 1977.

All photographs from Field Museum with the exception of: Fig. 9, reed boat, Walter R. Aguiar; Fig. 78, Tehuacán figurine, Robert S. Peabody Foundation, Andover, Mass.; Fig. 78, Curayacu figurine, Museo Nacional de Antropología y Arqueología, Lima; Fig. 80, Chavín de Huantar rubbing, The American Museum of Natural History, New York; Fig. 82, stirrup-spout bottle, Museum of the American Indian, Heye Foundation, New York; Fig. 85, acrobat, The Museum of Primitive Art, New York; Fig. 86, San Agustín sculpture, G. Reichel-Dolmatoff; Fig. 86, Olmec head, Walter R. Aguiar; Fig. 88, San Agustín sculpture, G. Reichel-Dolmatoff.

Library of Congress Catalog Card Number: 74-25248
ISBN 0-914868-01-2

Printed in the United States of America

Cover: Detail of a hollow figurine depicting a male. Chorrera period. **420**

Table of Contents

Introduction

The organization of an exhibition on the cultures of ancient Ecuador continues a long standing interest of Field Museum. In 1891 George A. Dorsey, who was a member of the Department of Ethnology of the World's Columbian Exposition and later became the Curator of Anthropology of the newly-founded Field Columbian Museum, excavated on La Plata Island off the coast of Ecuador. He found artifacts of the Bahía culture from the time of Christ and also a superb Inca burial dating from the late fifteenth century, when the area was incorporated into the Inca Empire. These materials became part of the Museum's collections.

Fifty years later the Museum sent John Murra and me to investigate the southern highlands of Ecuador. The major site we excavated, Cerro Narrío, proved to have deep refuse containing a variety of ceramic styles and marine shells that originated on the Ecuadorian coast. At the time of this excavation, 10 years before the development of radiocarbon dating, we did not realize how old Cerro Narrío was. We suspected the coastal connections of some of the pottery styles but could not follow up these suspicions because so little archaeological work had been done on the coast. We now know that the earlier phase of Cerro Narrío dates from before 1500 B.C. and that several of the varieties of pottery were astonishingly similar to pottery of the Machalilla phase on the coast. We have used some of these Cerro Narrío examples in the exhibition to demonstrate the connections between coast and highland.

Since 1941 a great deal has been learned by archaeologists about Guayas Province and particularly that part jutting into the Pacific called the Santa Elena Peninsula. First, Geoffrey Bushnell published a book on his research on the peninsula done before the war. Over the years Olaf Holm and Carlos Zevallos Menéndez and later Emilio Estrada carried out investigations in Guayas and Manabí provinces, and Betty J. Meggers and Clifford Evans collaborated with Estrada in a number of excavations of early village sites along the Guayas coast. Most recently, Presley Norton, Edward P. Lanning and his students from Columbia University, Pedro I. Porras Garcés, Carlos Zevallos Menéndez, Jorge Marcos, and Henning Bischof have carried out surveys and excavations to elucidate the development of the early cultures. During the same period Gerardo Reichel-Dolmatoff was discovering evidence of early agricultural villages with pottery on the lower Magdalena River in Colombia.

The collective result of these investigations of the past 20 years is to establish that there were sizable pottery-making communities on the coast of Ecuador before 3000 B.C., and that there were significant similarities in art and technology between these villages and the earliest known settled communities of Perú and Mesoamerica. The traditional view of archaeologists and New World culture historians has been that Ecuador, although achieving some interesting local developments, such as the smelting and alloying of platinum, played no significant role in the rise of civilization in the New World. The Central Andes (Perú and Bolivia) and Mesoamerica were believed to be the only significant centers of plant domestication and of the development of the settled villages, the arts and technology, and the religious ideas that underlay the later civilizations. But our new evidence shows that agricultural villages and pottery were 1000 years earlier in Ecuador than in Perú and Mexico. And we see influences moving from Ecuador to these other areas during the thousand years beginning about 1500 B.C. Clearly the generally accepted view of the culture history of Nuclear America, stretching from México to Perú, needs extensive revision.

It is the purpose of the exhibition and this catalogue to make known to a general audience the new information about ancient Ecuador and to point out its significance, particularly with respect to Ecuador's role in the rise of the Formative cultures of the New World. The variety, beauty, and beguiling quality of early Ecuadorian art, particularly Chorrera art, are almost unknown outside a small circle of archaeologists. The exhibition is rich in this material and presents a fair sample of what the potters and other artists were creating on the coast of Ecuador between 3000 and 300 B.C.

DONALD COLLIER
Curator, Middle and South American Archaeology and Ethnology, Field Museum of Natural History

Introducción

La creación de una exhibición de las culturas del Ecuador antiguo sigue siendo de mayor interés para el Museo Field. En 1891 George A. Dorsey, quien fue miembro del Departamento de Etnología de la World's Columbian Exposition y más tarde curador de Antropología del entonces recién fundado Field Columbian Museum, dirigió excavaciones en la Isla de la Plata, cerca de la costa del Ecuador. Allí encontró objetos de la cultura de Bahía y fases posteriores, además de un extraordinario sepulcro incaico de fines del Siglo XV, cuando esta zona fue incorporada al Imperio Inca.

Cincuenta años más tarde el Museo nos mandó a John Murra y a mí a investigar la zona sur de la sierra del Ecuador. En nuestra mayor excavación en Cerro Narrío encontramos depósitos profundos que contenían una variedad de estilos de cerámica y conchas marinas que tenían su origen en la costa ecuatoriana. Cuando hicimos esta excavación era diez años antes del desarrollo de la técnica del carbono 14 para determinar la antigüedad y no nos dimos cuenta de la edad de Cerro Narrío. Sospechamos que algunos estilos tenían relación con la cerámica costeña, pero no pudimos probar nuestra teoría debido a la falta de investigaciones arqueológicas hechas hasta entonces en la costa. Ahora sabemos que la primera fase de Cerro Narrío data de antes del año 1500 A.C. y algunas de las variedades de cerámicas son sorprendentemente similares a la cerámica de la fase Machalilla en la costa. Hemos usado algunos de estos ejemplos de Cerro Narrío en la exhibición para demostrar la relación entre la costa y la sierra.

Desde 1941 los arqueólogos han descubierto mucho acerca de la provincia de Guayas y particularmente de la parte que se extiende sobre el Pacífico llamada la Península de Santa Elena. Primero Geoffrey Bushnell publicó un libro acerca de sus investigaciones sobre la Península hechas antes de la Guerra. A través de los años Olaf Holm y Carlos Zevallos y más tarde Emilio Estrada han llevado a cabo investigaciones en las provincias de Guayas y Manabí. Betty J. Meggers y Clifford Evans colaboraron con Estrada en varias excavaciones en sitios establecidos en épocas tempranas a lo largo de la costa de Guayas. Recientemente Presley Norton, Edward Lanning y sus alumnos de la Universidad de Columbia, Pedro I. Porras, Carlos Zevallos Menéndez Jorge Marcos y Henning Bischof han llevado a cabo estudios y excavaciones para elucidar el desarrollo de las culturas formativas. Durante este mismo período Gerardo Reichel-Dolmatoff descubría pruebas de la existencia de pueblos agrícolas tempranos con cerámica en la parte baja del Rio Magdalena en Colombia.

Los resultados acumulados por estas investigaciones en los últimos veinte años determinan la existencia de comunidades alfareras de cierto tamaño en la costa del Ecuador antes del año 3000 A.C. Considerables semejanzas en el arte y la tecnología de estas aldeas se perciben en el Perú y Mesoamérica durante el milenio comprendido entre 1800 y 800 A.C. La opinión tradicional de los arqueólogos y de aquellos historiadores que se dedican a las culturas americanas ha sido que, a pesar de haber alcanzado logros interesantes (por ejemplo, la fundición y aleación del platino), el Ecuador no asumió iniciativas en el desarrollo de la civilización del Nuevo Mundo. Se creía que la región central andino (Bolivia y el Perú) y la mesoamericana eran los únicos centros significativos para la domesticación de plantas, las poblaciones asentadas, las artes y tecnologías, aun de las ideas religiosas de las civilizaciones posteriores. Sin embargo, la evidencia citada nos demuestra que las aldeas permanentes y la alfarería florecieron en el Ecuador por lo menos mil años antes que en México y el Perú. Obviamente la historia cultural de las civilizaciones americanas necesita ser extensivamente revisada.

Esta exhibición y su catálogo se proponen presentar al público lo que se ha aprendido recientemente acerca del antiguo Ecuador y enfatizar la influencia de sus habitantes en el surgimiento de las culturas Formativas del Mundo Nuevo. La variedad, belleza y cualidad seductiva del arte antiguo ecuatoriano, particularmente él

de Chorrera, son practicamente desconocidas fuera de un reducido círculo de arqueólogos. La exhibición es una rica muestra de las obras logradas en la costa ecuatoriana por los alfareros y demás artistas entre los años 3000 y 300 A.C.

DONALD COLLIER
Curador de Arqueología y Etnología Mesoamericana y Sudamericana, Field Museum of Natural History

Acknowledgments

This exhibition and catalogue were made possible by the cooperation and help of numerous individuals and institutions in South America, Mexico, and the United States. I wish to express the gratitude of Field Museum of Natural History, Donald Lathrap, and myself to all of them, including those not mentioned here.

Presley Norton played a major role in building the collection on which this exhibition is based; he conceived the need for a traveling exhibition on early Ecuador in the United States, and persuaded me to undertake it. His former wife, Leonor Pérez de Rivera, whose initiative started the Pérez (formerly Norton) Collection, enthusiastically supported the project, spent countless hours checking lists and catalogue data, and extended friendship, encouragement, and help at all stages of the project. Olaf Holm of Guayaquil, whom I knew from my first visit to Ecuador in 1941, offered stimulating discussions of early Ecuadorian archaeology and illuminating interpretations of individual pieces in the Pérez Collection. He gave me indispensable advice and help during the packing of the collection and the securing of the official loan and export permits.

For their official help and their friendship I wish to thank Hernán Crespo Toral, Director of the Museo del Banco Central del Ecuador, Quito; Rodrigo Pallares, Director del Patrimonio Artístico Nacional, Quito; Julio Estrada Ycaza, Presidente de la Comisión Regional del Patrimonio Artistico del Litoral, la Casa de la Cultura, Guayaquil; and Resfa Parducci Zevallos, Director of the Museo de la Casa de la Cultura, Guayaquil. Carlos Zevallos Menéndez, Professor of Archaeology, Universidad Central, Guayaquil, extended many kindnesses and made it possible to include in the exhibition specimens excavated by him which strongly indicate the cultivation of maize in the Valdivia period. Others in Ecuador who gave me various kinds of help and hospitality are Robert Agro, Pedro I. Porras Garcés, Eladio Chocair, Ana Velasteguí de Jaramillo, and Richard Zeller.

For assistance in securing photographs we are grateful to Rogger Ravines, Gerardo Reichel-Dolmatoff, Isabel Kelley, Noemí Castillo Tejero, Rosa Covarrubias, Junius B. Bird, Richard S. MacNeish, Frederick J. Dockstader, and Douglas Newton.

Donald Lathrap, Professor of Anthropology at the University of Illinois, Urbana, in addition to writing the text of this catalogue, was consultant for the exhibition, to which he contributed crucial data and the broad framework of organization. Others in the United States who gave us expert advice are David C. Grove, Jorge Marcos, and Betsy Hill. The latter two have excavated on the Santa Elena Peninsula and have special knowledge about Valdivia culture. Marcos advised us about Valdivia weaving and specialized tools, and Hill performed the laborious task of placing all of the exhibited Valdivia pots and figurines in her system of eight phases.

At Field Museum I wish to acknowledge the effectiveness of the Ancient Ecuador exhibit working group in creating the exhibition and this catalogue: Clifford Abrams, graphic designer; Helen Chandra, scriptwriter; Robert Martin, exhibit designer; and John White, educational consultant. The comprehensiveness and meaning of both exhibition and catalogue have been greatly enhanced by identifications and interpretations of our material by members of the scientific staff, as follows: Anthropology—Glen Cole; Botany—Donald Simpson, Patricio Ponce de León; Geology—Edward Olsen, Bertram Woodland; Zoology—Emmet Blake, Philip Hershkovitz, Robert Izor, Carol Jones, Robert Johnson, Hyman Marx, Alan Solem, Luis de la Torre, Melvin Traylor, and Loren Woods. Ruth Andris, restorer, and Louva Calhoun and Jean Armour, volunteers, repaired and strengthened the ceramic materials and painted previously-made plaster restorations. Patricia Williams edited this catalogue. The Spanish translations were made by Ada Casado, with advice from Patricio Ponce de León. John Alderson and Arthur Wise made the photographs in the catalogue.

DONALD COLLIER

Lenders to the Exhibition

Ecuador

Sergio Pérez Valdéz
Olaf Holm
Museo de la Casa de la Cultura, Núcleo del Guayas
Pedro I. Porras Garcés
Richard Zeller

United States

American Museum of Natural History
Field Museum of Natural History
Metropolitan Museum of Art
Peabody Museum of Archaeology and Ethnology, Harvard University
Donald W. Lathrap
Jorge Marcos
Norman E. Whitten

Contributors of Financial Support

Illinois Arts Council
National Endowment for the Humanities
Lawrence Roys

Map 1: Ecuador in Nuclear America

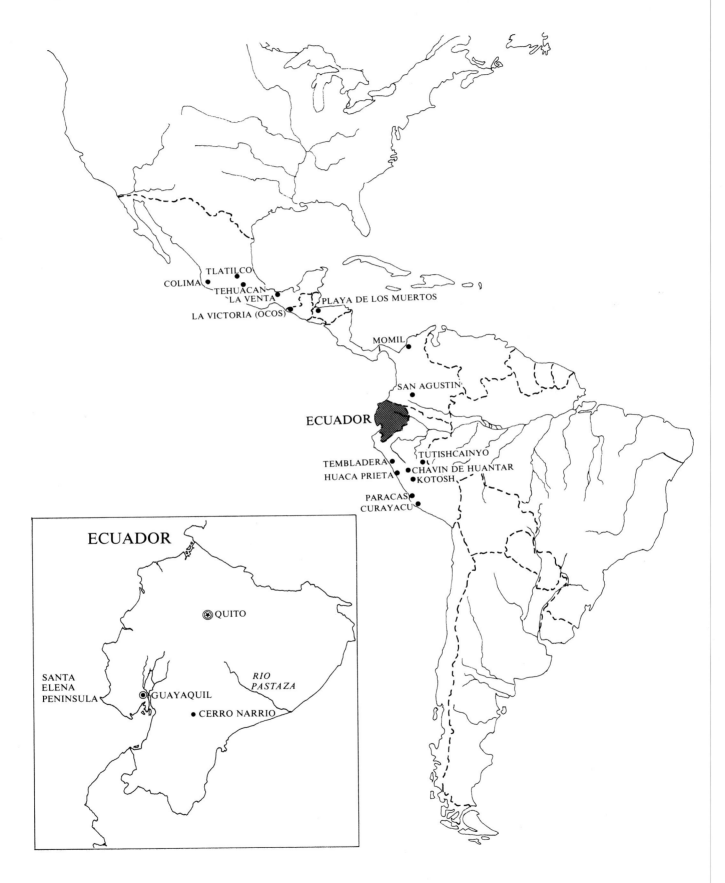

Map 2: Formative Sites in Coastal Ecuador

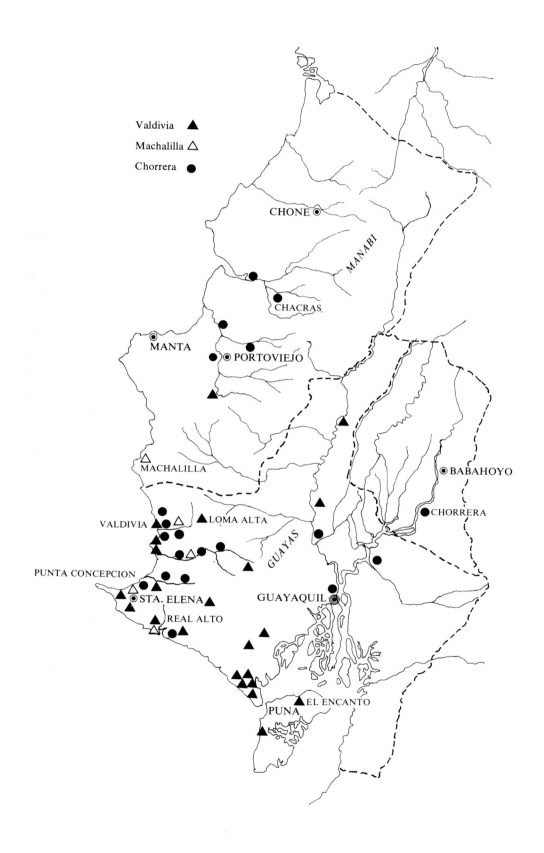

Valdivia ▲
Machalilla △
Chorrera ●

CHONE ◉

MANABI

CHACRAS ●

MANTA ◉

● PORTOVIEJO ◉

▲

▲

MACHALILLA △

● BABAHOYO

VALDIVIA ▲ △ ▲ LOMA ALTA

● CHORRERA

▲ GUAYAS

PUNTA CONCEPCION

▲ STA. ELENA ▲

GUAYAQUIL ◉

▲ REAL ALTO

△ ●

▲

▲ EL ENCANTO

PUNA

11

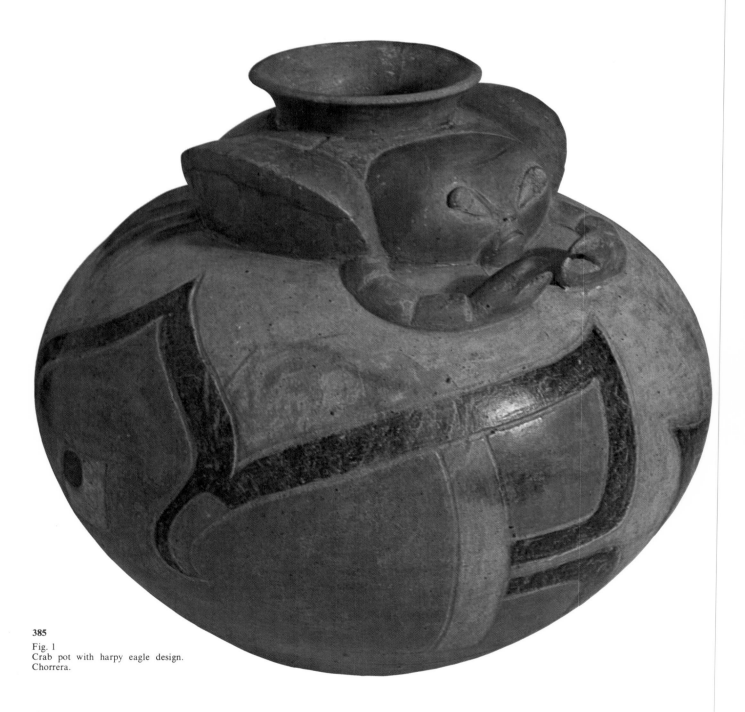

385
Fig. 1
Crab pot with harpy eagle design.
Chorrera.

Chapter I

The Appearance of the Formative Stage

"Ancient Ecuador: Culture, Clay and Creativity," deals with the Formative stage on the coast of Ecuador and its connections with Mexico, Perú, and Amazonia. Since the concept of the Formative is so important in the exhibition and this catalogue, this term should be clearly defined. All anthropologists who have studied the problem of the emergence of civilization are well agreed that civilization cannot appear until a truly productive agricultural system has been developed. Large groups of city dwellers who are not producing their own food can be fed only after really efficient patterns of agricultural production have been evolved. It is an urban population that provides the context for craft specializations, a large professional priesthood, a professional military, a bureaucracy, and finally writing—the various characteristics by which we define civilization. It is also generally agreed that civilization in this sense arose in two areas of the New World—one called Mesoamerica, including roughly the southeastern half of Mexico, Guatemala, and the western strip of Honduras, and the other the Central Andes of South America, including most of Perú and the northwestern part of Bolivia. The degree to which these two developments leading ultimately to civilization were independent of one another is a question still hotly debated by scholars. The materials of this exhibit offer some partial answers to this problem.

In the Old World the term Neolithic is used for the stage in cultural evolution when a truly effective agricultural system had been achieved, but before fully urban conditions and state-size social units appeared. In the New World it is customary to use the term Formative for this stage, defined by the appearance of large permanent communities that derived the greater part of their food from farming. Formative communities in this sense are rare or possibly totally absent in Mesoamerica before 1600 B.C. Communities of this nature appear in the coast and highlands of Perú no earlier than 2100 B.C. In each case, the characteristics of the cultures of the first settled farming communities appear to lack local antecedents. There is thus strong implication that the basis of the Formative society was developed neither in Mesoamerica nor in the Central Andes.

Origins of Agriculture

Over the last decade or so there has been a tremendous amount of archaeological work in the New World focusing on the origins of agriculture as a complete system and the appearance of the Formative level of development. In examining these questions it is necessary to distinguish clearly between man's first manipulation of the plants naturally available to him as a source of food and his later achievement of a system of agricultural production that yielded a dependable supply of food. Man was transplanting and protecting particular species of plants long before he achieved really productive agriculture. In fact, the archaeological record now suggests that in the New World twice as much time elapsed between the first pampering of useful plant species by man and the emergence of Formative societies (10,000 years) as between the first Formative societies and the present (5,000 years).

Intensive investigations on the higher and drier sections of the Mexican plateau, directed toward an understanding of the appearance of agricultural systems, has disclosed that none of the important crops were initially domesticated in that area. The work also indicates that the small mobile social groups in this area received from their lowland neighbors certain already developed crop plants, and in minor amounts cultivated these for several thousand years before this rudimentary practice of agriculture made a difference in their population size and stability.

Our best record of early planting in the New World comes from the coast of Perú. Here the extremely dry climate has preserved most of the plant material in refuse left

by the early inhabitants. Again, the record is clear that the important cultivated plants were not brought through the initial stage of domestication in this area, but were introduced as cultivated plants from elsewhere. An increasing body of evidence suggests that the initial experimentation with these plants took place in the Tropical Forest area east of the Andes.

All of the really important food crops, those that are the basis of productive agricultural systems, have been highly modified as a result of human manipulation of their genetic nature. Long before the principles of genetics were known, man was modifying the genetic makeup of the plants that he kept as crops. His meddling effected the accumulation in the plants of the changes that led to larger edible parts and ease in harvesting and preparation. In almost every case the accumulation of these genetic modifications led to plants that were progressively less able to compete under natural conditions. The appearance of potentially useful genetic characteristics, which could then be perpetuated, was a rare event and not under human control; so that the accumulation of several such changes implies a vast span of time for the genetic alteration of a staple such as maize.

Before the Formative level of agriculture could be achieved, the genetic makeup of the really efficient staple crops had to be totally altered. In the New World the basic staples are corn and manioc and in the cold highlands of the Central Andes, the potato. Other crops such as beans and squash in Mexico, quinoa (*Chenopodium quinoa*) in the high Andes, and peanuts in the Amazon Basin provided a smaller portion of the total caloric intake but were essential in giving nutritional balance to the diet. George Beadle recently suggested that the earliest known cultivated corn which appeared in the Tehuacán Valley in Mexico between 6000 and 5000 B.C., shows a level of genetic modification which could only be understood in terms of at least 1000 — 2000 years of prior development under primitive cultivation. Therefore, the experimental level of agriculture in the New World had to extend back into a time range of 7000 — 8000 B.C.[1] There are other lines of evidence which can be used in support of this startling conclusion.

Just as effective agriculture is dependent on a total modification of the key staple crops, so also it involves marked shifts in patterns of human activity. The incipient farmers developed patterns of land clearing and weeding and, finally, fertilization and irrigation. As the crops became more productive and more dependent on man, he directed an ever larger amount of effort and energy toward the maintenance of his food base, and his body of farming knowledge and practices became progressively more ordered. Customarily, the development of efficient agriculture is seen only in terms of man's modification of the plants involved. Equally illuminating is the complimentary view of the domestication of man by his ever more demanding crops.

Both the standardization of elaborate agricultural practices and the genetic modification of the key plants were long, gradual processes, and only when each had developed greatly did agriculture become sufficiently productive to support a Formative level of culture. In Mexico and in the Central Andes large permanent communities with indications of complex social divisions are taken as evidence of the establishment of a Formative way of life. Communities of this kind appeared in Ecuador and elsewhere in the tropical lowlands of South America 1000 to 2000 years earlier than in either Mexico or Perú. If we are to understand the whole pattern of agricultural evolution in the New World and the emergence of complex societies with developed technology and sophisticated art styles, we must consider the priority of Formative sites in Ecuador, Colombia, and the Amazon Basin.

Coverage of the Exhibit

The materials in this exhibit show the range of cultural achievement in coastal Ecuador from 3000 to 300 B.C. Scholarly publications on the early cultures of Ecuador have been available, but this is the first time that the technological complexity and aesthetic impact of these and of related objects have been emphasized.

The materials that form the core of the exhibition were collected by Presley Norton and his former wife, Leonor Pérez de Rivera, in part by purchase and in part as a result of his scientifically controlled excavations. The collection is now known as the Pérez collection. These objects come from a section of Ecuador extending from the Gulf of Guayaquil across to Santa Elena Peninsula and up the Pacific coast of

14

Ecuador into Manabí Province. Uncontrolled excavations on the Río Chico in the Manabí Province provided the Nortons with many of the whole figurines and effigy vessels of the Chorrera period. The context of these remarkable Río Chico materials is not secure.

The materials exhibited represent three cultural groups: Valdivia, Machalilla, and Chorrera. All are related, and all three are part of the same general stream of technological and artistic evolution.[2] In general, the three cultural groups could be stacked in sequence, with Valdivia the earliest, followed by Machalilla, which, in turn, is followed by Chorrera. However, the actual situation is probably more complex than that. As early as 1800 B.C., there may have been considerable regional variation between the Río Chico area and the Ecuador coast along the Santa Elena Peninsula.

Our knowledge of the area around the Santa Elena Peninsula is infinitely better than our knowledge of archaeological development in Manabí. Because the plant cover in Manabí is heavier, intensive archaeological work is more difficult and very little systematic work has been done there. We tend, then, to view the archaeology of Mánabí on the basis of our more detailed knowledge of the situation in the immediate vicinity of the Santa Elena Peninsula. Compared to the rest of the coastal strip, this zone is extremely arid. Although it was less arid during the Formative stage than today, at that time it probably was less desirable for agricultural settlement than Manabí and the Guayas Basin. The valley bottoms, which were the most desirable agricultural land for the earliest fisher-farmers, are more extensive in Manabí, and a still larger expanse of flood plain land is found in the Guayas Basin to the east.

The Chronology Utilized

In terms of art styles, the Santa Elena Peninsula was probably rural, "backwoodsy," and retarded compared to the areas to the north and east. With this caution, which should be kept continually in mind, we present the chronological sequence which has been worked out for the Santa Elena Peninsula through the combined efforts of Betsy Hill,[3] Allison Paulsen, and Eugene McDougle,[4] as the best available yardstick for the time period we are discussing. We have decided to use the more precise eight-part division of Valdivia developed by Hill because it allows a clearer picture of the progressive modification and elaboration of Valdivia ceramics. Hill achieved this high level of precision by a careful analysis of small unmixed depositional units in the village middens. The large arbitrary horizontal excavation units used by Meggers, Evans, and Estrada[5] typically cross-cut two or more depositional units, and the analysis of the pottery from these levels consequently blurred the true picture of cultural development.

It will be noted that on the chronological chart the term Engoroy is given as an alternate for Chorrera. Chorrera as a cultural entity was first defined on the basis of excavation in the Guayas Basin. Materials of comparable age and that share a number of characteristics were first noted near the Santa Elena Peninsula by Geoffrey Bushnell, and to these he gave the name Engoroy.[6] Engoroy has been accepted as the proper designation for these cultural materials by Edward Lanning and the group of archaeologists trained by him at Columbia University. For technical archaeological writing it is the preferred term for materials coming from sites within approximately 35 km. of the tip of Santa Elena Peninsula.

The bulk of the Chorrera materials in this exhibit comes from the Río Chico area in Manabí province. It is not clear whether these materials are more similar to the Chorrera (in the strict sense) of the Guayas Basin or to the Engoroy materials of Santa Elena. Apparently, they are about equally different from both. For simplicity we are using the term Chorrera in its general sense—a usage which is prevalent among the archaeologists of Ecuador.

The chronological chart is based on a number of radiocarbon dates. The most important of these is the series of dates from the earliest occupation at the Loma Alta site well up the Valdivia River valley. They are directly associated with the earliest variant of Valdivia pottery now known. They range from 3100 to 2700 B.C. but tend to cluster in the earliest part of this time span. A close look at these early Loma Alta pots convinces one that they are not close to the beginnings of ceramic art. If we accept the C-14 assays at face value, we note that the appearance of Formative sites in Ecuador was 1000 to 1500 years earlier than in either Mexico or Perú.[7]

Chronological Chart of the Formative

Based on uncorrected radiocarbon dates

B.C.

Period	B.C.	Phase
Chorrera (Engoroy)	300	
	400	
	500	
	600	
	700	
	800	
	900	
	1000	
Machalilla	1100	
	1200	
	1300	
	1400	
	1500	
Valdivia	1600	Phase 8
	1700	Phase 7
	1800	Phase 6
	1900	Phase 5
	2000	
	2100	Phase 4
	2200	Phase 3
	2300	
	2400	Phase 2
	2500	Phase 1
	2600	
	2700	
	2800	
	2900	
	3000	Loma Alta
	3100	

NOTES

1. George Beadle, "The Mystery of Maize," lecture presented at the Agronomy School Seminar, University of Illinois, Urbana, March 26, 1974.

2. The temporal overlap between Machalilla and Valdivia 6 suggested by Betty J. Meggers, Clifford Evans, and Emilio Estrada ("The Early Formative Period of Coastal Ecuador: The Valdivia Machalilla Phases," *Smithsonian Contributions to Anthropology*, I. Washington, D. C.: Smithsonian Institution, 1965) is not supported by any subsequent observations and would seem to relate to their misinterpretation of the stratigraphic sequence at the Buena Vista site. I have discussed this point in my review of Meggers, Evans, and Estrada in *American Anthropologist*, LXIX (1967), no. 1, 96-98.

3. Betsy Hill, "A New Chronology of the Valdivia Ceramic Complex," *Ñawpa Pacha*, in press.

4. Allison C. Paulsen and J. Eugene McDougle, "The Machalilla and Engoroy Occupations of the Santa Elena Peninsula in South Coastal Ecuador," paper presented at the 39th annual meeting of the Society for American Archaeology, Washington, D.C., 1974.

5. Meggers, Evans, and Estrada, "Early Formative Period." See note 2.

6. G. H. S. Bushnell, *The Archaeology of the Santa Elena Peninsula in Southwest Ecuador* (Cambridge: Cambridge University Press, 1951).

7. There are strong arguments that this differential is even greater. We do not want to present a technical discussion of C-14 dating technique. Such discussions are widely available. The radiocarbon determined age of a particular specimen depends not only on how much of its radioactive carbon has deteriorated since the sample was placed in context, but also on the level of radiation in the atmosphere at the time the sample was living tissue. There have been marked fluctuations in this level. Studies of the very long lived bristlecone pines on mountains in the southwest United States indicate marked divergence in the age of wood determined by counting the tree rings and the age of the same wood as determined by an examination of carbon 14. Curves are available showing these divergences. They become marked at around 1800 B.C. and suggest that a C-14 age of 3100 B.C. really indicates a calendrical age of around 4000 B.C., so that the differential between the appearance of Formative communities in Ecuador and Formative communities in Mexico and Perú is even greater, exceeding 2000 years.

For the sake of simplicity and computation, uncorrected C-14 dates are used in the exhibit labeling and in the catalogue discussions. In terms of the appreciation of the remarkable antiquity of Ecuadorian culture it should be kept in mind that the beginning date of 3100 B.C. corrects to an actual calendrical date of around 4000 B.C.

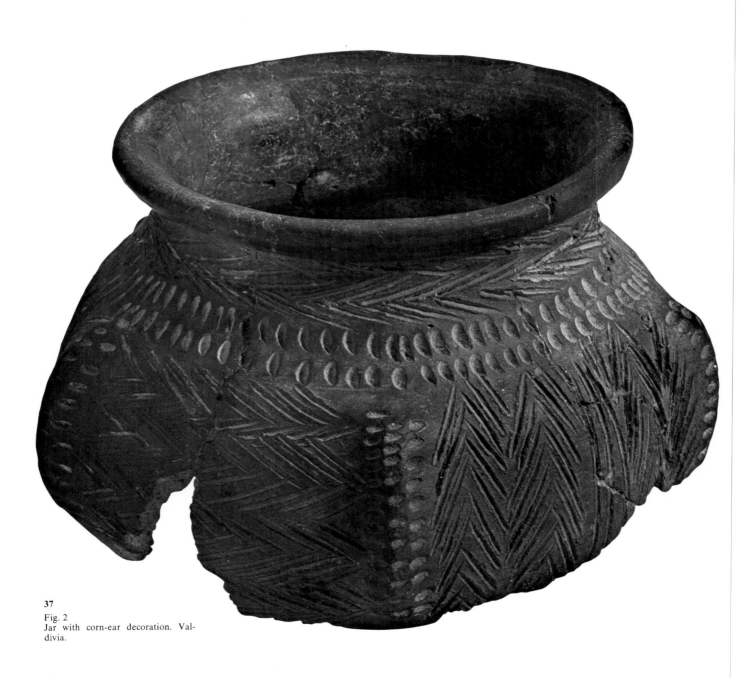

37
Fig. 2
Jar with corn-ear decoration. Valdivia.

Chapter II

The Economy of the Formative Stage

Valdivia communities have large, deep deposits of cultural refuse and quantities of well-made pottery. In Mesoamerica or Perú these characteristics would be taken as evidence of a fully efficient agricultural system. It is our contention that one should consider even earliest Valdivia fully Formative, but the direct evidence that would prove this contention is still incomplete.

The initial discovery of Valdivia culture was in locations on or very near the seashore. The coastal Valdivia sites contain a moderate amount of marine shell, but only the large circular community excavated by Pedro Porras Garcés[1] on the Island of Puná has a sufficient concentration of seashell to be classified as a shell midden. It is clear that the Valdivia people took advantage of molluscan and crustacean resources of the shore. It is also clear from an examination of the fish bones recovered from various sites that ocean fishing was practiced at a fairly sophisticated and productive level. As long as only coastal sites were known, it was possible to maintain that the Valdivia economy was comparable to other hunting and gathering economies of coastal North and South America. More intensive survey by Presley Norton,[2] Carlos Zevallos Menéndez,[3] and Jorge Marcos[4] has indicated that not all Valdivia sites are oriented entirely or even primarily toward the sea. The Loma Alta site, which has provided the earliest securely dated Valdivia ceramics, is 15 km. up the Valdivia River. The depth of cultural deposition here is impressive. The scarcity of marine shell and the fairly large amount of land-mammal bone indicate a much greater involvement in hunting than was manifest in the remains at the Valdivia site, itself downstream on the coast.

The Loma Alta site is on a hill immediately adjacent to a fairly large expanse of flat valley bottom. Since the whole valley floor is actively aggrading alluvium, the soil fertility and water table are high and the area could be farmed continuously without irrigation. This is precisely the kind of setting that would be sought by people with efficient agriculture and a dependence on agriculture, but who had not yet achieved the economic innovations of canal irrigation and deliberate fertilization of the soil. Since the discovery of Loma Alta, several other Valdivia sites have been noted with a similar orientation to the active, level flood plains of moderate-sized rivers crossing the coastal strip of this part of Ecuador. In some instances, such as the Azucar site recently excavated by Zevallos, these are as much as 30 km. from the sea.

Dependence on Agriculture

The site locations strongly suggest that the various contemporary Valdivia communities were oriented to a variety of environmental settings and a wide resource base, but the locations of the larger and more permanent settlements may be explained in terms of a major dependence on agriculture.

Another significant feature of the Loma Alta refuse is the very large number of stone hand mills. These hand mills consist of a hand stone and grinding slab, which are usually known in the New World as the mano and metate and are typically used to grind corn (*Zea mays*). It is certain that the manos and the metates so common at Loma Alta, and also at the huge San Pablo site closer to the coast, were used in the processing of vegetable materials. In North America there are aboriginal situations where similar manos and metates were used for grinding wild vegetable foods, especially the seeds of certain wild grasses, but the amount of refuse both at Loma Alta and San Pablo suggests a larger and more sedentary population than could have been supported on the basis of locally available wild plants. If the manos and metates were used in the processing of a stable cultivated crop, then the most likely candidate would have been an efficient variety of corn—corn with a large cob and large kernels

in the group of varieties that we would call flint corn, as opposed to the low-yield races with small cobs and minute kernels that are wide-spread in early agricultural contexts in Mexico and Perú. Such a race of flint corn would be high yielding and could have been very effectively cultivated on the excellent bottom lands adjacent to Loma Alta.

Carlos Zevallos, on the basis of his long-term program of excavations at the San Pablo site, has argued most convincingly for the dependence on efficient maize agriculture.[5] A particular style of incised and appliqúed decoration occurs relatively frequently on Valdivia pots from phases 5 and 6. Zevallos has argued that such decoration is a clear representation of an ear of corn (Figs. 2, 75; **36**, **38**).* In some instances these ears are provided with faces, so that the whole representation becomes a kind of maize deity. In support of this interpretation is an actual cast and carbonized remains of a maize kernel in a Valdivia sherd from San Pablo (**40**) with the kind of brushed decoration most typical of Valdivia 5 and 6; the kernel had been embedded in the moist clay of the pot before firing. The large size and advanced characteristics of the corn kernel so well preserved in the Valdivia sherd have caused some experts to doubt the authenticity of the find, but there are no rational grounds for questioning the context of the sherd. The relatively great breadth of the kernel suggests that it could have been accommodated only on a cob with as few as eight to ten rows. The corn effigies on the beautiful Valdivia 6 pot previously illustrated by Zevallos and included in the exhibit (Fig. 2) are not simple strips of appliqúe, but each is a carefully formed solid with three equally wide sides visible—precisely what is visible when an octagon is viewed directly from one side. An eight-row cob is thus strongly indicated and the orderly arrangement of kernels depicted in each of the five cobs on the pot suggests that an eight-row flint corn was the model. Ongoing work by a team of archaeologists from the University of Illinois, Urbana, offers further proof of the early importance of corn agriculture to Valdivia populations. A class of Valdivia 3 pot from the Real Alto site near Chanduy is typically decorated with multiple impressions of corn kernels circling the rim (Fig. 3). Upon examining all this recent evidence, Earl R. Leng, Department of Agronomy of the University of Illinois, suggested that the race of corn known as *Kcello Ecuatoriano* shows all of the characteristics of the Valdivia corn, including the large kernel size, and the extremely straight eight rows of kernels so clearly depicted on the Valdivia 6 pot (Fig. 2). This identification makes a great deal of sense, as Leng has pointed out. *Kcello* is currently raised in the highlands of southern Ecuador, in areas with westward drainage and easy access to the Pacific coast, and near the very ancient site of Cerro Narrío, which was in intensive trade contact with the Valdivia peoples. Leng suggests that *Kcello* could have become adapted to the western lowlands in the course of 50 years or less. Though productive and having very large kernels, *Kcello* is in some respects a rather primitive race of maize and could be derived with a moderate amount of genetic change from a very primitive race of corn like *Nal-Tel*. Something very like *Kcello* is the most likely basic ancestor of the super efficient races of corn of the Peruvian Andes, culminating in the giant corn of Cuzco. It is also a possible ancestor of the West Mexican flour corns, particularly *Harinoso de Ocho*, a fact which will take on considerable importance when we come to examine the origins of the West Mexican Formative.

If, as the evidence now suggests, the earliest efficient system of corn agriculture appeared in Ecuador, we are faced with the question of how this eight row flint corn relates to the earlier initial domestication of corn from its wild ancestor *teosinte*. George Beadle favors the idea that the initial domestication of *teosinte* took place in Mexico and argues that the large stands of *teosinte* along the Rio Balsas make the state of Guerrero a logical hearth for the very beginnings of corn cultivation. Assuming a Mexican origin for corn, we can imagine a very primitive race of the cultivated plant spreading southward through the tropical lowlands of Central America. Once across the Isthmus of Panama and into Colombia, this very primitive corn, rather like the surviving race, *Nal-Tel*, would have been traded from group to group along a chain of agricultural communities lying in the tropical lowlands at the eastern foot of the Colombian, Ecuadorian, and Peruvian Andes.

15
Fig. 3
Corn-kernel decoration. Valdivia.

* **Boldface** indicates catalog numbers.

The pattern of the earliest appearance of maize in various of the highland basins and coastal valleys of Perú indicates that primitive races of maize entered Perú along such a corridor rather than down either the Andean highland or the Pacific Coastal strip. The history of several other important crops such as chili peppers (*Capsicum*) and tobacco (*Nicotiana*) make it clear that the eastern foot of the Andes was, in fact, a zone where very early experimentation with plant domestication took place.[6] If such a spread occurred, we could expect that a primitive race of corn like *Nal-Tel* reached the tropical lowlands of eastern Ecuador by 6000 B.C. Under progressively more intensive cultivation and careful selection such maize could have gone through the evolution into the more efficient *Kcello*. Better corn, in turn, would have led to still more productive farming and ultimately to colonial expansion into highland basins such as Cuenca, and on down into the Guayas Basin and Colonche Hills.

George Beadle's argument that maize was first domesticated in Mesoamerica is unassailable if *teosinte* was confined to Mexico and northwestern Central America in Pre-Colombian times. At present there are no fully authenticated reports of stands of this wild grass to the south and east of Honduras, but as J. DeWet mentioned to me recently, certain accounts by early botanists strongly suggest the presence of *teosinte* in the tropical lowlands of northern South America and field research is continuing to see if *teosinte* does, in fact, exist in this zone. If these reports are verified, the tropical lowlands of northern South America cannot be excluded as the original hearth of corn agriculture.

We have reason to suspect that corn was not the only important crop in the Formative stage of coastal Ecuador. I have discussed elsewhere[7] the evidence supporting the probability that manioc was developed as a highly productive staple somewhere in the tropical lowlands of northern South America as early as 4000 - 5000 B.C., and that this was the key staple in effective agricultural patterns of the kind referred to as the Tropical Forest system. The large number of carefully struck stone bladelets from Valdivia sites such as Real Alto suggest that wooden grater boards set with stone teeth were common. Such graters would have served in the preparation of manioc. In the Amazon basin and in the riverine flood plains of Venezuela and northern Colombia, this economic pattern was practiced at a very early time by people who invariably settled at the edge of actively aggrading river bottoms. In earlier publications I have discussed[8] the reasons for believing that this system was fully efficient before 3000 B.C. The locations of Valdivia sites such as Loma Alta and Azucar suggest a westward extension of this whole agricultural system, so that I would anticipate that a complete inventory of the crops planted by the Valdivia communities would include manioc, sweet potato, *achira* (*Canna edulis*), arrowroot, the New World yam, *mangareto* root (*Xanthosoma*), peanuts—in other words the full catalogue of Tropical Forest crops. This combined with a truly effective race of maize would have provided a most secure economic base.

There are still other indications that the people responsible for Valdivia culture were well acquainted with the practice of agriculture. Among the most striking Valdivia ceramics are a series of carved bowls dating from Valdivia 3 through 5. In every case these mimic the shape of half a bottle gourd. The carved decoration on these bowls is of a style that strongly suggests prior development in the medium of gourd carving, an artistic tradition that still survives in Perú in the production of the elaborate *matés* of the region of Huancayo. The suspicion that these Valdivia bowls are copies of carved gourd containers is strengthened by the occurrence of two actual examples of carved gourd containers from the pre-ceramic site of Huaca Prieta in the Chicama Valley on the arid northern coast of Perú (see p. 29). The style of the carving on these pieces is Valdivia 4 and has no relationship to any other known examples of Peruvian art. These are almost certainly pieces traded to the north coast of Perú from some Valdivia site in Ecuador.

The unequivocal evidence of a trade in carved bottle gourd containers suggests that large quantities of the bottle gourd fruit were available. In the New World the bottle gourd is known only as a cultivated plant. We can be certain that if the soil of the Loma Alta and other Valdivia sites was as totally dessicated as the refuse at Huaca Prieta, large numbers of similar carved gourds would have been preserved and recovered from the middens.

A similar argument can be presented to support the hypothesis that cotton was also a cultivated crop. The impressions of two textiles of different weave have been noted on a lump of partially fired clay from Real Alto, the large Valdivia site adjacent to the lower flood plains of the Rio Verde (**140**). It is conceivable that a plant other than the New World cultivated cotton was the source of the fiber that went into the yarn of the textile, but the very fine and even character of this yarn makes such an alternative unlikely. Although it is possible that the particular kind of weave, a true weave with paired warp and weft elements, could have been achieved without a mechanical means of moving the warp elements, given the fineness of the yarn and the high warp count per centimeter, it is most likely that a heddle loom was used. Lacking such a device, the separation of these numerous very fine threads would have been frustratingly difficult and time consuming.

The probable presence of the heddle loom in the Valdivia context argues that the textile industry of coastal Ecuador was much in advance of that of coastal Perú during the second and third milleniums B.C. For the same period in Perú we have literally hundreds of actual scraps of cotton textiles almost entirely made by twining, a hand-technique wide-spread before the invention of the loom. The moister conditions at Valdivia sites have prevented the preservation of textile fragments, as well as gourds. In any event, the Real Alto evidence implies that cotton textiles were of considerable importance and that the cultivation of cotton was significant and not just casual.

A further kind of evidence suggests dependence on agriculture and some considerable advance in farming practices during Valdivia times. Adjacent to the San Pablo site, with its vast area of refuse (nearly 2 km. long) and its hundreds of manos and metates, are remains of moderately elaborate dams and other indications of a deliberate effort to preserve the water supply and impede run-off. The extent of these works suggests rather intensive cultivation of the adjacent valley floor. Only Valdivia materials are found near these constructions.

201
Fig. 4
Stone ax. Valdivia.

The particular kind of ground stone ax with ears (Fig. 4) that is typical of Valdivia has a long history in coastal Ecuador and the far North Coast of Perú. Essentially identical ground stone axes were recovered by James Richardson from sites in the Talara area dating 5000 B.C.[9] Similar axes are still in use among the most remote groups in the Tropical Forest areas of South America, where their essential function is cutting down trees to clear land for agriculture. The presence of such ground stone axes in these early contexts suggests the possibility that farming was going on even before the introduction of pottery to the Ecuadorian coast.

Fishing and Hunting Systems

It would be useful if we could specify precisely what percentage of the daily caloric intake of the Valdivia people was supplied by corn, manioc, and other cultivated crops. Possibly further archaeological excavation with more attention to small charred plant fragments may allow us to approach such an estimate. Present evidence argues for the presence of large stable communities with an efficient agriculture base. The collecting of shellfish certainly provided a significant addition to Valdivia diet. The near absence of marine shell at Loma Alta may be misleading. It is conceivable that shucked and smoked mollusks were traded inland from the seaside communities in exchange for agriculture surplus raised on the more extensive agricultural lands at the disposal of the inland villages. This possibility is strengthened by the numerous fishbones at the inland Loma Alta site. These bones are from a large number of species of marine fish. Some of these could have been caught by reef-fishing, but other species were probably caught by fishing in the open ocean. A small ocean catfish was by far the most common species represented. It seems unlikely that inhabitants of Loma Alta themselves directly engaged in marine fishing. It is more probable that a shoreside Valdivia community traded its excess fish to the interior, a local system still in operation today.

The pattern of efficient marine fishing in Valdivia culture is also indicated by specialized fishing equipment. The deeply recurved fishhooks ground from a pearl shell (*Pinctada mazatlanica* Hanley) served both as hook and lure (**147-154**). The manufacture of such fishing equipment was facilitated by stone reamers (**180-185**) of easily recognizable form used to enlarge progressively the central perforation in the circular blank. It has been noted frequently that the hook of mother-of-pearl shell,

which functions both to engage the fish's mouth and to serve as a lure, is remarkably similar over the whole Pacific. In the New World such hooks of an early date are known from the pre-ceramic occupation of the north coast of Chile. The fishing equipment of the late prehistoric and historic Chumash Indians of Southern California is also remarkably similar. Comparable hooks were also in use on most of the Polynesian and Micronesian islands.

Such parallels in fishing gear extend beyond the fishhook. A kind of bone barb exemplified by two Machalilla examples (264,265), which is used to fix the composite harpoon head within an animal, can be duplicated almost exactly in pre-ceramic finds in Chile and again in the composite harpoons of the Chumash Indians. Such composite harpoons are also found in Polynesia. Various stages in the manufacture of the shell fishhooks of Valdivia are illustrated in this exhibit (Fig. 5).

The pattern of deep-sea fishing indicated by fish remains and fishing gear raises the question of the kind of water craft available to the Valdivia fishermen. One ceramic fragment from phase 4 appears to be a model of a dugout canoe (Fig. 6). Zevallos has recognized a group of Valdivia shell tools which he has called spoons (158-161). These are carefully cut and ground from the shells of large marine snails, usually of the genus *Malea*, and of other genera. The functional interpretation implied by the name "spoon" seems questionable. One of the long sharpened edges of the tools typically shows evidence of very heavy use. Perhaps these served as draw knives to scoop out the charred wood from the interior of dugout canoes, or alternatively as paring knives to take the tough cortex off tubers, such as manioc. The smaller examples probably did function as spoons.

At Loma Alta there is far more bone from Virginia deer, brocket deer, and large rodents than has been recovered from the coastal sites. Apparently, the inhabitants of the inland sites had a greater involvement in hunting, with a possible surplus of butchered and dried meat to be traded down to the seashore communities. The lack of well-made flaked-stone projectile points in Valdivia sites has suggested to some observers that there was a lack of interest in hunting land mammals. It should be noted, however, that the whole weapon arsenal of Tropical Forest culture is made of perishable materials. Spearheads and arrowheads are made of cane and palm wood, which will not survive long in the ground except in the driest conditions. It is far more likely that the Valdivia people had the set of weapons that can still be reported among surviving Tropical Forest groups. Some Tropical Forest projectile points were also made of bone, and quite possibly a more complete examination of Valdivia worked bone will reveal such projectile points. Rare examples of Valdivia bone projectile points are catalog nos. 171-173; no. 513 is a good example of the same class of bone artifact from a Chorrera site.

Machalilla and Chorrera Developments

We assume that the economic practices of the subsequent Machalilla and Chorrera peoples represented an elaboration of an already efficient agricultural system. Until more carefully collected excavation data are available, the precise nature of further economic evolution cannot be specified, but two of the remarkable Chorrera effigy vessels shed some light on the subject. One is a replica of a palm grub (387). This is the larva of a particular species of large snout beetle (*Rhynchophorus*) that develops only in the rotting trunks of certain palm trees. The grub is extremely oily, highly nutritious, and very tasty. Throughout most of tropical South America the supply of the grub is artificially increased by cutting down young specimens of the palm tree that is the host of the grub and chopping these into short segments. The nurturing of this food supply approaches animal husbandry.[10]

Even more interesting is the dog beautifully depicted in Figure 7. This particular dog representation, as we will suggest later, is the ancestor of the whole range of delightful dog effigies from the state of Colima in western Mexico. Similar figures of dogs are particularly common in the late prehistoric Chimu empire on the North Coast of Perú where they are executed in a burnished black ware. All of these dog representations seem to form a single artistic tradition of which this Chorrera vessel is the oldest known example. It also appears to depict the particular breed of dog so faithfully portrayed by Colima and Chimu potters. This is the breed usually referred to as the Mexican hairless.

141, 143-145

Fig. 5
Stages in making shell fishhooks.

26

Fig. 6
Dugout canoe model. Valdivia.

23

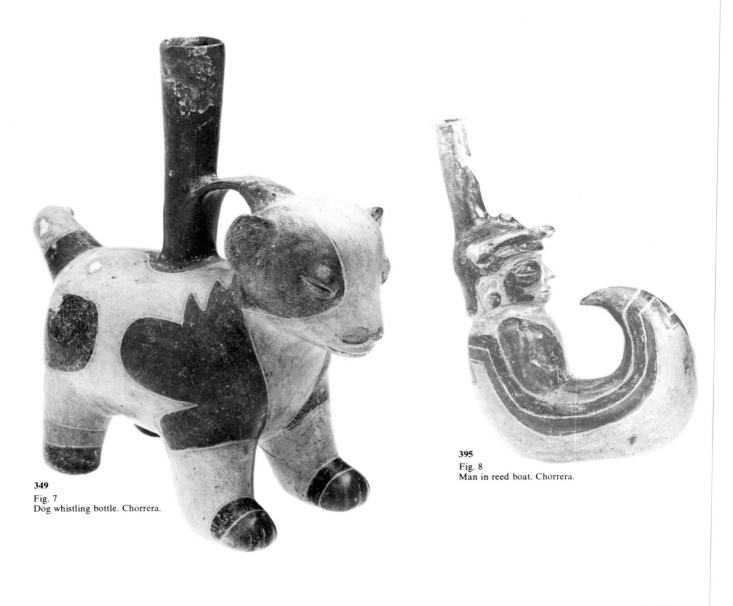

349
Fig. 7
Dog whistling bottle. Chorrera.

395
Fig. 8
Man in reed boat. Chorrera.

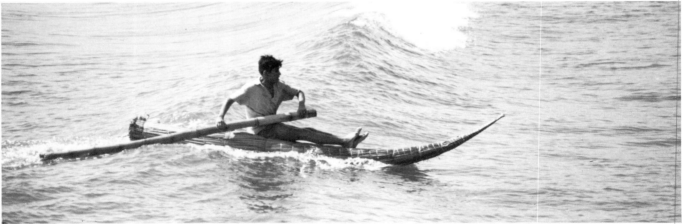

Fig. 9
Modern reed boat, Perú.

The Mexican hairless was bred as a source of meat, its low massive body having the same relationship to the contours of a normal dog as our own Angus steer has to the basic configuration of wild cattle. The presence of this highly specialized breed of dog in Chorrera before 500 B.C. suggests a long prior history of attention to the food potential of this oldest of domesticated animals, and argues that the breed first appeared in Ecuador and from there spread to northern Perú and West Mexico. A complication in this hypothesis lies in the fact that a very similar, and also hairless, dog is known from China where it was bred for eating before 2000 B.C. Some people have suggested that the presence of this particular breed in the New World is the result of contact eastward across the Pacific around 1000 B.C. Such transpacific diffusion might account not only for the dog but also for the peculiar ceramic pillows to be discussed later, and for certain kinds of human figurines and house effigies that are peculiarly East Asian in appearance.

Additional information on Chorrera agriculture is provided by two other effigy vessels. One is a remarkably accurate depiction (**391**) of the South American hard-shelled winter squash (*Cucurbita maxima*). The other is an equally exact representation of a pineapple (**389**). The pineapple is a major crop in the Tropical Forest system. It is very ancient and in the course of long term cultivation has totally lost the power of propagation by seed. Though it is an old crop in the moist tropics of South America, it seems never to have penetrated the coastal valleys of northern Perú, and this depiction is the first really direct evidence for its early cultivation.

We have noted the importance of deep-sea fishing in Valdivia and Machalilla, demonstrated both by the range of fish remains recovered from Valdivia sites, such as Valdivia itself and Loma Alta, and by the highly specialized fishing gear in both cultures. The pair of large turtle effigies (Fig. 10; **379**) seem to refer to one of the marine species, a food resource available in vast quantity on certain beaches during the nesting season.

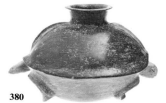

380
Fig. 10
Turtle effigy vessel. Chorrera.

We have noted the probable depiction of a dugout canoe for Valdivia. An interesting whistling bottle (Fig. 8) appears to depict a man riding or merged with a balsa boat. This type of boat, constructed of bundles of reeds, is still used for surf fishing on the north coast of Perú, where it is called a *caballito del mar* ("little horse of the sea") (Fig. 9). This effigy tells us that this class of boat was in use on the coast as early as Chorrera times.

NOTES

1. Pedro I. Porras Garcés, *El Encanto, Isle de la Puná, Guayas* (Quito, 1973).

2. Presley Norton, "A Preliminary Report on Loma Alta and the Implications of Inland Valdivia 'A'," *Primer Simposio de Correlaciones Andino-Mesoamericano*, (Salinas, Ecuador, July 1971), Guayaquil, in press. Also see: Norton, "Early Valdivia Middens at Loma Alta, Ecuador," paper presented at 37th annual meeting of the Society for American Archaeology, Bal Harbor, May 6, 1972.

3. Carlos Zevallos Menéndez, *La Agricultura en el Formativo Temprano del Ecuador.* (*Cultura Valdivia*) (Guayaquil: Casa de la Cultura Ecuatoriana, 1971).

4. Jorge G. Marcos, "Loomed Textiles in a Late Valdivia Context (Ecuador)." (Unpublished mss., University of Illinois, Urbana, 1973).

5. Zevallos, *La Agricultura en el Formativo.*

6. Barbara Pickersgill, "The Archaeological Record of Chili Peppers (*Capsicum* spp.) and the Sequence of Plant Domestication in Peru," *American Antiquity*, XXXIV (1969), 54-61.

The possibility of a corridor of cultivation down the eastern foot of the Andes has also been supported by David Buge ("Maize in South America," unpublished mss., University of Illinois, Urbana, 1973).

7. Donald W. Lathrap, "The Antiquity and Importance of Long-Distance Trade Relationships In the Moist Tropics of Pre-Columbian South America," *World Archaeology*, V (Oct. 1973), no. 2, 170-186.

Also see: Lathrap, "The Moist Tropics, the Arid Lands, and the Appearance of Great Art Styles in the New World," pp. 115-158, *in* Mary Elizabeth King and Idris R. Traylor, Jr., eds., *Art and Environment In North America*, Special Publication No. 7, Texas Tech University Museum, 1974; and Lathrap, *The Upper Amazon* (Ancient Peoples and Places, LXX) (New York: Praeger, 1970).

8. Lathrap, "Our Father the Cayman, Our Mother the Gourd: Spinden Revisited, or a Unitary Model for the Emergence of Agriculture in the New World," paper presented at the 9th International Congress of Anthropological and Ethnological Sciences (Chicago, Ill., 1973), in press.

9. James B. Richardson III, "The Preceramic Sequence and the Pleistocene and Post-Pleistocene Climate of Northwest Peru," pp. 199-211, in Donald W. Lathrap and Jody Douglas, eds., *Variation in Anthropology: Essays in Honor of John C. McGregor* (Urbana: Illinois Archaeological Survey, 1973).

10. An ethnographic study of the Cayapa Indians of Ecuador published in 1925 gives the following description of the storage and cooking of palm grubs:

"A rather rare food, and one much prized by the Cayapa, is a large white, brown-headed grub, called kómucū, which is found in rotten trunks and stumps of fallen palms. Their presence is easily detected by their low, crunching sound as they eat the tough palm fibers within. Such a log is cut open and the grubs are carefully taken out, along with a considerable quantity of the rotted palm-wood. They are usually placed in burden-baskets and then stored in the house in a closely-covered olla until needed. The grubs have a very tough skin, and contain a considerable quantity of rich fat, resembling lard, which is used by the Indians in several ways. The kómucū may be eaten raw, but more frequently it is broken open, placed over the fire in a small pottery vessel, and fried in its own fat, so to speak, resulting in a very rich oily food." S. A. Barrett. *The Cayapa Indians of Ecuador*. Part 1, p. 77 (Indian Notes and Monographs No. 40). (New York: Museum of the American Indian, Heye Foundation: 1925).

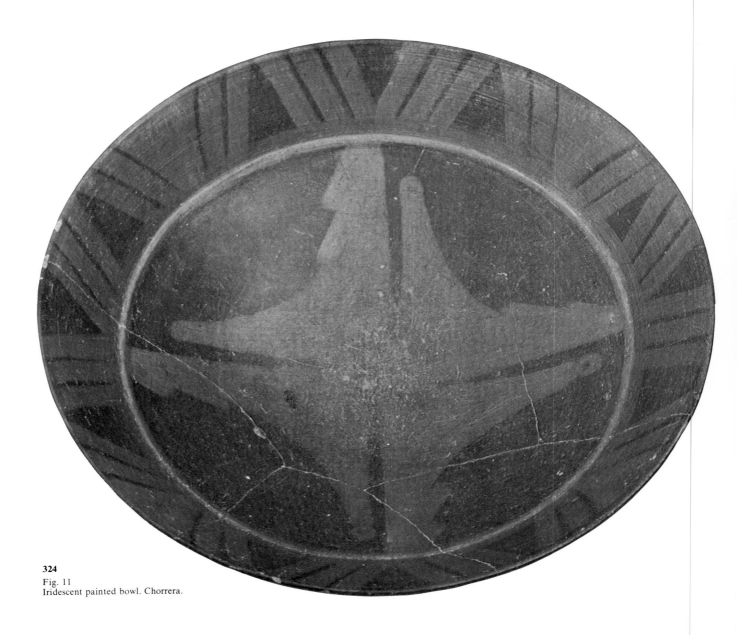

324
Fig. 11
Iridescent painted bowl. Chorrera.

26

Chapter III

THE CERAMICS OF THE ECUADORIAN FORMATIVE

It is not the intended function of this catalogue to present a refined chronology of the pottery, which makes up so large a part of the surviving art of ancient Ecuador, although the illustrated Valdivia specimens are labeled in terms of Hill's eight-phase framework for Valdivia. The typological classifications that have been used in discussing this pottery are often detailed to the point that the major outlines of cultural development have been obscured. We will confine ourselves to a few broad observations about the nature of the whole ceramic inventory and how this changes through time.

Valdivia Ceramics

It has been noted that the earliest known pottery in the Valdivia series comes from the very bottom of the midden at the Loma Alta site, 15 km. up the Valdivia River from the coast. A small amount of similar pottery was noted by H. Bischof and J. Viteri[1] in their recent excavation at Valdivia, but this phase was not recognized or separated in the earlier work of Meggers, Evans, and Estrada.[2] Although the Loma Alta material appears to stand as the ancestor of the other phases of Valdivia culture, it is not necessarily the oldest pottery in Ecuador. Bischof and Viteri recovered at the Valdivia site a few fragments of pottery in a different cultural tradition from a level underlying that containing Loma Alta materials. The single vessel shape and decorative modes of this pottery, which has been named San Pedro, are outside the known range of Valdivia stylistic practices. Though San Pedro materials are earlier than Valdivia, they do not appear to be ancestral to Valdivia in a developmental sense. The facts force us to consider the existence of not just one but a minimum of two distinct pottery traditions at a time period earlier than 3000 B.C., namely San Pedro, and an as yet undiscovered complex ancestral to the earliest Valdivia of Loma Alta.

It has already been noted that Valdivia as a way of life can be understood only in terms of the evolution of progressively more efficient agricultural systems based on crops unique to the New World. We have suggested also that Valdivia took advantage of both the highly efficient system of root crops typical of the Tropical Forest in South America, and the progressively more efficient seed crop agricultural system that had corn as the basic staple and beans and squash as the other two mainstays of the diet. It is assumed that the origins of Valdivia ceramics and the tight integration of the pottery with the economic patterns are also to be understood in terms of indigenous development in northern South America. The San Pedro pottery, on the basis of the very limited sample (27 sherds), does appear to be simple but technically competent. The earliest Valdivia pottery from Loma Alta is technically developed and shows several distinctive shape categories, each presumably related to a particular culinary, serving, or storage function.

From the beginning there appear to be three distinct categories of vessel shape. One pot form has a tall, moderately concave neck and a nearly spherical body (Figs. 12, 15; **3, 5**). Such pots may be completely plain, but a large number carry on their neck a broad zone of incised decoration or carefully executed cross-combed decoration. Apparently, the end of a notched stick or the edge of a mollusk shell was sometimes used to comb the surface of moist clay.

The second form of pot has a squat outline, and a rather marked shoulder emphasized by bosses pushed out from the interior of the vessel. The neck is short. The rim is thickened by the addition of an extra strip of clay, and is modified by pinches at regularly spaced intervals so that it bears a remarkable resemblance to the

2
Fig. 12
Incised jar. Valdivia.

4
Fig. 13
Pot with pie crust rim. Valdivia.

27

6

Fig. 14
Bowl with red slip. Valdivia.

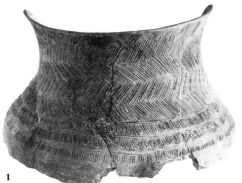

1

Fig. 15
Incised jar fragment. Valdivia.

Fig. 16
Early facial treatment. Valdivia.

593 *(drawing)*

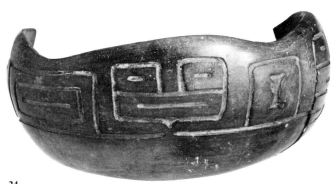

24

74

Fig. 17
Rectangular facial treatment. Valdivia.

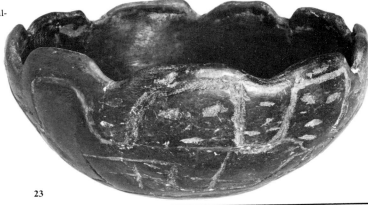

23

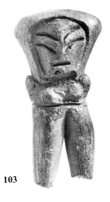

94

Fig. 18
Arched facial treatment. Valdivia.

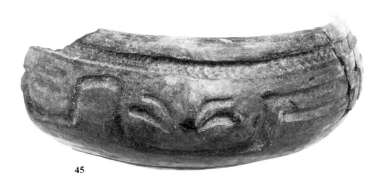

45

103

edge of a pie crust (Fig. 13). A third clearly defined vessel (Fig. 14) is a nearly hemispherical bowl that is covered with a red slip (a paint of iron oxide applied before the vessel is fired). In the earliest levels at Loma Alta such bowls lack any form of incised decoration. There is certainly a long history of development behind this set of task-specific vessels, as evidenced by the well controlled decoration and technologically sound production. A really experimental ceramic complex would be expected to have a low level of standardization and little or no clear differentiation among vessel shapes. Loma Alta is far from such a primitive beginning of ceramic art.[3]

Any discussion of the origins of Valdivia ceramics must focus on the characteristics that are peculiar to the earliest pottery at the Loma Alta site. At present no other known complex either within South America or anywhere else in the world shares this particular set of ceramic characteristics.[4] Even in this early form, one of the most basic distinctive features of Valdivia ceramic tradition is evident. There is clearly a sharp conceptual distinction between pots—vessels with markedly restricted openings and clearly demarcated necks—and bowls. There was apparently a clear conviction that decorative techniques appropriate to pots were inappropriate to bowls, and vice-versa. This principle of a clear division of pots and bowls and of the appropriate embellishment of each is maintained throughout the 1500 year developmental history of Valdivia pottery.

The group of pottery from Punta Concepción studied by Hill and which is the basis for Hill's Valdivia phase 1, differs from the earliest Loma Alta material mainly in the addition of incising rather cursorily executed through the red slip after the slip and vessel had dried (7). Also, the pie crust rims are not present at Punta Concepción. By Valdivia 2, the red-slipped bowls have become much larger. They are frequently equipped with low tetrapod feet and are often decorated with incised lines carefully cut through the red slip, executed either while the clay is still slightly moist, a procedure known as incising (9, 10), or after the vessel was fired, a procedure technically known as engraving (Fig. 19). The pots show a range of incised decoration on the neck that is largely a continuation from the earliest Loma Alta material, but there is frequently an exuberant use of finger-trailing executed in fairly moist clay (11) which gives a deeply fluted effect to the vessel neck.

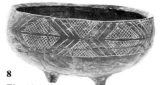

8

Fig. 19
Engraved bowl. Valdivia.

Valdivia 3 is characterized by low, broad pots whose rims are pushed out from the interior, with a strip of red slip circling the interior of the lip (14). Such rims typically have four to six vertical projections and the contemporaneous bowls have rims which are alternately elevated and cut away.

Valdivia phases 3-5 show a wide range of bowls, many of which are clearly imitations of halved, carved bottle gourds (Fig. 20; 19, 23-25, 27, 45). The treatment of the human face, which is a major motif in this tradition of carved bowls, follows the same stylistic evolution as can be observed on the figurines. The early pattern of facial treatment on the carved bowls and on the Huaca Prieta carved gourds is closest to the stylization seen on the stone figurines of Valdivia 1 and 2 (Fig. 16). The flat, rectangular incised form is very similar to the faces on the early group of clay figurines (Fig. 17). With the passing of time, the treatment becomes more cursive, and finally in Valdivia 6 the arching eyes and eyebrows and modeled nose typical of the San Pablo style figurine are seen (Fig. 18). At least in the earliest part of this development, the decoration on the bowls lags slightly behind the treatment of figurines, suggesting that innovation occurred mainly in figurine manufacture and gourd carving and slightly later was transferred to bowls.

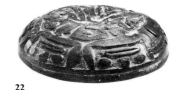

22

Fig. 20
Bowl imitating carved gourd. Valdivia.

In Valdivia 5, another variant of bowl becomes common. In this bowl a zone extends from the rim part way down the side of the vessel, sharply demarcated by a ridge or even by a highly salient shelf of clay. In some bowls this zone is sharply demarcated by a red slip that contrasts with the deliberate, dense black smudging applied to the rest of the surface of the vessel (31). This deliberate contrastive use of zones of red slip with zones of intentional smudging is greatly elaborated in the later part of the Ecuadorian Formative.

During Valdivia 4-5 pots are characterized by a fairly tall neck decorated with geometric fine-line incision or rows of punctation. The rim is externally thickened. Frequently the external and internal surface of the rim is painted with a red slip while the rest remains the natural color of the fired clay (Fig. 21; 21).

Phase 6 is characterized by considerable variety of vessel form. One group of pots (Figs. 2, 22; **32, 33, 36**) has a very short, deeply concave neck that is frequently bridged by multiple loop handles. A moderately broad incised line frequently encircles the vessel; the bottom of this line may carry rocker stamping or some other surface modification (Fig. 18).

Another group of pots has much taller rim sections with marked internal cambering (Fig. 23; **38, 43, 44**). This form of pot is typically associated with a highly burnished red slip contrasting with zones of punctation or other forms of surface tooling (**43**).

In Valdivia 7 the outward flaring of jar rim becomes even more extreme so that there is frequently an incised decoration on the inside of the vessel mouth. Unfortunately, the Pérez Collection lacks good examples of this style.

The transition from Valdivia 7 to 8 is marked by a number of innovations. Vessels show a very strong tendency to carination, that is, a sharp ridge or angle between the side and bottom of the vessel. Very frequently the sides of the vessels, both pots and bowls, are markedly concave, making the boundaries between the sides and bottoms of the various vessel shapes even more evident (Fig. 24). The decoration typically consists of a very carefully executed zone of closely spaced incisions. This zoned incision may take the form of groups of parallel lines lying more or less at right angles and forming triangular patterns or the texturing may be of very fine cross-hatched lines. Both forms of zoned texturing serve as footing for three-color painting laid on after the vessel is fired, almost certainly in a melted resin base. The three colors most often used were Indian red, from ground hematite; yellow ochre, from limonite, the less-reduced variant of iron oxide; and a dead white, possibly a koalin-like clay. Placed against the highly burnished black smudged surfaces, these three vivid colors produced striking, indeed almost gaudy, effects (Fig. 25).

The elaborate use of zoned textured decoration in combination with multi-colored, resin-based paints put on the vessel after it was fired appears suddenly in the Valdivia tradition and has no local developmental antecedents. These stylistic influences seemed to work more strongly on the Valdivia sites around Santa Elena Peninsula than on Valdivia manifestations further to the north. Luckily, we can specify the direction from which these influences came. In the Huánuco Basin on the eastern slope of the Peruvian Andes and at sites along the Ucayali on the floor of the Amazon Basin in eastern Perú one finds a shared ceramic tradition in which sharply carinated vessels are typically decorated with the same range of zoned texturing combined with three-color, resin-based, post-fired painting. This kind of painting again contrasts sharply with an intense, highly burnished black background. The vessel shapes and decorative style of Valdivia 8 bowls are derived from the decorative tendencies which appear earlier in eastern Perú. All available evidence clearly indicates that this pottery tradition known from the lowland forest site of Tutishcainyo and the Huánuco Basin sites of Kotosh and Shillacoto was initially a lowland Tropical Forest development spreading from the west Amazon Basin up the eastern slope of the Andes. This aesthetically spectacular style, which is a manifestation of developed Tropical Forest culture, greatly modified and enriched the ceramic inventory in the final phase of Valdivia.

Another characteristic of the Tropical Forest tradition shared by the eastern Peruvian lowlands and the Huánuco Basin was the use of a particular form of closed bottle with two spouts and a connecting bridge. Typically, these spouts arise from a dome-like protuberance on top of the body of the bottle. The same kind of domed top occurs on the stirrup spout and the double-spout-and-bridge of Machalilla and even on the spout-and-whistle bottles of Chorrera (**298**).

The material from the late Valdivia component at the site of Chacras in Manabí is of great interest and it is unfortunate that there is little information on its precise dating. The Valdivia vessels are characterized by extreme carination with the exaggerated keels (**63**) that have their only close parallels in the Late Tutishcainyo pottery of the Upper Amazon and eastern Perú (**588-592**). The sharply angular, incised designs also have close parallels in the Late Tutishcainyo complex, as does the pattern of executing deep gashes in the carination and all other projecting edges of the pot.

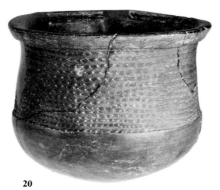

20
Fig. 21
Punctate decoration. Valdivia.

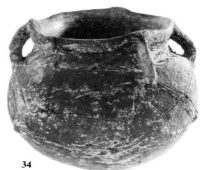

34
Fig. 22
Jar with loop handles. Valdivia.

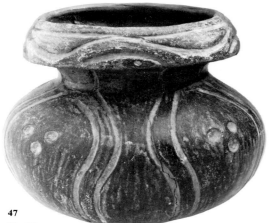

47
Fig. 23
Jar with cambered rim. Valdivia.

51
Fig. 24
Bowl with concave side. Valdivia.

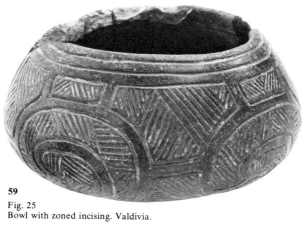

59
Fig. 25
Bowl with zoned incising. Valdivia.

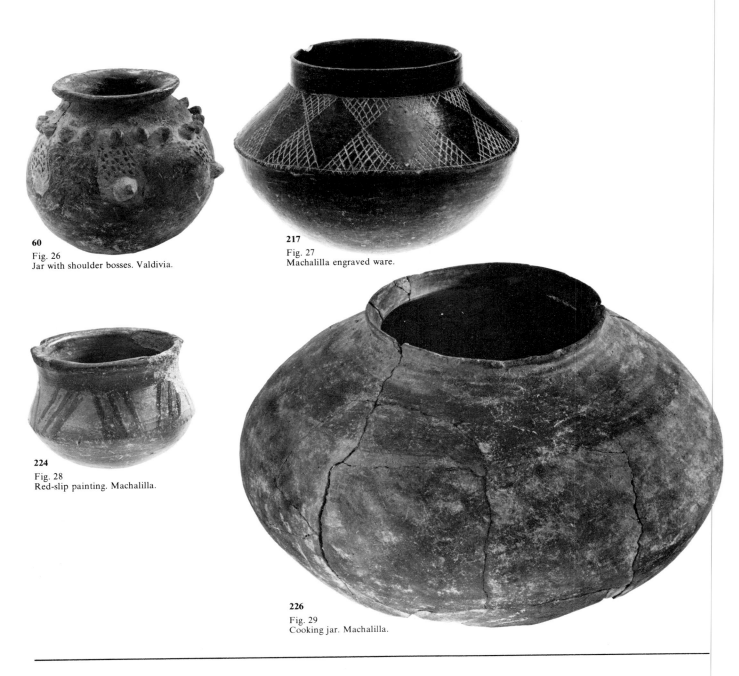

60

Fig. 26
Jar with shoulder bosses. Valdivia.

217

Fig. 27
Machalilla engraved ware.

224

Fig. 28
Red-slip painting. Machalilla.

226

Fig. 29
Cooking jar. Machalilla.

Fig. 30
Comparison of Machalilla and
Cerro Narrío engraved ware.

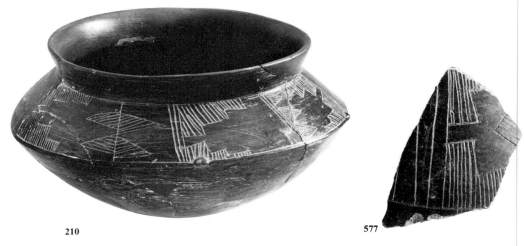

210

577

The pot forms of the Valdivia component at Chacras show the further exaggeration of the markedly flaring rims noted in Valdivia 7 and, again, much of the incised decoration is just inside the rim (**64-65**). Some of the other vessels show a kind of conical noding and a combination of zoned red slip and fine punctation already very close to Chorrera norms (Fig. 26). We have no idea as to the time span of the Valdivia occupation at Chacras. Apparently, the Chacras style is a Valdivia variant that evolved directly into the Rio Chico variant of Chorrera without passing through an intermediate Machalilla-like phase. The figurine tradition is strongly supportive of this suggested pattern of development and will be discussed in greater detail later.

Machalilla Ceramics

The ceramics of the Machalilla culture continue many features noted in Valdivia 8, and, in general, Machalilla pottery can be considered an outgrowth of Valdivia, though a completely convincing transitional phase has not been described in the published literature. Materials recently recovered from the Real Alto site on the Rio Verde show a predominance of finely engraved red ware and seem to represent a fully intermediate stage between Valdivia and Machalilla. Later phases of Machalilla are characterized by deeply smudged, burnished blackware, usually further decorated by lines engraved into the vessel after firing and smudging. Such engraved designs are generally further accentuated by rubbing a pigment, most frequently white, into the lines (Fig. 27; **207, 210, 215**). These bowl forms show extreme carination. At this particular time there is remarkable similarity among the vessel shapes of Ecuador, the Upper Amazon, and coastal Perú, suggesting considerable contact and interchange of ideas.

There is also a great deal of pottery deliberately fired under oxidizing conditions to a light tan. Frequently, such tan or brownish ware is decorated with linear red-slip painting. Differential red-slip painting appears, of course, well back in the Valdivia sequence, but the geometric designs typical of Machalilla slip painting represent a further elaboration on this theme (Fig. 28; **220-223, 225**). This kind of linear red-slip painting also is fairly frequently combined with black burnished smudging to give a red-and-black color scheme (**228**). The forms of cooking vessels seem mainly to be a continuation of late Valdivia norms, but a nearly spherical jar with extremely thin walls and a short, sharply out-curved rim around which were painted one or more red bands is an innovative form (Fig. 29). This form is identical with the most common vessel form at Cerro Narrío in the south highlands of Ecuador. Thus Machalilla was influenced not only from the Upper Amazon, but also by the flourishing highland farming communities of southern Ecuador.

We know these southern highland communities were fully agricultural, as a carbonized corncob was found in a very deep part of the deposit at the Cerro Narrío site. Contact and interchange of ideas between the coastal Machalilla people and the highland Formative complexes continued with increasing intensity. Late in the Cerro Narrío occupation there are engraved vessels which are absolutely identical with the coastal engraved wares typical of the arbitrary boundary between Machalilla and Chorrera (Fig. 30). Another spectacular example of these parallels is on an engraved stirrup-spout bottle from Azuay (Fig. 31). The shape of the spout is typically Machalilla and the scroll design is repeated on certain engraved and carved Machalilla sherds from La Ponga, which also resemble the *raspada* ("rasped") ware of the Middle Formative of Mexico.

A further innovation in Machalilla ceramics is the appearance of tall pedestal bases (Fig. 32; **209, 213, 227**). The use of such bases is another characteristic of the early ceramic tradition of the Amazon and Orinoco drainages and we should probably look to that area as the source of this trait.

Bottles with a rather short, markedly flaring, neck (Fig. 33; **222**) and red-on-tan linear decoration occur in Machalilla. These are of the greatest interest, since they are essentially identical with the very early bottle forms of West Mexico and Tlatilco. Ecuador would appear to be the source of the West Mexican bottle tradition.

One of the most interesting forms in Machalilla ceramics is the stirrup-spout bottle. This bottle form was of great importance in the ceramic art of northern Perú, where from 800 B.C. on up to the Spanish Conquest and even into Colonial times it

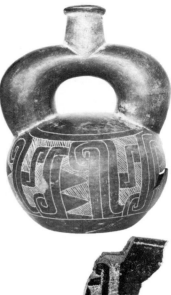

218

Fig. 31
Engraved bottle from Azuay and Machalilla sherd.

212

Fig. 32
Bowl with pedestal base. Machalilla.

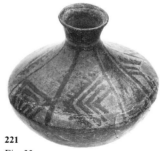

221

Fig. 33
Bottle. Machalilla.

was the vessel which received the most elaborate artistic embellishment. The stirrup spout also appears in the Capacha culture of Colima in West Mexico in 1450 B.C. and continues as a West Mexican specialty even up into the protohistoric Tarascan ceramics. From Mexico the form spread to the United States, both into the Southwest and the Southeast, where it occurs only rarely. Available dating suggests that the Machalilla development is the source of both the Peruvian North Coast tradition and similar vessels in West Mexico. It is now clear that the stirrup spout developed in Machalilla is a modification of the kind of double-spout-and-bridge bottle found in the earliest known ceramic tradition of the Upper Amazon (Fig. 34). From the Machalilla midden at the site of La Ponga there is a fragment of a double-spout-and-bridge bottle fragment (**229**) with the mouths of the two spouts converging along the short bridge. The typical form of the individual halves of the Machalilla stirrup spouts resembles that of a double-spout-and-bridge bottle of Tutishcainyo and has the same outward bulge. It is not the bent cylinder form typical of later Peruvian examples. The Machalilla stirrup spout is simply a double-spout-and-bridge bottle with the mouth of the two spouts merged along the top of the bridge. The Machalilla stirrup spouts are set on a dome-like protuberance. This arrangement first appears in the double-spout-and-bridge bottles of the Tutishcainyo ceramic tradition of the Upper Amazon.

Chorrera Ceramics

Chorrera represents the artistic climax of the Ecuadorian Formative, but many of the elements which reach their most masterful elaboration in Chorrera have their roots in Machalilla or Valdivia. Chorrera makes extensive use of a creamish white slip which appears as a rare item in late Machalilla. The kind of zoned, hatched engraving (Chorrera Incised) that is used on Chorrera whistling bottles and other vessel forms evolves imperceptibly from the kind of engraved decoration typical of late Machalilla (Ayangue Incised). (See Fig. 27 for a Machalilla example and Fig. 35; **280** for Chorrera examples.) The numerous and delightful anthropomorphic and zoomorphic vessels of Chorrera, which are a high point in realistic modeling in New World art, have their antecedents in the relatively rare anthropomorphic vessels of Machalilla (Fig. 36; **256**). The use of resist decoration is extensive in Chorrera. This involves protecting the surface of certain areas of the vessel from the greasy smudging atmosphere of the kiln so as to produce a design in which the dense, shiny black smudge contrasts with the natural clay color of the pot (**301**). Resist decoration is a variant of the more general practice of intentional smudging of pottery. Such smudging was accomplished in a second low temperature firing of the vessel after the clay had been converted to a ceramic during the initial high temperature firing. Such differential smudging can be applied against the light tan surface of the vessel (Fig. 37), against a uniform background of red slip (Fig. 38), or against a vessel already differentially painted red and white (Figs. 1, 7 and 39). We can only speculate as to the material applied to impede the absorption of the smudge. The modern Cashinahua Indians of eastern Perú and Brazil now achieve an identical effect with a paste of very fine ash.

There is extensive use of black in Chorrera color schemes. This often appears to be organic in nature or even the result of smudging. It may be that many of the elaborate bichrome and trichrome designs on vessels (Figs. 40, 41) are thus a highly specialized form of resist. Only further analysis and experimentation can determine the range of black paints involved in the production of Chorrera pottery, but the fugitive, organic nature of much of Chorrera black pottery is clearly indicated by the little turtle effigy (Fig. 42). After it was broken and discarded, one of the fragments of this vessel inadvertently found its way into the fire and the black smudged surface was totally removed. The deliberate smudging of part or all of a vessel to achieve a shiny black surface can be traced back at least as far as Valdivia 3. The resist of smudging to produce complex patterns has not been noted on the coast prior to Chorrera, but is found in quantity even to the very lowest levels of the Cerro Narrío site in highland Ecuador, which is known to predate Chorrera by a number of centuries.

A similar method of resist decoration occurs in the very earliest ceramics of the South Coast of Perú, which also predate Chorrera. There is reason to suspect that the patterned use of resist combined with intentional smudging is typical of all of the very early pottery in Amazonia, but the dismal condition of the surfaces of the eroded

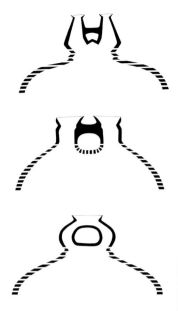

Fig. 34
Development of stirrup spout, Upper Amazon double-spout-and-bridge (above); Machalilla double-spout-and-bridge (center); Machalilla stirrup spout (below).

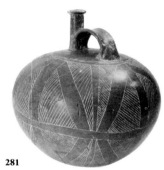

281
Fig. 35
Engraved whistling bottle. Chorrera.

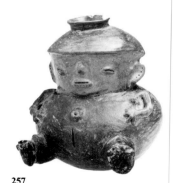

257
Fig. 36
Anthropomorphic vessel. Machalilla.

34

313
Fig. 37
Black smudging on tan. Chorrera.

303
Fig. 38
Black smudging on red slip. Chorrera.

302
Fig. 39
Smudging on red and white. Chorrera.

315
Fig. 40
Whistling bottle with trichrome design. Chorrera.

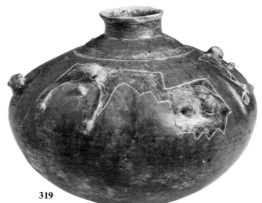

319
Fig. 41
Jar with bichrome design of bats in flight. Chorrera.

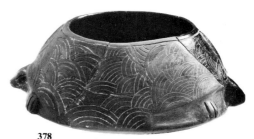

378
Fig. 42
Partly refired turtle effigy. Chorrera.

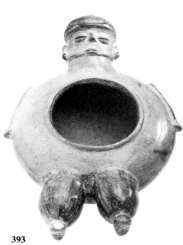

393
Fig. 43
Effigy jar with Cerro Narrío-style modeling. Chorrera.

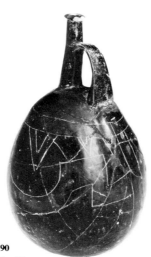

390
Fig. 44
Gourd-shaped whistling bottle. Chorrera.

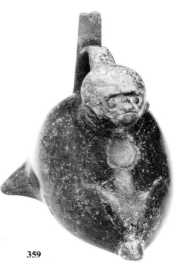

359
Fig. 45
Spider monkey whistling bottle. Chorrera.

35

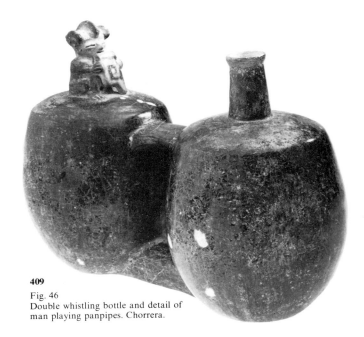

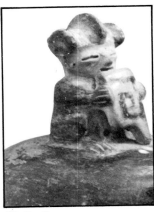

409 *(detail)*

409

Fig. 46
Double whistling bottle and detail of
man playing panpipes. Chorrera.

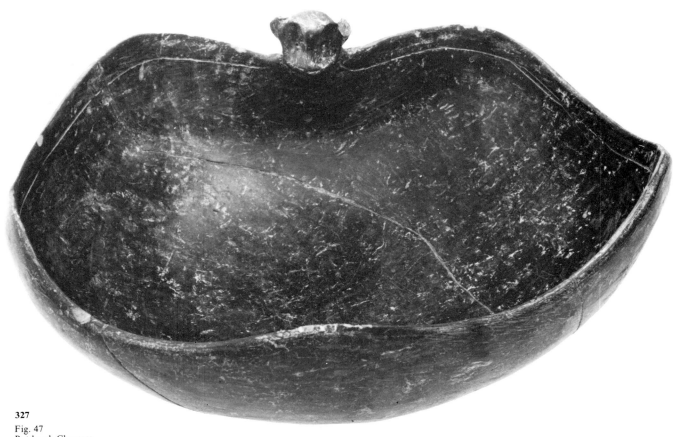

327

Fig. 47
Bat bowl. Chorrera.

ceramics from these sites makes the detection of resist decoration difficult. The most likely source of resist in Chorrera is to be found in Early Cerro Narrío.

Massive highland influence on coastal ceramics is confirmed by a particular form of effigy vessel recovered from Chorrera sites in Manabí (Fig. 43; **353, 392, 394**). Bulges are pushed out from the interior of the vessel to represent the head and limbs of the creature portrayed. This style of modeling also occurs in the earliest pottery of Cerro Narrío and appears suddenly on the coast at a much later date.

The so-called iridescent painting of Chorrera will receive attention in a later section. It is merely a slight refinement of the red-and-black color scheme common in Machalilla.

The major innovation in Chorrera is the conversion of the double-spout-and-bridge bottle into a bottle with a spout, bridge, and whistle. This is simply a variant of the double-spout-and-bridge idea and was for Chorrera the vehicle for the expression of the most fully realized artistic impulses (Figs. 44, 45).

These Chorrera vessels seem to be the prototype for the early Paracas bottles on the South Coast of Perú, which frequently carry elaborate Chavín designs. The pitch of the whistle in the Chorrera bottles was carefully regulated and, in some instances, there are two whistles at an interval of a third. The musical implications of the whistle were often emphasized by the addition to the whistling bottle of an effigy of a performer on the panpipes (Fig. 46).

The vessel forms of Chorrera are too numerous and diversified for extended comment, but one form deserves special notice. There are a number of elegant bowls, frequently on high pedestal bases, in which the whole interior area of the bowl is conceived as the body of an animal, with the head, limbs, and tail executed as modification of the rim, and with the head looking inward on the interior volume of the vessel. Most of the Chorrera examples in this tradition represent bats (Fig. 47; **328-331**). The whole concept of transforming an open bowl into a zoomorphic effigy through modification and modeling of the rim is typically Amazonian, and has its most thorough expression in the Barrancas ceramics of the flood plain of the Orinoco River. This concept is present in a wide range of related complexes throughout the Amazon Basin. These pedestal bat bowls seem to be a further example of influences coming to Chorrera from the Amazon.

The Chorrera ceramic pillow or neckrest also deserves brief comment. This form is strikingly similar to east Asian pillows and it has been suggested that they represent the influences of transpacific contact during the first millenium B.C. Such ceramic pillows become rather more common in the later complexes, such as Bahía, which followed Chorrera, but the decoration of several specimens in the Pérez collection is typically Chorrera. The droll armadillo effigy (Fig. 48) is a particularly charming example of these pieces. It would appear as if some of the large hollow human figurines in prone and supine position also served as pillows (**343-345**).

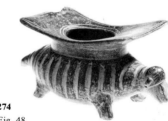

274

Fig. 48
Armadillo effigy neckrest. Chorrera.

NOTES

1. Henning Bischof, "Una investigación estratigráfica en Valdivia (Ecuador): Primeros resultados," *Indiana*, I (1973), 157-163, Berlin. Also see: Bischof and Julio Viteri Gamboa, "Pre-Valdivia Occupations on the Southwest Coast of Ecuador," *American Antiquity*, XXXVII (Oct. 1972), no. 4, 548-551.

2. Meggers, Evans, and Estrada, "Early Formative Period."

3. There is a discrepancy between the range of pottery that Hill (*Ñawpa Pacha*, in press) recovered from the Punta Concepción site and regards as very early Valdivia and the pottery that Norton recovered from the very lowest levels of Loma Alta. Hill has no evidence of the pie crust rim and bossed shoulder, but such vessels occur in the very earliest occupation of Loma Alta associated with the early dates (3100 B.C.).

4. Meggers, Evans, and Estrada ("Early Formative Period") have discussed similarities between the ceramics of Valdivia and Middle Jōmon in Japan, and have postulated that Valdivia pottery was introduced to coastal Guayas from Japan by the chance landing of Jōmon fishermen whose boat had been blown off course. These ceramic similarities do not seem sufficiently close (for example, the vessel shapes are completely different) to warrant a detailed discussion of this theory here. It has been amply commented on elsewhere (see: Lathrap, review of Gordon R. Willey's "Summary or Model Building: How Does One Achieve a Meaningful Overview of a Continent's Prehistory?" in *American Anthropologist*, LXXV [1973], no. 6, 1755-1767).

It seems clear today, a decade after the Jōmon theory was proposed, that the immediate ancestor of the earliest Valdivia pottery (Loma Alta) is to be sought in Ecuador and that pottery in South America is many centuries older than the postulated Jōmon Odyssey.

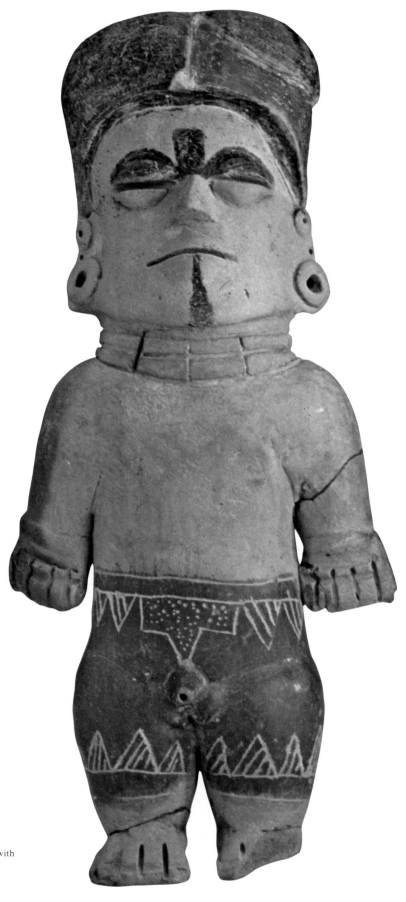

420
Fig. 49
Hollow figurine of nude male with
body painting. Chorrera.

Chapter IV

The Figurine Tradition

The figurine tradition so typical of the Ecuadorian Formative cultures represents the earliest known appearance of this form of artistic expression in the New World. Small clay models of humans were not uncommon in the very earliest Peruvian farming communities, but were of rather minor importance to later civilizations of the Central Andes. The production of human figurines was of vast importance to most of the Formative cultures of Mesoamerica, and the creation of tremendous numbers of these effigies continued on up to the time of the Spanish Conquest in that area. The early dating of the Ecuadorian examples, as well as other evidence for Ecuadorian influence on Mesoamerica, discussed elsewhere in this text, leads to the conclusion that the figurine tradition of Mesoamerica was directly derived from that of the Ecuadorian Formative.

The earliest human figurines in the Ecuadorian tradition are of carved stone. These range from simple ground plaques to elaborately carved representations in which the facial features are clearly indicated and the hands are depicted as a feather- or rake-like design. The stone prisms are turned into human effigies by low-relief carving emphasizing the eyes and hands. This style of carving was also applied to gourds and may well have been first developed in that medium. It has been suggested by Meggers, Evans, and Estrada[1] that there is a progressive sequence of stone figurines, from the simple rectangular plaque (**66-69**), to plaques with a groove indicating the division between the legs (**70, 71**), to the more detailed depiction of the human face and limbs (**74-76**; see Fig. 50). This is possible, but there is some reason to suspect that the elaborately carved stone examples occur as early as the very earliest Valdivia ceramics represented at Loma Alta.

By Valdivia 3, fired clay was substituted for stone as the medium for figurine production and the particular technique of forming the torso and legs by squeezing together two rolls of clay was established. Some of the Valdivia 3 clay figurines are very simple and repeat the simple grooved plaque form developed in stone. Most typical of Valdivia 3 are female figures with tiny faces almost hidden by a mass of hair. The top of the head shows a short incised line running from front to back. The arms are barely indicated and the legs are separated by a narrow slot-like cut. A clear definition of the breast shows that a woman is intended, but the whole figurine has the overall form of a penis with the massed hair explicitly in the form of the glans (see **82**, Fig. 51).

The union of both sexes is indicated in the earliest elaborate clay figurines and this strongly supports the conventional interpretation of these objects as fertility symbols. The next stage is characterized by relatively flat faces with the eyes and mouth indicated by simple horizontal incised lines (see **92**, Fig. 51). The depiction of the hair becomes progressively more elaborate and the breasts are given increasingly greater prominence and a more realistic sculptured treatment (**100**). Most characteristic of the female figurines is the careful and often exaggerated depiction of the breasts. There are rare instances of male figurines. In one, the male wears a belt and loin cloth, a costume still typical of the Tropical Forest culture of today (**95**). Until Valdivia 5 or 6 the face is treated as a relatively flat plane, but in the San Pablo variant of Valdivia figurines the nose is indicated by a high ridge while the eyes and eyebrows are depicted by long, slanting and usually arched lines (see **102**, Fig. 51).

In the southern range of the Valdivia culture there was a loss of interest in the manufacture of figurines during the final phases of Valdivia, but the characteristics of the San Pablo figurine tradition were continued and further elaborated in the late Valdivia figurines of the Chacras site in Manabí.

Fig. 50
Valdivia stone figurines.

66 71 76 77

Fig. 51
Valdivia ceramic figurines.

Fig. 52
Machalilla solid figurines.

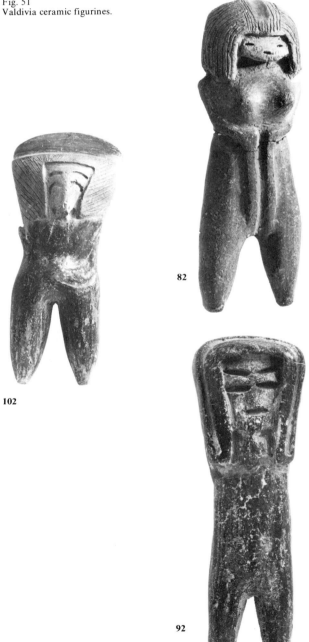

102

82

92

242

249

239

247

40

The Chacras figures are variable. The eye treatment may be a continuation of the San Pablo practice, or small appliqué pellets in the shape of coffee beans may be used to indicate the eyes (Fig. 53). The high flattened head that is so clearly depicted in the San Pablo figurines is almost certainly evidence that frontal-occipital head deformation was being practiced (see **102**, Fig. 51). The high flattened head is even more evident in the Chacras figurines, particularly in the large modeled head shown in Figure 68. The hair or headdress area frequently carries an elaborate incised design. As will be emphasized later, the stylization of the better-made examples of Chacras figurines fully anticipates the hollow figurines in the Rio Chico variant of Chorrera (Figs. 53, 68). Especially interesting are a number of Chacras examples that are depicted in positions suggesting motion, with the head, body, and limbs all aligned in different planes (**109, 110**). The figurine tradition of Chacras bears a close resemblance to that of the early Momil culture of the tropical lowlands of northern Colombia, both in the treatment of the hair, the hairdress, and the facial features.

Compared to the dynamic and detailed modeled figurines of terminal Valdivia, a few of which are startlingly realistic and which in every way anticipate the facial features of Chorrera hollow figurines, the figurine tradition of Machalilla is rather crude and markedly stylized (Fig. 52). It does show, however, the same pattern of coffee-bean eyes and salient nose frequently present in the Chacras tradition, suggesting that the two regionally distinct traditions may be of approximately the same age.

A peculiarity of the figurines is a row of perforations or punctations frequently seen along the edge of the head or along the edges of the ears. One suspects that hair or feathers were inserted as a form of adornment. In two of the larger hollow figurines (Fig. 54; **258**), such a row of perforations also extends along the lower lip. This feature is clearly suggestive of the style of multiple skewer-like labrets still to be found among certain Tropical Forest Indian groups, notably the Mayoruna Indians of eastern Perú.[2]

A hollow figurine fragment showing breasts with multiple-colored, post-fired painting (**255**) is deserving of special notice. The excavated context of this fragment was clearly Machalilla.

The hollow Chorrera figurines are a high point in the ceramic art of the New World. They are paralleled by a continuing industry in small solid figurines, which in a number of instances show the same peculiarities, such as two-headed figures, that characterize the earlier Valdivia solid figurine tradition.

NOTES

1. Meggers, Evans, and Estrada, "Early Formative Period."

2. See photograph by Helen and Frank Schreider on page 84 of *Exploring the Amazon* (National Geographic Society, 1970).

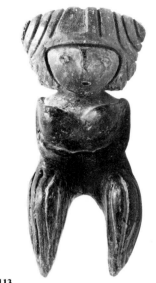

113
Fig. 53
Chacras-style figurine.

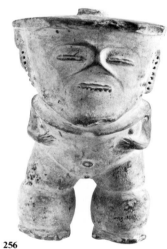

256
Fig. 54
Machalilla hollow figurine.

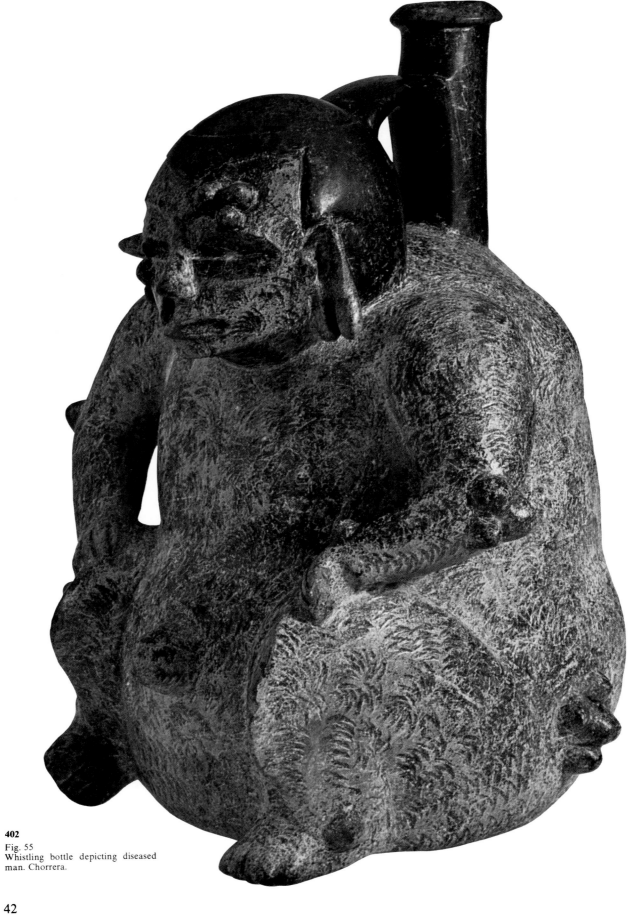

402
Fig. 55
Whistling bottle depicting diseased
man. Chorrera.

42

Chapter V

LIFE IN FORMATIVE ECUADOR

The goal of the archaeologist is to reconstruct as fully as possible the total cultural patterns of long-dead societies. This ideal is most easily achieved in the domain of economic activities: what the people ate and what pursuits occupied most of their time. The goal must also include an attempt to reconstruct a social system and a system of cosmology and beliefs that can serve as a context for interpreting the meager preserved remains recovered by the archaeologist. In the Ecuadorian Formative, the greatest body of evidence available to the scholar comes in the form of durable ceramics. The bowls, vessels, and effigy figures are what give a sense of life and reality to Ecuador's distant past.

One of the archaeologist's most useful tools is the search for analogies. He must study the life ways of surviving groups who may represent a continuity of cultural tradition from the much earlier time represented by the archaeological site. It has already been suggested that the economic practices and life style of the early sedentary inhabitants of coastal Ecuador were an extension of Tropical Forest culture, which itself expanded out of the Amazon Basin, first to the Guayas Basin and then on west to the coast. It was a Tropical Forest economy further enriched by the presence of developed races of corn.

In this chapter we wish to show that much of the surviving remains of the Ecuadorian Formative can be understood in terms of beliefs and practices continuing among the Indians of tropical South America east of the Andes. We have already noted that the weaponry of Formative Ecuador almost certainly was of the pattern surviving in extant Tropical Forest communities. The prevalence of fragmentary human bone at the Loma Alta site suggests that the inhabitants practiced cannibalism, a gastronomic specialty of Tropical Forest peoples.

Prior to August 1974 there was no information on the nature of Valdivia houses. Continuing excavations at the Valdivia site of Real Alto by a team of archaeologists from the University of Illinois, Urbana, have uncovered the complete floor plan (Fig. 57) of one Valdivia house and traces of several more. The house was large with its walls encircling an oval area 10.3 m. by 8 m. Massive hardwood posts up to 20 cm. in diameter formed the frame of the structure and were deeply embedded in a trench which served as the foundation for the outer wall. It was a sturdy structure built to endure for a long time. During the period it was occupied, 20 cm. of trash gradually built up on the floor. This cultural deposit contains the remains of the hundreds of pots and dozens of figurines made, used, and discarded by the inhabitants. The style of these remains precisely dates the house to Valdivia 3 (ca. 2300 - 2200 B.C.).

Fig. 56
Hypothetical reconstructed drawing of Valdivia house, Real Alto.

The size of the house is not compatible with the interpretation that it sheltered a single nuclear family. Rather, the structure is comparable to the *malocas* of the Upper Amazon which house lineage groups, several families related through the male line. A population of 30 people for the house does not seem excessive. During Valdivia 3 times there were many similar houses at Real Alto, all oriented according to an overall plan. Further excavations will permit a precise house count, but 50 to 100 seems a reasonable estimate. The population of this planned, permanent town, then, can be bracketed between 1500 and 3000. Populations of this size and stability must have been maintained by a truly efficient agricultural system.

The houses of Real Alto were arranged in rows or streets which, in turn, were oriented around a central open plaza containing the remains of what appears to have been a somewhat larger structure (Fig. 57). One might characterize the whole plan of Real Alto as a rectangle with rounded corners or as a somewhat squarish oval. El Encanto, the other Valdivia site for which information on town planning is available, was clearly a perfect circle with a large open plaza in the center.[1]

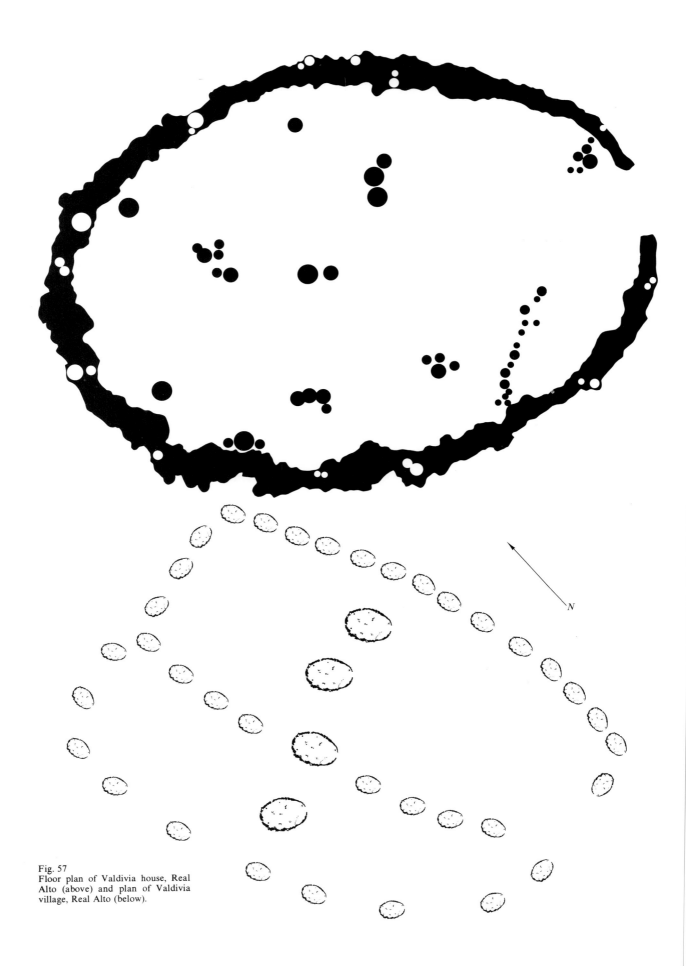

Fig. 57
Floor plan of Valdivia house, Real
Alto (above) and plan of Valdivia
village, Real Alto (below).

N

Thus in instances where the arrangement of individual structures within Valdivia communities is indicated, it is certain these structures were located so as to surround a large open plaza with a central structure or structures in the middle of the open area. This pattern of town planning has its closest parallels in modern Indian communities occurring in a broad belt from the highlands of northeastern Brazil to the south and west on up to the eastern foothills of the Andes in Bolivia. This kind of circular plan with one structure in the center is best developed among Gĕ speaking tribes of northeastern Brazil and the Bororo of more southernly Brazilian highlands. Among these groups the village plan is a clear map of the way in which the whole community is integrated. It is legitimate to look to the village plans of Ge and Bororo communities and the social order they exemplify for clues to the interpretation of Valdivia society.

Modern Tropical Forest communities are notable for the large number of young wild animals that are caught and raised as pets. The nurturing of young wild animals even extends to breast feeding by the women of the village. This love of wild animals and the keeping of a large number of such animals in a semi-domesticated condition in the village is strongly suggested by the thematic material of many of the remarkable whistling bottles from the Rio Chico variant of Chorrera. Most of the species so realistically depicted—the *Cebus* monkey (Fig. 58), the wooly monkey, the spider monkey—are all easily tamed to make excellent pets. This is also true of the coati and the kinkajou, both tropical members of the raccoon family, and many of the birds depicted (Fig. 59). Though many of the animals depicted in the Chorrera effigies are of species highly appropriate to be kept as pets, such an explanation would not cover the palm grub (**387**), the sea turtles (Fig. 10; **379**), or the magnificent four-color representation of the crab (Fig. 1). Here a focus on important food resources seems indicated.

360
Fig. 58
Cebus monkey. Chorrera.

The Chorrera ceramics also indicate that the tumpline and burden basket were used to transport heavy loads (Fig. 60; **397, 437**). This method is typical of Tropical Forest culture but is so widespread throughout the New World that it is not a particularly distinguishing factor.

Use of Hallucinogenic Drugs

The surviving data offer the possibility of a surprisingly complete reconstruction of religion. Tropical Forest cultures of South America are remarkable in that they use far more hallucinogenic drugs and integrate the use of such drugs into their religion in a more complex way than any other peoples on earth. More species of plants containing chemicals which can alter the physiological or psychological state of the human organism have been identified and used by Indian groups of the Amazon than by any other people. Both species of domesticated tobacco were clearly brought under cultivation in the Amazon drainage. Coca, the source of the modern drug cocaine, was domesticated on the eastern slope of the Andes. The tropical vine, *Banisteriopsis*, frequently referred to as *ayahuasca*, and the seeds of the mimosa-like tree, *Anadenanthera*, are two of the most powerful vision-producing agents known, resulting in particularly intense and complex colored hallucinations. These are only a few of the most widespread and powerful mind-expanding drugs in the arsenal of the Tropical Forest religious practitioners. The visions and experiences achieved through the use of these drugs are of great religious importance, both in ceremonials binding the living group to the collective body of dead relatives, and in curing rituals. The most common religious practitioner in the Amazon Basin is a shaman, who gets his power through repeated sacramental use of *ayahuasca* and/or the snuff ground from seeds of the *Anadenanthera*. It is believed that while under the influence of these elements, the shaman is possessed by or turns into a ferocious animal, most typically a cayman (a kind of South American alligator) or a jaguar. While possessed by or transformed into his supernatural helper, or alter-ego, he is believed to be capable of traveling at incredible speed through both time and space and in this state can retrieve the soul of his patient or determine what other conditions must be met to insure the recovery of his patient.

369
Fig. 59
Macaw whistling bottle. Chorrera.

Over most of tropical South America east of the Andes the symbol of this kind of shaman is a wooden stool that is carved in the form of the ferocious creature who is the alter-ego of the individual shaman. Most typically, the stool is in the form of a

399
Fig. 60
Burden carrier wearing tumpline. Chorrera.

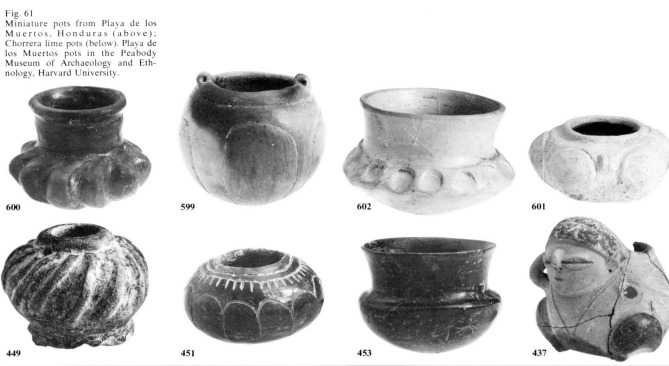

Fig. 61
Miniature pots from Playa de los Muertos, Honduras (above); Chorrera lime pots (below). Playa de los Muertos pots in the Peabody Museum of Archaeology and Ethnology, Harvard University.

600

599

602

601

449

451

453

437

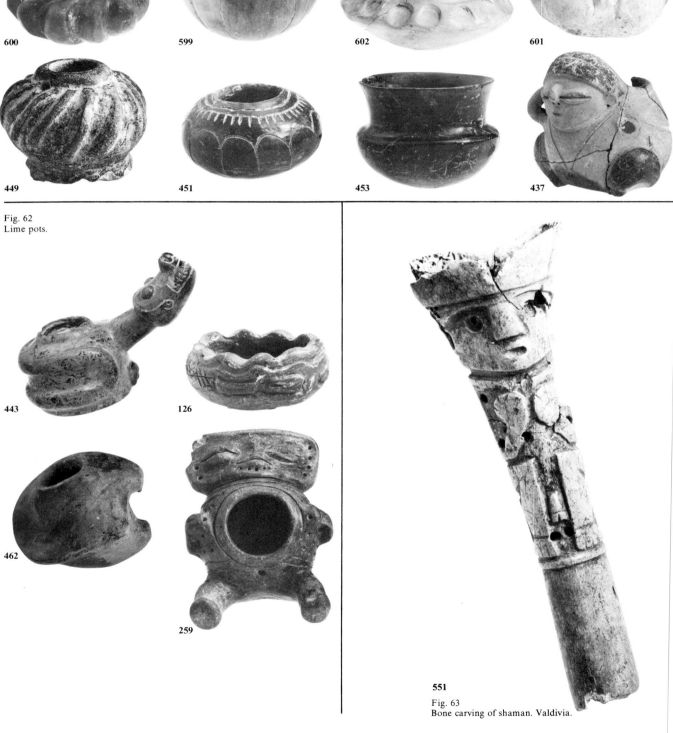

Fig. 62
Lime pots.

443

126

462

259

551

Fig. 63
Bone carving of shaman. Valdivia.

jaguar, although the cayman is also frequent and there are even examples implying a double load of power, with one end carved as a cayman and the other as a jaguar.[2]

The uniformity of this complex of beliefs and practices throughout South America indicates that it is a very old system of thought and can be projected back to the earliest variants of Tropical Forest culture. It is thus of tremendous interest that along with the solid human figurines of Valdivia, which may have served in curing rituals, we find exact minature replicas of the zoomorphic wooden shaman's stools which are the prerogative of the Tropical Forest curer. One of the Valdivia examples is even clearly a jaguar (**119**), and is identical except in scale to a recently carved wooden stool from one of the tribes in the upper Xingu Basin in Brazil. A Chorrera carving on a human arm bone depicts a male figure seated on a four-legged stool with carved ends depicting an animal, probably a jaguar (Fig. 63). The man very probably is a shaman.

Wooden stools could not have survived in the moderately moist soil of Valdivia sites and it is fortunate that small clay replicas were made. The same pattern of making small clay copies of shaman's stools occurs in early levels of the Momil site, a very early example of Tropical Forest culture in northern Colombia. The presence of this kind of shaman's stool implies the use of either *ayahuasca* or the snuff from the *Anadenanthera* tree.

96
Fig. 64
Figurine carrying snuff tablet on head. Valdivia.

While there is no other direct evidence for the use of *ayahuasca*, the remarkable little hollow figurine (Fig. 64) with a rattle in her belly, carries on her head the kind of flat tablet or pallet that is used when inhaling the hallucinogenic snuff. This specimen is rather small for a functional snuff tablet, but a fragment of a similar much larger figurine with a pallet on the head was recovered in the excavation of Meggers, Evans, and Estrada, and would have been of a size totally appropriate to a snuff tablet.

These snuff tablets were usually made of palm wood and conform to a remarkably uniform pattern from the Atacama desert of northern Chile on through the Amazon Basin and out to the Greater Antilles. A carved wooden example from a dry cave in the Dominican Republic (thought to date from the fifteenth century A.D. and now in the Museum of Primitive Art, New York) shows the closest parallel to th ̣ Valdivia clay replicas of snuff tablets.

Throughout that great area the snuff was inhaled by means of tubes of wood, bone, or pottery. None of the former have survived on the coast of Ecuador but we have two Chorrera ceramic snuffing tubes, one representing a crocodilian head (Fig. 65), the other ornamented with three human heads (**482**).

483
Fig. 65
Snuffing tube. Chorrera.

It is highly probable that the seed of the *Anadenanthera* was in use by Valdivia times and even then was an important article of trade, as it remains today in the highlands of the Central Andes. The chewing of dried coca leaf with lime is one of the most widespread characteristics of Andean peoples. It is used by a traveler or workman to alleviate feelings of hunger, thirst, and fatigue, and, especially in the northern Andes, it is used in vast quantities as a part of the most sacred religious ceremonies. Coca was brought under cultivation east of the Andes, quite probably on the eastern slope of the Ecuadorian or Colombian Andes. It requires sufficiently cool and moist conditions, so it could not be grown in Ecuador west of the Guayas Basin. There is strong reason to believe that the full complex of chewing cultivated coca with lime was present in Valdivia culture from the beginnings of the Loma Alta occupation on. The presence of coca in archaeological contexts is most easily inferred from the recovery of small containers used to carry the powdered lime and from which the lime is introduced into the mouth. Most typically these are of gourd, and thus not preserved in coastal Ecuador. Lime containers were also very carefully made ceramic vessels of small size, many of which contained lime when found.[3] There is a tradition of carefully decorated miniature vessels that starts in Valdivia (**122-130**), extends through Machalilla (**259-261**), and reaches its maximum elaboration in the beautifully executed miniature effigy vessels of Chorrera (**434**, **436-466**; for a representative selection from all three periods see Figure 62.) These take the form of human burden carriers, monstrous snakes, and a wide range of threatening animals of the kind associated with possession. Some of the non-zoomorphic miniature vessels used as lime containers are interesting in that they are identical in form and decoration to miniature vessels from the early Formative site of Playa de los Muertos on the Ulua River at the southeastern edge of Mesoamerica (Fig. 61).

A particularly interesting vessel (see **462**, Fig. 62) is an exact copy of the bivalve shell *Anadara grandis*. There are also examples of lime containers actually made from these shells. The tradition of elaborate lime containers stretching through the whole range of the Valdivia, Machalilla, and Chorrera continuum is a very persuasive argument that coca chewing was a highly significant part of the life of these early Ecuadorians. It is possible the lime was also chewed with domesticated tobacco.

The importance of coca chewing is further emphasized by a dynamic and carefully modeled figurine in Chacras style from the Valdivia site. In this figure the quid of coca in the cheek is clearly depicted (Fig. 66). This is the earliest known example of a long tradition of figurines clearly delineating coca chewers manufactured mainly in the northern highlands of Ecuador.

The coca habit of the peoples responsible for Valdivia culture is a strong suggestion that the ultimate origin of these people was east of the Andes and that plantations of fully domesticated coca were extant on the eastern and western slopes of the Ecuadorian Andes by 3000 B.C.

108

Fig. 66
Head of man chewing coca. Valdivia.

A particularly curious Chorrera whistling bottle may shed further light on drug use and belief systems. The head of the creature depicted is plainly a toad rearing back and presenting threatening claw-like limbs. On closer inspection these limbs seem to be the heads of raptorial birds (Fig. 67). This monstrous, threatening toad seems to relate to an entity in the mythology of a number of Central American and South American groups, as Peter T. Furst has discussed in a recent article.[4] This toad is an all-powerful female deity who is both a source of life and the destroyer of life. Furst has also argued that the importance of the toad deity is tied to the use of the poisonous skin secretion of certain species of toads as an hallucinogenic drug.

The presence of coca at a very early time level in the Valdivia communities suggests well established trade networks tying coastal Valdivia communities with agricultural communities more than 100 miles away. As I have indicated in an earlier publication,[5] the long distance exchange of vegetable products and particularly craft specialities is another characteristic of Tropical Forest culture which apparently developed very early.

Personal Adornment

The Valdivia figurines and the subsequent elaboration of this tradition in Chorrera suggests that clothing was of a rather minimal nature, but various forms of personal adornment, including necklaces, labrets, and ear spools are indicated. The working of several kinds of seashell into articles of personal adornment, especially beads, starts early. The red rim of the *Spondylus* shell (**565**) was an especially valued material. *Spondylus* shell from which the red rim has been cut is fairly common in Valdivia sites, but finished artifacts of this material are rare, suggesting that most of the cut rim was for export. In contrast, the contemporary site of Cerro Narrío in the south highlands of Ecuador yields fantastic quantities of *Spondylus* rim and ornaments manufactured from this material. One can argue that the cut red rims were traded to Cerro Narrío in exchange for coca and products coming out of the Amazon Basin, and that Cerro Narrío was a factory center for producing elaborate shell ornaments, which were traded out in all directions.

Cerro Narrío was certainly in a favorable position to mediate, indeed dominate, trade routes connecting the Amazon Basin to the coast. The Valdivia-like culture recently discovered by Porras Garcés on the Rio Pastaza in eastern Ecuador gives us some idea of the Amazon Basin groups involved in such a trade network (**584-586**) . Many of the finished shell ornaments from Machalilla and Chorrera appear to be in the style of Cerro Narrío.

Olaf Holm has recently cited evidence that the purple dye obtained from the rock shell *Murex* was in use in Valdivia times.[6] This, too, could have served as an important trade item moving inland and up into the mountains.

Shell ornaments became progressively more elaborate in Machalilla and Chorrera, though the most complex piece from a Machalilla site again seems to be an import from Cerro Narrío (**263**). Chorrera jewelry also includes carefully shaped beads of rock crystal, a most resistent material for people without power-driven equipment

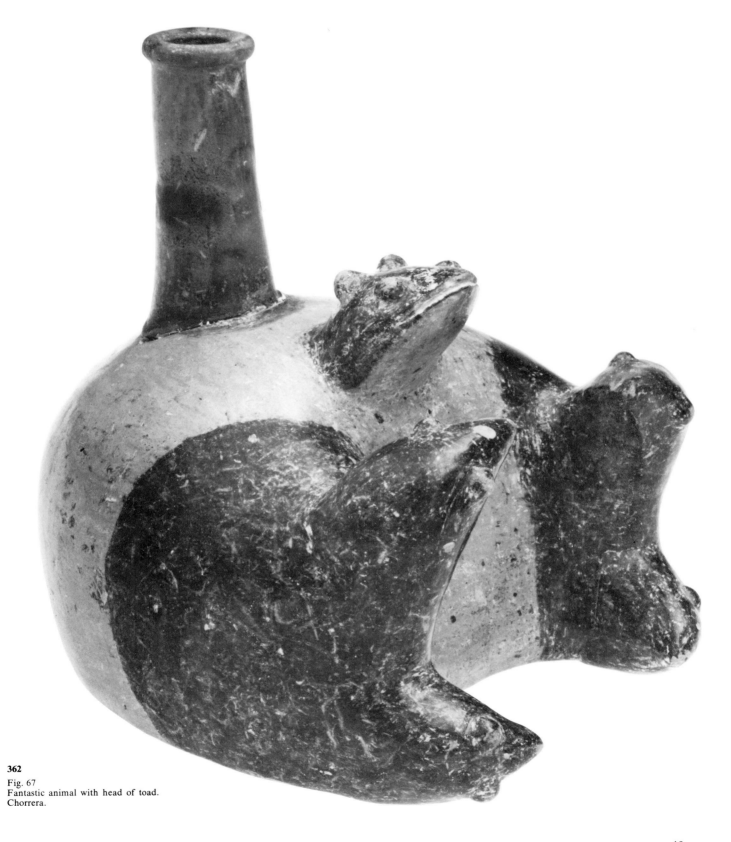

362
Fig. 67
Fantastic animal with head of toad.
Chorrera.

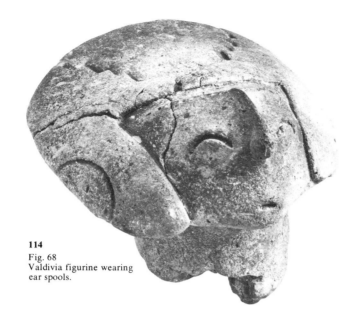

114
Fig. 68
Valdivia figurine wearing
ear spools.

412
Fig. 71
Fragment of figurine showing body
painting. Chorrera.

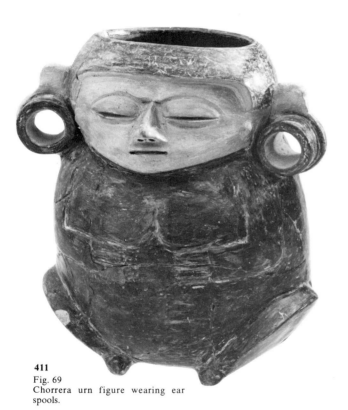

411
Fig. 69
Chorrera urn figure wearing ear
spools.

474
Fig. 70
Ceramic ear spool. Chorrera.

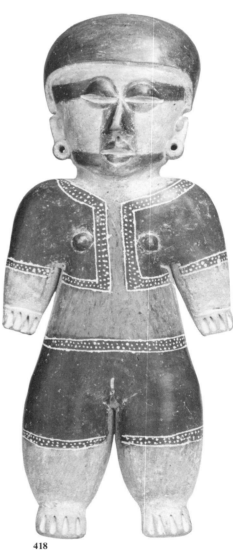

418
Fig. 72
Hollow figurine of woman with
body painting or patterned textile.
Chorrera.

(**566, 567**). Along with the well-made shell beads and ornaments, people of Machalilla culture also produced neatly carved cylindrical beads of fired clay (**262**).

Throughout the Tropical Forest and eastern Brazil, recent tribes have the habit of perforating earlobes and gradually expanding the diameter of the perforations by inserting progressively larger spools. In the Amazon Basin and eastern Brazil these spools are typically of carved wood and the diameter of such spools worn by mature males frequently reaches 3 in. The Spanish commonly used the designation *orejones* for tribes whose ear spools were particularly large, many of whom they observed in their early explorations through the Amazon Basin.

The presence of this practice in Formative Ecuador can be documented as early as the Chacras variant of Valdivia. The large, solid modeled head shown in Figure 68 clearly indicates such ear spools. The most fully realistic depiction of such enormously stretched lobes is on a large Chorrera urn in the form of a seated male (Fig. 69). One suspects that in Valdivia and Machalilla such ear spools were usually of carved wood. In Chorrera there are numerous examples made of thin, beautifully polished smudged ceramics (Fig. 70; **472, 475**), as well as of *Spondylus* shell, onyx, and other attractive materials (**479-481**).

A number of the large hollow figurines suggest that though the human body was often unclothed, it was frequently painted with complex designs. Most of these figurines show the breasts and genitalia with sufficient clarity so as to suggest that the patterns on the torsos represent body painting rather than textile clothing (Figs. 49, 71, and 72). In several instances such body painting is remarkably similar to that still practiced by the Witotoan-speaking tribes of northeast Perú.

That body painting was a much favored form of personal adornment is also suggested by the flat stamps and roller stamps that are very common items in Chorrera refuse (Fig. 73; **515-517, 519, 520, 522-537**), and examples of roller stamps are present as early as Machalilla (**233**). In the Tropical Forest similar roller stamps are used exclusively for the purpose of laying painted designs on the face and body. Most Tropical Forest examples are of carved wood and would not survive under archaeological conditions. One suspects that the preserved ceramic stamps and roller seals made up a very small part of such implements available to the people of the Formative culture of Ecuador.

The people of Valdivia made do with local lithic material for their flaked stone tools. But later in the Ecuadorian Formative, as more controlled and precise stone-working techniques were instituted, large quantities of obsidian were imported from regions of volcanic activity high in the Ecaudorian Andes. The carefully prepared obsidian blades which occur in late Chorrera contexts (**571-575**) are similar to the blade tradition in obsidian which is typical of the highlands of Central Mexico.

521

518

Fig. 73
Flat and roller stamps. Chorrera.

NOTES

1. See site plan opposite p. 24, Porras Garcés, *El Encanto, Isla de la Puná.*

2. Otto Zerries, "Bancos zoomorfos y asientos de los espíritus en la América del Sur," *Supplemento Antropológico*, V (1970), nos. 1-2, fig. 20, Asunción.

3. Chemical analysis by Bertram Woodland of samples of the whitish powder from five Chorrera lime pots has shown that it is mainly a very fine grained calcium carbonate, which apparently was precipitated through the action of ground waters containing carbon dioxide. It is thus probable that the original material when the pots were in use was lime. Burned shells are the probable source because the phosphate content of this lime (about 1 per cent) is much too low for bone, probably too high for limestone, but closest to shell.

4. Peter T. Furst, "Hallucinogens in Precolumbian Art," pp. 11-101, in Mary Elizabeth King and Idris R. Traylor, Jr., eds., *Art and Environment in North America*, Special Publication No. 7, Texas Tech University Museum, 1974.

5. Lathrap, "The Antiquity and Importance of Long-Distance Trade Relationships In the Moist Tropics of Pre-Columbian South America."

6. Cited by Olaf Holm in personal correspondence to Donald Collier, July 27, 1974.

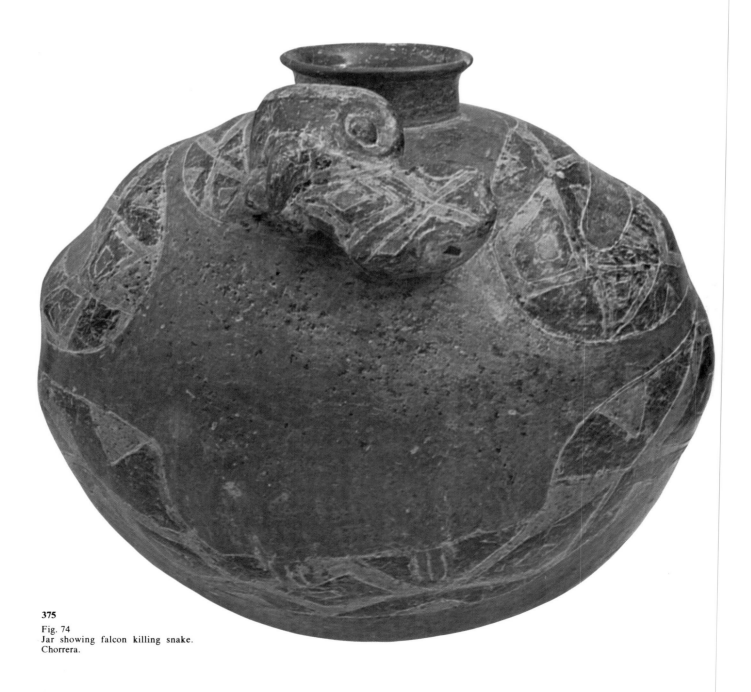

375
Fig. 74
Jar showing falcon killing snake.
Chorrera.

Chapter VI

INFLUENCES OF THE FORMATIVE ON THE EMERGING CIVILIZATIONS OF MESOAMERICA AND PERU

It has been asserted here that the Ecuadorian Formative developed on the secure economic base designated as Tropical Forest agriculture. This system became even more efficient with the addition of productive races of corn acquired before the Tropical Forest people pushed over the passes of the southern Ecuadorian Andes and entered the tropical lowlands of the Guayas Basin.

The highly efficient agricultural system which appeared so precociously in coastal Ecuador had a marked influence on the agricultural developments underlying the civilizations of Perú and Mesoamerica, and with further study of archaeological maize it should be possible to trace the spread of large-kernel flint corn from Ecuador into these two regions. Until we have far more information about the economic patterns of Valdivia, Machalilla, and Chorrera than is available at present, it is impossible to offer direct proof for this assertion. What we do have at hand is a large amount of evidence on ceramic technique and art style, and with this evidence it is possible to demonstrate that the Formative cultures of coastal Ecuador did, in fact, exercise a decisive influence on both of the New World areas where civilization was ultimately achieved.

Ecuador's Early Cultural Preeminence

A number of near cultural identities have been noted between Ecuador and various sites in Mesoamerica, particularly along its Pacific coast. We wish to examine a few patterns of shared similarity, in each case indicating that the direction of influence was from Formative Ecuador to Mesoamerica or Formative Ecuador to Perú. Perhaps the most massive influences in Mesoamerica are those which related to the red-on-tan pottery tradition of the early Formative of West Mexico. David Grove, who has worked extensively in the Mexican states of Morelos and Guerrero, finds that the earliest Formative communities in this area and elsewhere in West Mexico are characterized by a red-on-tan ware.[1] The red paint is laid on in a simple geometric design. Shapes include rather squat bottles, and stirrup-spout bottles that show all of the specific peculiarities of Machalilla stirrup-spout bottles, including the stirrup rising above a sharply marked dome or shelf. There are vessels that mimic the form of a stack of progressively smaller pots. This is a ceramic peculiarity found in Machalilla and can be traced back as early as Valdivia 6 (Fig. 75).

48

Fig. 75
Valdivia double pot.

The extensive use of carination, and all aspects of vessel shape, suggest a direct derivation of this whole ceramic complex from some Ecuadorian prototype very like the transition from terminal Valdivia to Machalilla. Grove has gone so far as to suggest that the presence of this ceramic complex in West Mexico is due to a direct colonization of the area by expanding farming communities moving out from coastal Ecuador. If this is the accepted reconstruction of what actually happened, such colonization took place through long distance voyages rather than by overland march, for similar pottery is not found in the intervening area. One might guess that these colonists were the ancestors of the Tarascans, who even at Spanish contact times were separated from other Mesoamerican peoples by their language and customs and who maintained into the Colonial period a red-on-tan ceramic tradition that included the stirrup spout. This group of Formative peoples expanded rather rapidly, and at an early time moved eastward into the Valley of Mexico, where their pottery forms a part of the ceramics recovered from the great cemetery site of Tlatilco.

The Example of Iridescent Painting

Iridescent painting as used by Chorrera potters produced some of the most aesthetically satisfying ceramics of Ecuador (Figs. 11, 76). Pottery with almost identical decoration is known from the Ocos component at the La Victoria site on the south

322
Fig. 76
Iridescent painted bottle. Chorrera.

32
Fig. 77
Valdivia smudged jar with red-slip rim.

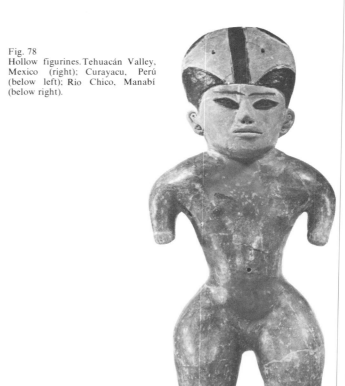

Fig. 78
Hollow figurines. Tehuacán Valley, Mexico (right); Curayacu, Perú (below left); Rio Chico, Manabí (below right).

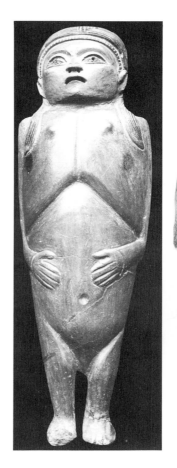

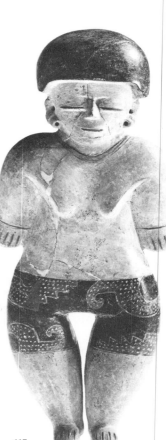

417

54

coast of Guatemala.[2] This is one of the very earliest settlements of Formative peoples in Mesoamerica. The parallels between the iridescent painting from Ocós and from Chorrera, including both technique and design motifs, could scarcely be more precise. It is difficult to doubt that the two groups of pottery have a common origin. Unfortunately, the Ocós material is now less spectacular because of its eroded condition.

If we examine the technology which the ancient potters used to achieve this effect, we can understand its history. The areas of iridescence are produced by a very dilute slip of clay containing iron oxide. The thin wash of iron oxide gives a pinkish color to the paint; the very fine clay particles of the slip give the lustrous quality to the surface. This thin red slip was applied to the vessel before its initial firing. After the first firing, the vessel was returned to a closed smoky kiln for a low-temperature firing, during which time the intense black smudging was achieved.

This technique is only a special variant of the differential use of red slip and black smudging which in Ecuador was a productive artistic device as early as Valdivia 3. The small Valdivia 6 pot with its brilliant red-slipped lip and black body is a particularly striking example of this technique in Valdivia (Fig. 77). We had originally assumed that the red slip inhibited the absorption of the dense greasy smudge, but Robert Sonin of the Brooklyn Museum informs me that careful experimental work indicates the smudge passes through the red slip and accumulates in the paste of the pot. If the red slip is carefully removed with steel wool or some other abrasive, the black surface is found underneath. The red slip masks the smudging but does not prevent its absorption.

In Valdivia this combination of techniques is used only to produce broad bands of red around the neck to contrast with a black smudge over most or all of the vessel's exterior. Linear red-painted designs are combined with all-over black smudging in Machalilla, and, in some instances, when the slip was rather dilute, the iridescent effect is approached.

The Chorrera examples employ a very dilute slip in which only the finest particles are suspended, apparently applied as finger painting, with the index finger. This represents the culmination of ceramic experimentation that began at least 1000 years earlier. The open bowl (273) is particularly instructive because the red slip is less dilute; it thus falls halfway between the linear red slip and smudging characteristics of Machalilla and the iridescent painting of Chorrera. Iridescent painting was an almost inevitable result of the long period of ceramic experimentation in the Ecuadorian Formative. In contrast, there is no evidence of such a tradition of experimentation in southern Mesoamerica that could account for the iridescent pottery of Ocós. We must conclude that this technique was transmitted in fully developed form to coastal Guatemala from Ecuador.

Another feature that the early Formative of southern Mesoamerica shares with Chorrera is the so-called napkin-ring ear spools.[3] These ear ornaments are found in Ocós culture in Guatemala, as well as in Tlatilco culture in the Valley of Mexico. The representation of such spools is found as far back in time as terminal Valdivia, so this form of ear ornament is clearly older in Ecuador than in Mesoamerica.

Hollow Figurines

The earliest Mesoamerican Formative cultures on the south coast of Guatemala and along the lowlands of the Gulf of Mexico have a tradition of solid figurines. At a very early stage carefully carved hollow figurines appear in West Mexico and from there penetrate the Central Mexican highlands. The large complete specimen excavated by Richard S. MacNeish's project in the Tehuacán valley is typical of these figurines, which also occur widely in the West Mexican Formative context just mentioned.[4]

Most lines of evidence suggest that this group of figurines appears in Mesoamerica between 1200 and 1000 B.C. In about the same time range very similar hollow figurines appear on the Central Coast of Perú without any known local developmental antecedents. This style is represented by several moderate-sized examples at the Tank site at Ancón, and most spectacularly by the tall specimen excavated by Frederic Engel at the coastal site of Curayacu a short distance south of

Lima.[5] Also from the Tank site at Ancón is a jointed doll carefully carved from palm-wood, a material available on the central coast of Ecuador but not locally available in coastal Perú.

This range of hollow figurines shares a large number of characteristics with the large Chorrera specimens from tombs in the Rio Chico area of Manabí (Fig. 78). The helmet-like treatment of the hair or headdress is especially noteworthy. It is delineated with carefully polished black or red paint or in some instances with a design executed in both colors. The facial features of the figurines are similar, particularly in the manner in which the line of the eyebrow is carefully delineated and the way in which the mouth and nose are accommodated in a sharply marked isosceles triangle. The limbs are abnormally shortened and the rudimentary digits on both the hands and feet are shown by crudely executed slashes. The whole torso is massive and carefully modeled. Frequently, there is a delineation of the rectangular configuration of the abdominal muscles and the musculature of the shoulders is quite accurately observed and depicted.

If, indeed, all of these examples relate to the same artistic tradition, which way did the influences flow? The Mexican examples occur in the context of the very earliest Formative cultures in that particular area of Mesoamerica. There are no known prototypes of antecedents in Mesoamerica. The Peruvian examples also lack any local experimental antecedent. It was noted earlier that the large hollow figurines of the Chorrera tombs on the Rio Chico are the end products of a gradual stylistic evolution in coastal Ecuador that started as early as the San Pablo style of Valdivia figurine in Valdivia 6, continued through the late Valdivia variant in the Rio Chico site of Chacras, and culminated in the spectacular Rio Chico Chorrera examples.

The idea of hollow figurines does not occur in Mexico earlier than the style we have been discussing and the same observation can be made for the Peruvian coast and highlands. But hollow human figurines are not unknown in Machalilla (**255-258**) and the idea even appears in Valdivia, where some of the pregnant female specimens are hollow and contain rattles (**96**). This suggests that the figurine tradition of the three areas is an historical unity and that the immediate point of origin was coastal Ecuador. The long distance and lack of comparable examples in the intermediate area again suggest transmission through coastwise voyages.

If we took the chronological chart (p. 16) at face value, it would be impossible to accept a Chorrera origin for the early hollow figurines of Mesoamerica and coastal Perú. If we assume that Chorrera appears no earlier than 1000 B.C., it is not of sufficient antiquity to have been the donor either for the Mesoamerican examples or for those from the coastal sites of central Perú. We have already suggested, however, that the sequence in Manabí is probably rather different than that in the immediate vicinity of the Santa Elena Peninsula, with a direct development at Chacras from late Valdivia into something more like Chorrera than Machalilla. If this is true, the variety of Chorrera figurines in the Manabí area would be several centuries earlier and of sufficient antiquity to have been a source of dissemination of this style both to Mesoamerica and to the Central Coast of Perú.

So far we have seen Ecuadorian ceramics influencing or even intruding into the very earliest Formative contexts of Mesoamerica and Perú. In each case technologically sophisticated and aesthetically advanced features with a long history of development in Ecuador were accepted by peoples with a far more primitive ceramic tradition. Oddly, though Perú is far closer geographically to Ecuador than is Mesoamerica, Ecuadorian influences are far more evident in the earliest Formative of Mesoamerica. At this period, about 1800 to 1200 B.C., Perú seems more under the influence of the advanced artistic tradition of Tutishcainyo in eastern Perú, which was impinging on the Central Andes from the Upper Amazon jungles.

The Chavín-Olmec Horizon

Chorrera culture flourished on the coast of Ecuador during the time that Chavín culture laid the foundation for all later cultural developments in the Central Andes and Olmec culture established the basic Mesoamerican artistic and iconographic traditions. Both Olmec art and Chavín art are based on the same religious system, cosmology, and origin myths.

56

The most important part of this myth cycle relates to a conception of the whole universe as a great cayman floating in an infinite sea, who in its first transformation becomes a dual deity—a cayman of the sky, denoted by a consistent association with the harpy eagle, the most powerful predatory bird of the New World; and a great cayman of the water and underworld so designated by association with a ring-tailed fish, aquatic vegetation, and large marine mollusks: the spiny oyster (*Spondylus*) and conch-like shells (*Malea* or *Strombus*).

These two all-embracing and all-powerful deities communicate to the human world and its inhabitants through the medium of the jaguar, who is in the position of being a messenger between the sacred and the secular worlds. The cayman is venerated as the source of everything; particularly important is the belief that the cayman is the source of useful vegetation. In a number of Mesoamerican and Peruvian monuments the cayman is presented in the act of bestowing useful vegetation on man. In most instances the vegetation emerges through an intermediary jaguar mouth. Gordon R. Willey has suggested that the orderly, elaborately structured view of the universe implied by the shared iconographic core of Chavín and Olmec religion was in some sense an absolutely essential condition to the rise of civilization in Mesoamerica and Perú.[6]

The Chorrera culture of Ecuador rarely shows the specific combinations of iconographic features shared by Chavín and Olmec. The most striking exception on exhibit is the harpy eagle design on a polychrome bowl fragment (Fig. 80). Here the harpy eagle is abbreviated in a specifically Chavín manner, with only its head and tail indicated. The plumed crest, the most essential feature of the bird, is clearly indicated. This compressing of the harpy eagle appears earliest in the smaller of two harpy eagle representations on the great Chavín monument, the Obelisk Tello from Chavín de Huantar. A more complete representation of a harpy eagle is seen on a lintel relief at Chavín de Huantar (Fig. 80). The conceptualization occurs on a number of the painted Chavín-style textiles from the site of Carhua on the south coast of Perú, and becomes further abstracted in the so-called clothespin bird of Paracas ceramic design. In the Chorrera fragment discussed above, the artist was using a specific Chavín iconographic element, but most Chorrera art is far more naturalistic and lacks the complex iconographic structuring typical of Chavín and Olmec. Available evidence suggests that Chorrera peoples largely rejected the "High Church" aspects of Chavín and Olmec, while their own sophisticated ceramics continued to influence developments in Mexico and Perú.

Zoned rocker stamping of a rather bold curvilinear form is characteristic of both Tlatilco pottery in the Valley of Mexico and much Chavín pottery. Such use of rocker stamping is well developed in Chorrera and this could be the source from which Mexico and Perú received the impetus for this particular style of surface texturing. The anthropomorphic whistling bottle depicting a man with a multitude of infirmities (Fig. 55)—a veritable Job—is a most spectacular example of effective Chorrera use of this technique.

595

We have already noted that the stirrup bottle, which is so important for the Chavín-horizon ceramics of the North Coast of Perú, has its probable origin in Machalilla. The particular form of spout, bridge, and whistling bottle which is the most frequent vehicle for Chavín design on the South Coast of Peru[7] is in its formal characteristics identical to the early Chorrera whistling bottles. It would appear that there were direct influences connecting the South Coast of Perú and Ecuador that bypassed the North Coast of Perú. This pattern of influence would seem to extend still later when there are precise parallels between the turbaned human figurines on whistling vessels from the transitional period between Chorrera and Bahía and the turbaned human figures that appear on the South Coast in phases 8 and 9 of Paracas (Fig. 79). Chorrera whistling bottles on occasion have a body form in the shape of a doughnut (**308, 334, 335**). Such vessels are known from Chavín and early West Mexican pottery. Again, it would appear that Chorrera culture was the donor of this form to Perú and Mexico.

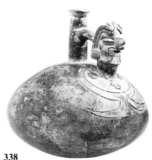

338

Fig. 79
Whistling bottles with turbaned figurines. Paracas period, in the collection of The Metropolitan Museum of Art, (above); and Chorrera period from Salaite, Manabí (below).

Although coastal Ecuador did not accept Chavín religion and iconography to any notable degree, Ecuador was the physical source of two elements that were basic to Chavín religion. Two marine shells, *Malea* and *Spondylus*, are frequent and important elements of Chavín religious art.[8] They are almost always presented as a

Fig. 80
Harpy eagle, from Chorrera bowl fragment (right) and rubbing of lintel relief at Chavín de Huantar, Perú (below). Rubbing in the collection of The American Museum of Natural History.

326

Fig. 81
Rubbing of panel at Chavín de Huantar. Rubbing in the collection of The American Museum of Natural History.

594

58

pair. Both appear on the Obelisk Tello and they are both shown held by a deity carved on a panel at the great temple of Chavín de Huantar (Fig. 81). The deity holds a *Malea* in the right hand and a *Spondylus* in the left hand. The association of the univalve conical shell with the right hand and the bivalve with the left hand is probably not fortuitous. The first is an obvious male symbol while the bivalve suggests the female sexual organ, an interpretation supported by the beliefs of surviving groups in northern South America. The deity or his surrogate priest can thus be seen as balancing in his right hand the male principle of order and structure against, in the left hand, the female symbol representing disorder, that is to say, both destruction and regeneration.

There are a number of other Chavín representations, particularly modeled vessels, where the two marine species are depicted together as a set (Fig. 82). In economic rituals of the modern highland Peruvian communities these marine shells still play an important part in ensuring proper rainfall and crop fertility. Neither of these species occurs naturally along the coast south of the Gulf of Guayaquil. Both are difficult to obtain, and large specimens of *Spondylus*, in particular, can be obtained only by diving to reefs at depths of 50 ft. or more.

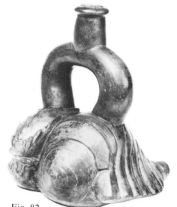

Fig. 82
Stirrup-spout bottle with shells. Tembladera, Perú. Collection of the Museum of the American Indian.

Chavín art demonstrates that as early as 800 B.C. *Malea* and *Spondylus* were accepted as essential parts of the sacramental system. Indeed, there are representations of the *Spondylus* from a slightly earlier context at the site of Kotosh in the Huánuco Basin.[9] The people of Chavín and Kotosh had to obtain these shells by long-distance trade from coastal Ecuador. By this time the people of Ecuador had convinced the people of Perú that *Spondylus* and *Malea* were necessary to their very existence. The Formative people of Ecuador used the bright red rims of the *Spondylus* shell for their own jewelry. They also traded this material to their southern neighbors as a most profoundly sacred and necessary commodity.

Though there are few specific parallels between the more sacred part of Olmec art and the art of Chorrera, the human effigies on Chorrera whistling bottles share a curious feature with Olmec heads of stone which are thought to be the portraits of rulers (Fig. 86; **400, 407**). Both wear a headgear strikingly similar to a football helmet with a ridge running around the circumference of the head at the forehead level and with a tassel hanging in front of or over the ear. Conceivably these parallels could be accidental, but they are curiously precise. The probability of a valid historical link is strengthened by the occurrence of identical helmets on armed guardian figures carved in stone at the highland Colombian site of San Agustín.[10] The presence of representations of acrobats both in Chorrera ceramics (Fig. 84) and in various Mexican Formative contexts (Fig. 85), especially Tlatilco, is probably not accidental. Again, the occurrence of such acrobats among Valdivia figurines indicates an Ecuadorian origin.

Though Chorrera pottery typically lacks Chavín design, many of the Chavín-horizon bottles with stirrup-spouts from the North Coast of Peru carry curvilinear designs of zoned black-and-red which very closely parallel Chorrera curvilinear motifs. The major difference between the Chorrera and Chavín examples is in the vessel shape.

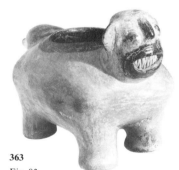

363

Fig. 83
Jaguar-like monster. Chorrera.

The rather bloated and toothy Chorrera monster (Fig. 83) quite possibly is a variant form of jaguar representation. Though rare, it is precisely paralleled by a stirrup-spout vessel from the late Chavín horizon of the Chicama Valley on the North Coast of Perú.[11]

The lively realistic sculpture embodied in the Chorrera whistling bottles is a summit in New World ceramic art (see, for example, the charming kinkajou in Figure 87). This tradition seems certainly ancestral to the well-known hollow figurine tradition of West Mexico, which reaches its peak in the states of Colima and Nayarit around the time of Christ. It has been postulated that these figures of humans and animals served as tomb guardians and companions to the important people interred in the deep shaft tombs. The close parallels between these Mexican figurines and Chorrera effigy bottles and figurines suggest that the latter may have fulfilled a similar function in the burial chambers of the Rio Chico area of Manabí. The Chorrera animal and human effigies are also far more relaxed and realistic than any of the contemporary ceramics of Perú though they clearly influenced the Chavín Horizon ceramics of the North Coast of Perú. Thus they served as an inspiration for

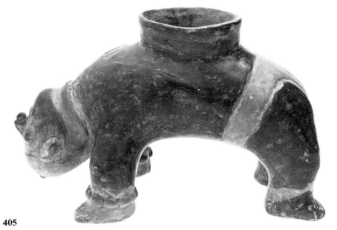

405

Fig. 84
Acrobat. Chorrera.

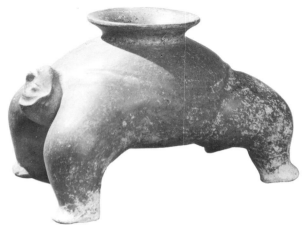

Fig. 85
Acrobat, ca. A.D. 100-300. Colima,
Mexico. Collection of The Museum
of Primitive Art.

Fig. 86
Similarities of headgear (L-R)
Chorrera bottle from Resbalón, Ma-
nabí; stone sculpture at San Agustín,
Colombia; and Olmec head, La
Venta, Mexico.

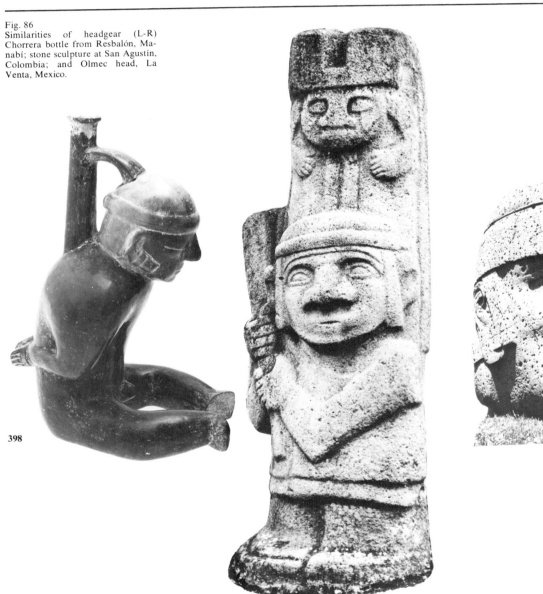

398

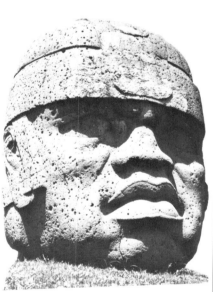

60

the later development of realistic modeling centered in the Moche and Chicama Valleys. This modeling reached its peak of development in Moche culture around 300-500 A.D.

By 800 B.C. it is probable that the societies dominated by Chavín religion in Perú and the societies dominated by Olmec religion in Mesoamerica had already surpassed any society in Ecuador in size and complexity of the political units. But at this time no other ceramic tradition in the New World approached Chorrera in terms of the naturalistic depiction of life forms or the technical virtuosity embodied in the form and decoration of a wide range of ceramic vessels.

In summary, the spectacular pottery of the Ecuadorian Formative seems to have served as a source of inspiration for the developing ceramic traditions of Mesoamerica and Perú. This influence started in the second millenium B.C. and continued well into the first millenium B.C. Specific spectacular techniques of ceramics, such as iridescent painting, were borrowed from Ecuador. Complex vessel shapes, such as whistling bottles, stirrup bottles and multi-tiered vessels, appeared first in Ecuador and then slightly later in Mesoamerica or Perú. If we look only at these ceramics, it would be easy to argue that the society of coastal Ecuador was in some respects more advanced than the contemporary societies of Perú and Mexico. Ecuador's lead in these matters seems to relate to the long history of large stable communities that extends back at least to 3000 B.C. In this environment of expanding sedentary populations, ceramic techniques flourished and reached a spectacular climax in the Chorrera effigy vessels of the Rio Chico area. There was no comparable long tradition of ceramic experimentation in either Mexico or Perú.

The Effects of Continuing Trade

After 1000 B.C., Perú and Mesoamerica surpassed Ecuador in social complexity and gradually evolved toward the complex states encountered by the Spanish. We cannot examine here the causes for these spurts of development, but they were partially connected with the presence of certain kinds of agricultural lands in the two areas. The emergence of state-sized societies in these two regions was accompanied by rapid developments in technology and it was no longer necessary to look to Ecuador for technological or artistic stimulation. Nonetheless, certain farflung thematic influences continued to spread out of Ecuador. An example is in the late Chorrera representations of large pit vipers attacked and subdued by falcons (Figs. 74, 88). The bird represented is almost certainly the laughing falcon (*Herpetotheres cachinnans*), which is, in fact, largely a predator of snakes. This theme recurs in the sculptural art of San Agustín,[12] and has numerous Mesoamerican parallels. The monumental sculptural depiction of the coiled pit vipers on Chorrera vessels convinces one of the importance of this creature in Chorrera art and religion (**376, 377**).

By 300 B.C. it is clear that the peoples of Ecuador had lost their position as the pre-eminent cultural innovators in the New World, but there remains the suggestion that the inhabitants of the coast of Ecuador continued to dominate maritime communication between the two fully civilized regions of the New World, assuming a role similar to that of the Phoenicians in the Mediterranean. Within the context of such maritime commerce there is a continuing pattern of shared cultural content between coastal Ecuador and various points in Central America and West Mexico. This is most spectacularly documented in the polychrome designs shared by Guangala culture of coastal Ecuador and certain of the polychromes in the Nicoya region of Costa Rica, a point most fully documented by Allison Paulsen.[13] The transmission of metallurgical techniques to West Mexico was almost certainly through a scheduled and routinized sea trade. Metallurgy can now be pushed back to 2000 B.C. in Ecuador, since gold occurs in Early Cerro Narrío. That such regular maritime trade continued until the arrival of the Spanish is well documented by the ethnohistoric research of Robert West.[14]

When viewed from Ecuador, civilization in the New World appears to have had a largely unitary base. The contributions of early Ecuadorian culture to that base and to the two civilizations that emerged from it were far from negligible.

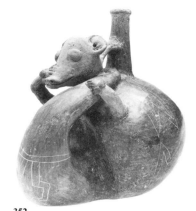

352

Fig. 87
Kinkajou whistling bottle. Chorrera.

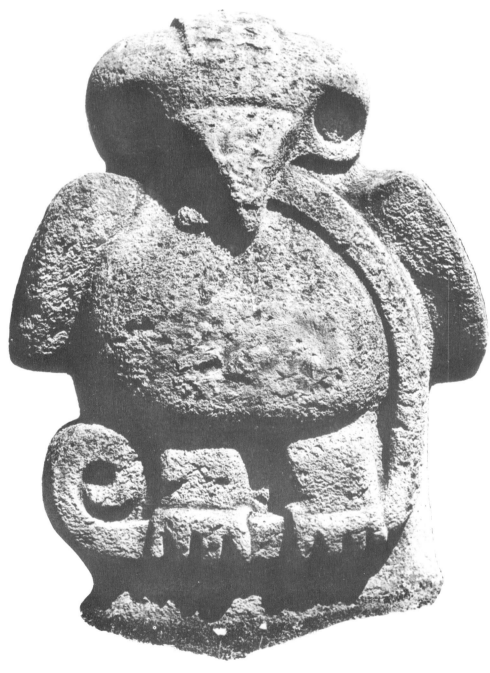

62

NOTES

1. David Grove, "The Mesoamerican Formative and South American Influences," *Primer Simposio de Correlaciones Andino-Mesoamericano*, (Salinas, Ecuador, July 1971), Guayaquil, in press.

2. Michael D. Coe, "Archaeological Linkages with North and South America at La Victoria, Guatemala," *American Anthropologist*, LXII (1960), 363-393. Also see: Coe, "La Victoria. An Early Site On the Pacific Coast of Guatemala," *Papers of the Peabody Museum of Archaeology and Ethnology*, LIII (Cambridge; Harvard University Press, 1961).

3. See references given in note 2.

4. Richard S. MacNeish, Frederick A. Peterson and Kent V. Flannery, *The Prehistory of the Tehuacán Valley, Vol. 3 : Ceramics* (Austin / London: University of Texas Press, 1970).

5. Frederic Engel, "Curayacu — a Chavinoid Site," *Archaeology*, IX (1956) no. 2, 98-105.

6. G. R. Willey, "The Early Great Styles and the Rise of the Pre-Colombian Civilizations," *American Anthropologist*, LXIV (1962), 1-14.
 For a full discussion of Olmec and Chavín iconography also see: Donald W. Lathrap, "Complex Iconographic Features Shared by Olmec and Chavín and Some Speculations on Their Possible Significance," *Primer Simposio de Correlaciones Andino-Mesoamericano*, (Salinas, Ecuador, July 1971), Guayaquil, in press.

7. John Howland Rowe, *Chavin Art. An Inquiry Into Its Form and Meaning* (New York: Museum of Primitive Art, 1962).

8. Allison C. Paulsen, "The Thorny Oyster and the Voice of God: *Spondylus* and *Strombus* in Andean Prehistory," *American Antiquity*, in press.

9. For a discussion of the Kotosh material see: S. Izumi and T. Sono, *Andes 2: Excavations at Kotosh, Peru* (Tokyo: Kadokawa Publishing Co., 1960).

10. Gerardo Reichel-Dolmatoff, *San Agustin. A Culture of Colombia* (Art and Civilization of Indian America) (New York: Praeger, 1972), figs. 61, 62.

11. Rowe, *Chavin Art*.

12. Reichel-Dolmatoff, *San Agustín*, fig. 32.

13. Paulsen, "La sequencia de la cerámica de Guangala de la Peninsula de Santa Elena y sus impliaciones para un contacto prehistorico entre el Ecuador y América central," *Primer Simposio de Correlaciones Andino-Mesoamericano*, (Salinas, Ecuador, July 1971), Guayaquil, in press.

14. Robert C. West, "Aboriginal Sea Navigation Between Middle and South America," *American Anthropologist*, LXIII (1961), 133-135.

Sumario

Esta exhibición presenta las culturas Formativas del Ecuador costero (Valdivia, Machalilla, y Chorrera), las cuales se iniciaron antes del año 3000 A.C. El término Formativo es aplicado a la etapa del desarrollo cultural en las Américas en el cual un sistema agrícola eficiente llevó al desarrollo de comunidades permanentes de considerable tamaño que derivaban la mayor parte de su alimentación del cultivo de las tierras. Basadas en la Etapa Formativa, culturas con ciudades, organización de estado y sistema de clases, se desarrollaron en Mesoamérica y los Andes Centrales (Perú y Bolivia). La Etapa Formativa se desarrolló varios siglos antes de 3000 A.C. en el Ecuador pero no hasta 2000 A.C. en Mesoamérica y los Andes Centrales, así que es en el Ecuador y las tierras bajas tropicales de sus alrededores en donde debemos buscar los orígenes de la cultura Formativa.

A pesar de que se ha editado un considerable número de publicaciones eruditas que tratan sobre las culturas Valdivia, Machalilla y Chorrera (véase la Bibliografía), esta es la primera exhibición de mayor importancia que trata de su complejidad y el impacto estético de su arte. La mayor parte del material de esta exhibición fue comprado o excavado por Presley Norton y la que fuera su esposa, Leonor Pérez de Rivera. Esta colección es actualmente la colección Pérez. Los objetos provienen del territorio que se extiende desde el Golfo de Guayaquil hacia el oeste hasta la Península de Santa Elena y hacia arriba por la costa del Pacífico hasta el centro de la provincia de Manabí.

Hemos seguido una cronología detallada de estas culturas hecha acerca de la península de Santa Elena por Hill (en prensa) y por Paulsen y McDougle (trabajo leído, 1974) porque esta es la mejor que se puede obtener sobre toda esta región, a pesar de que no se adapta completamente al complicado desarrollo de las culturas de Valdivia y Chorrera en la región de Río Chico en Manabí.

La Economía del Período Formativo

Las primeras villas de Valdivia conocidas por los arqueólogos estaban cerca del mar y sus depósitos de desechos contenían conchas y huesos de pescados, indicando esto alguna dependencia de sus habitantes en el pescado y los mariscos para su alimentación. Más tarde, investigadores encontraron muchas villas de Valdivia en el interior y convenientemente situadas cerca de las planicies de inundación de los ríos que cruzan la zona costera. Loma Alta, 15 km. hacia arriba del río Valdivia, es un buen ejemplo de estas villas de la Etapa Formativa temprana en el interior. El asentamiento de estos pueblos implica una dependencia en el cultivo de la tierra. Así que no nos sorprende que estos lugares contengan muchas manos y metates los cuales eran usados para moler semillas, muy posiblemente de maíz. Además contenían hachas afiladas de piedra con orejas de un tipo comunmente empleado en tiempos recientes en las selvas tropicales para limpiar el terreno para el cultivo. Otras pruebas de que los agricultores de Valdivia definitivamente cosechaban el maíz son: *1)* la costumbre de decorar el borde de las vasijas en la fase 3 de Valdivia con impresiones de granos de maíz; *2)* la costumbre de adornar los hombros de los cántaros de las fases 5 y 6 de Valdivia con mazorcas de maíz modeladas; y *3)* el descubrimiento de un grano de maíz carbonizado en la pared de una vasija de Valdivia 5-6. Estas pruebas demuestran que el cultivo de un maíz duro con ocho hileras similar a una raza primitiva llamada *Kcello Ecuatoriano*, la cual crece hoy en día en las provincias montañeras de Loja, Cuenca y Bolivar. Otra prueba del cultivo de la tierra es la presencia constante de pequeñas hojas de piedra que probablemnte eran los dientes impuestos en un rallador de mandioca hecho de madera. Ambos, los ralladores y la mandioca eran parte del sistema agrícola de la selva tropical. Probablemente los agricultores de la cultura Valdivia cosechaban otros productos tropicales, como por ejemplo el camote, achira (*Canna edulis*), maranta (*Maranta sp.*), ñame del Nuevo Mundo (*cara o carahu*), maní (cacahuetes), y algodón. La presencia de este último se deduce de impresiones de tejidos en barro cocido.

A pesar de que los pueblos de Valdivia dependían principalmente de la

agricultura, los mariscos y los pesces del océano eran una parte importante de su dieta. Estos incluían varios moluscos marinos, concha prieta *(Anadara tuberculosa)*, un molusco bivalvo que habita en los manglares, y pesces capturados tanto en los arrecifes como en alta mar. Es probable que los habitantes de las villas del interior no fueran pescadores, pero obtenían productos marinos a cambio de cosechas sobrantes, un sistema que ha continuado en esta zona hasta el día de hoy. Los anzuelos de una pieza eran de madreperla. El uso de canoas talladas de un tronco (piraguas) es sugerido por un modelo de una canoa hecho en cerámica en la fase 4 de Valdivia, y por la presencia de sitios en la costa donde se encontraron muchas cucharas de conchas pesadas o cuchillos de raspar afilados en un borde, los cuales pueden haber sido usados para sacar la madera carbonizada durante la fabricación de las canoas. De una época posterior tenemos una botella silbato representando a un hombre montado en una balsita o *caballito del mar* hecha de juncos de totora. Este tipo de embarcación debe haber sido muy útil para la pesca de anzuelo o para colocar y recoger redes cerca de la costa, pero no para la pesca en alta mar.

También del período de Chorrera existen vasijas de efigie representando la larva de escarabajo *(Dynastes hercules)*, criada y comida como un manjar por los habitantes de las selvas tropicales, un perro que puede haber sido criado como comestible parecido al "mejicano sin pelo," y una piña de un tipo cultivado.

Cerámicas del Período Formativo Ecuatoriano

Las cerámicas más antiguas de Valdivia, que datan de alrededor del año 3100 A.C., pertenecen a los niveles más bajos de Loma Alta. Esta no es la alfarería más antigua de la región, debido a que Bischof y Viteri (1972) han encontrado una cerámica no relacionada, compleja llamada San Pedro, estratigraficamente más antigua que la de Valdivia. La cerámica de San Pedro es bastante diferente a la de Valdivia y no parece ser ancestral a ella. No sabemos el origen de la cerámica de Valdivia, pero la forma funcional en que está integrada a la economía de la selva tropical es una fuerte indicación de que el origen debe ser buscado en el Ecuador o en el norte de Sudamérica. La hipótesis de que Valdivia tiene un origen Jōmon (Japonés) propuesta por Meggers, Evans y Estrada (1965) parece ser menos probable a medida que acumulamos información sobre Valdivia durante la pasada década.

Este examen de la alfarería de Valdivia está basado en el sistema de ocho fases creado por Hill (en prensa). Las vasijas mas primitivas de Loma Alta, que datan de antes de la fase 1, están hechas en tres formas: un cántaro alto con decoraciones incisas o brochadas; un cántaro grueso y corto con el borde engrosado y pellizcado similar a la costra de un pastel; y un tazón hemisférico cubierto con un engobe de óxido de hierro. La alfarería de la fase 1, identificada por Hill en Punta Concepción, carece ·de borde en forma de pastel de la cerámica primitiva de Loma Alta y tiene diseños incisos cortados descuidadamente sobre el engobe rojo. En la fase 2 las vasijas grandes tienen bases tetrapodas y diseños elaborados y cuidadosamente cortados a través del engobe rojo. Las ollas son incisas o estriadas con los dedos cuando el barro estaba muy suave. Lo mas común en la fase 3 son los cántaros cortos con una banda de engobe rojo en el interior del borde. Durante las fases 3 a la 5 la forma más interesante es el tazón que imita la mitad de una calabaza o jícara. Estas vasijas estan profundamente grabadas sobre la mayor parte del exterior tal como eran las jícaras antiguas.

El estilo usado en los rostros humanos de estas vasijas cambió a través de los años de una manera paralela al cambio estilístico de las figurillas de Valdivia. Son de gran interés en las fases 5 y 6 los cántaros con mazorcas de maíz modeladas en los hombros rodeados de diseños incisos en forma de puntas de espiguillas simulando las hojas del maíz. Es notable en la fase 7 los cántaros con bordes sobresalientes decorados con diseños incisos en la superficie interna.

Los cántaros y tazas de la fase 8 con paredes aquilladas, es decir un ángulo agudo entre el lado y el fondo, son relativamente nuevos en la tradición de Valdivia. Eran decorados en zonas con una textura de lineas finas cruzadas y pintadas después de cocidas en rojo, amarillo y blanco con una pintura de base de resina. La combinación de rasgos de esta cerámica no tiene antecedente en el Ecuador costeño, pero es típico de la cerámica más antigua de la cuenca de Huánuco y del Río Ucayali en el Perú oriental y parece haber tenido una amplia distribución en la cuenca occidental del Amazonas, de donde se extendió hacia las laderas orientales de los Andes. En resumen la fuente de este complejo en la octava fase de Valdivia es la selva tropical del

Ecuador oriental o el Perú.

En general la cerámica de Machalilla fue un desarrollo de Valdivia. Las cerámicas rojas grabadas descubiertas recientemente en el sitio de Real Alto en el Río Verde parecen ser intermedios entre Valdivia y Machalilla. Son característicos de Machalilla los cántaros y tazas de cerámica negra ahumada y pulida con diseños lineares grabados en los hombros después de cocidos. Estos diseños están acentuados usualmente por pigmentos blancos frotados en las lineas grabadas. A menudo estas vasijas tienen base en forma de pedestal. También comunes son los cántaros y tazas en cerámica café con diseños lineares pintados con engobe rojo. Una de las formas más interesante del Período Machalilla es la botella de asa de estribo. Esta forma también aparece en el norte del Perú y en el oeste de México. La fecha que tenemos disponible sugiere que Machalilla es la fuente de estos casos en que aparece el asa de estribo. El asa de estribo en Machalilla se deriva a su vez de una botella de dos picos conectados por un asa-puente, una forma que se encuentra entre la cerámica más antigua conocida en la parte alta del Amazonas (Tutishcainyo Temprano).

Los alfareros de Chorrera alcanzaron el climax artístico del Ecuador Formativo. Muchos de los elementos de la cerámica Chorrera—engobe crema, grabado zoniforme, y modelado realístico de hombres y animales—tienen sus raices en Machalilla o Valdivia. El uso del proceso de la pintura negativa o por resistencia en la cerámica es muy extenso en Chorrera. Esto era llevado a cabo con un segundo cocimiento a una baja temperatura, el ahumado orgánico de donde una brillante capa negra se adhería a la superficie de la vasija, pero no a las areas protegidas por la pintura resistente. El material usado en Chorrera como resistente es desconocido, pero era probablemente un engobe de barro o una pasta fina de cenizas. A pesar de que el ahumar para crear una superficie negra brillante puede retroceder en tiempo hasta Valdivia 5, el uso de la técnica de ahumamiento formando un diseño no es más antiguo que Chorrera en la costa del Ecuador. Esta técnica aparece en el Cerro Narrío temprano y en la cerámica más antigua de la costa sur del Perú, ambos varios siglos más antiguos que Chorrera y es probablemente muy antiguo en la zona oeste de la cuenca del Amazonas. Cerro Narrío es la fuente más probable de la decoración en negativo de Chorrera.

La mayor innovación en Chorrera es la transformación de la botella de dos picos y un asa-puente en una botella con un solo pico y un puente (o asa) y un silbato. Esta botella silbato es el vehículo para las bellas formas de animales y hombres modelados que fueron la más alta ejecución de los artistas de Chorrera. Otra forma notable en Chorrera es la de las tazas efigies de animales, usualmente representando a un murciélago, en el cual el interior completo es concebido como el cuerpo, con la cabeza, extremidades y rabo ejecutados como modificaciones del borde y la cabeza mirando hacia adentro. Algunas de estas vasijas estan descansando sobre una base en forma de pedestal. El concepto de convertir una taza en la efigie de un animal es típicamente amazónico. La almohada de cerámica o descanso para el cuello es otra de las caracteristicas de Chorrera que parece señalar para un lugar de origen muy lejos del Ecuador. La forma es tan similar a las almohadas del Asia oriental que Estrada y otros han postulado que llegaron al Ecuador a traves del Pacífico durante el primer milenio antes de Cristo.

La Tradición de las Figurillas

Las figurillas humanas de Valdivia son las más antiguas que se conocen en el Nuevo Mundo. Las Figurillas nunca fueron muy importantes en el Perú, pero en Mesoamérica fueron producidas en grandes cantidades desde el comienzo de la Etapa Formativa hasta la conquista española. La gran antigüedad de las figurillas de Valdivia y las pruebas de la antigua influencia ecuatoriana sobre Mesoamérica llevan a la conclusión de que la tradición de las figurillas de Mesoamérica se derivó del Ecuador. Las figurillas más antiguas de Valdivia son simples placas de piedra sin delineaciones de la cara o extremidades excepto por una grieta en un extremo para indicar la división entre las piernas. Más tarde la cara y las manos fueron claramente indicadas, y finalmente las placas se convirtieron en efigies humanas convincentes con un tallado en bajo relieve que enfatiza los ojos y las manos. Ya en Valdivia 3 las figurillas son hechas de cerámica en lugar de piedra. Son típicas las figuras femeninas con pechos mínimos y pequeñas caras casi completamente cubiertas por una masa de cabello. Las figurillas de la fase siguiente tienen caras planas con los ojos y boca indicados por lineas incisas horizontales. La representación del cabello se vuelve más elaborada y a los pechos se les da mayor prominencia. Hay pocos casos de figuras

masculinas. La variante de San Pablo se caracteriza por la nariz de alto tabique y los ojos y cejas representados por lineas inclinadas y usualmente arqueadas hechas por incisiones. En la península de Santa Elena hubo una pérdida de interés en la creación de figurillas durante las fases finales de Valdivia, pero el tipo de San Pablo fue continuado y elaborado en el sitio de Chacras en Manabí.

Las figurillas de Machalilla son de barro gris sin engobe o de barro café con lineas de engobe rojo. Son bastante toscas y marcadamente estilizadas pero tienen los mismos ojos en forma de granos de café y la nariz prominente que se encuentran en figurillas de Valdivia terminal en Chacras. Muchas de estas figurillas tienen hileras de perforaciones a lo largo de los lados de la cara o de las orejas y en dos casos bajo el labio inferior. Estos casos nos hacen recordar los múltiples bezotes en forma de espetón usados todavía en perforaciones faciales por los hombres de ciertas tribus sudamericanas que habitan las selvas tropicales. Las magníficas y bellas figurillas huecas de Chorrera serán examinadas en la última sección de este sumario.

La Vida en el Ecuador Formativo

La meta del arqueólogo es reconstruir los más completamente posible las características culturales de sociedades muertas por largo tiempo. Este ideal se alcanza más facilmente dentro del dominio de las actividades económicas, los hábitos de alimentación y las tareas que ocupaban la mayor parte del tiempo. Pero esta meta debe además incluir un intento a reconstruir el sistema social y el sistema de cosmología y creencias que sirven como contexto para interpretar los escasos desechos preservados descubiertos por el arqueólogo. En el caso de la Etapa Formativa ecuatoriana la mayor parte de las pruebas al alcance del escolar se producen en forma de cerámicas duraderas. Las tazas, vasijas y figuras efigies dan sentido de vida y realidad al pasado distante del Ecuador.

Uno de los instrumentos más útiles para el arqueólogo es la búsqueda de analogías. Se debe estudiar la vida de los grupos sobrevivientes que puedan representar una continuación de las tradiciones culturales de los tiempos más antiguos representados por el sitio arqueológico. Ha sido previamente sugerido que las prácticas económicas y el estilo de vida de los más antiguos habitantes sedentarios del Ecuador costeño eran una extensión de la cultura de la selva tropical que se extendió desde la cuenca del Amazonas primero a la cuenca de Guayas y después hacia el oeste a la costa. Muchos de los restos sobrevivientes del Ecuador Formativo pueden ser interpretados en términos de las creencias y las prácticas que aún existen entre los indios de la América del Sur tropical al oriente de los Andes.

Investigaciones recientes en Real Alto han revelado la naturaleza de las casas y el sistema de establecimiento urbano de un pueblo período Valdivia durante la fase 3, alrededor de 2300 - 2200 A.C. La primera casa que fue excavada es un óvalo de 10.3 m. por 8 m. Las paredes y techo estaban soportados por postes macisos de madera dura empotrados en una trinchera. La casa es muy grande para una sola familia, pero posiblemente alojaba, como las *malocas* del alto Amazonas, un linaje de varias familias relacionadas por la linea paterna haciendo un total de alrededor de 30 personas. Las 100 o más casas de Real Alto estaban colocadas alrededor de una plaza abierta formando un rectángulo de esquinas redondeadas. En el Encanto, el pueblo del período de Valdivia en la Isla Puná, el plano de la villa era circular. El número de casas en Real Alto no se sabe con certeza, pero sí está claro que el pueblo contenía por lo menos 2000 habitantes.

En las comunidades modernas de las selvas tropicales un gran número y variedad de animales jóvenes salvajes son capturados y criados con cariño. La nutrición de los animales pequeños salvajes llega al extremo de ser amamantados por las mujeres de la villa. Este cariño a los animales salvajes y el mantenerlos en la villa es sugerido fuertemente por las extraordinarias efigies de animales representadas en botellas silbato de Chorrera. Muchas de las especies que son realísticamente representadas— el mono capuchino, el mono lanudo, el mono araña, el kinkajou, y el coati — son facilmente domados y hacen excelentes animales caseros.

Los habitantes de las selvas tropicales son notables por usar mucho más las drogas halucinogénicas e integrar su uso a la religión en una forma más compleja que ningún otro pueblo en la Tierra. Las más importantes de estas numerosas plantas son el tabaco, la coca (fuente de la cocaina), la *ayahuasca* (la parra tropical *Banisteriopsis*), y la semilla del árbol parecido a la mimosa, *Anadenanthera.* Este último es aspirado como el rapé. El y *Anadenanthera* son dos de los más potentes agentes productores

de visiones conocidos. Las visiones y experiencias alcanzadas a través de estas drogas son de gran importancia religiosa en ceremonias conmemorativas por los difuntos y en ceremonias curanderas llevadas a cabo por el shaman (brujo-adivino). Cuando está ejecutando esta ceremonia el shaman se sienta en un banquillo de madera casi siempre en la forma de un jaguar que representa a su alter-ego. En un trance creado bajo la influencia de una de las drogas el siente que es transportado vastas distancias para recuperar el alma del paciente o para determinar las condiciones requeridas para su restablecimiento. Réplicas de cerámica en miniatura de estos banquillos de madera han aparecido en Valdivia. Muchos de estos son zoomórficos y representan a un jaguar. Dos figurillas de Valdivia llevan en la cabeza paletas que parecen ser tabletas usadas para aspirar drogas.

No se han encontrado desperdicios de hojas de coca en sitios formativos de la costa, pero desde Valdivia en adelante gran número de cántaros en miniatura de cerámica conteniendo cal confirman que se mascaba la coca con cal, así como también lo demuestra una figura de Valdivia tardío con un bocado de coca en el cachete. Probablemente las vasijas más antiguas para la cal eran hechas de calabazas talladas (jícaras) pero estas no se han preservado, excepto por dos pequeñas jícaras talladas con caras del estilo de Valdivia 4 encontradas en Huaca Prieta en el Perú. Estas llegaron hasta el Perú a través de trueques. Ellas no fueron usadas en su nuevo hogar para contener cal. En Chorrera las vasijas para la cal tomaron la forma de bellas efigies modeladas de una variedad de animales, incluyendo serpientes monstruosas y animales temibles.

El adorno personal durante la Etapa Formativa costeña consistía de pinturas en el cuerpo, collares, bezotes, y orejeras. La concha *Spondylus*, de borde rojo, era recogida en grandes cantidades y canjeada en las sierras ecuatorianas y más adelante hacia el Perú. Aparentemente muchas de estas conchas, o la porción roja de ellas, pasaron a través de Cerro Narrío en las montañas y muchos ornamentos ya terminados fueron encontrados allí. Parece ser que las poblaciones de la costa cambiaron los bordes rojos a Cerro Narrío por coca y otros productos del este de los Andes, y que Cerro Narrío era el sitio de una fábrica productora de ornamentos hechos de conchas que eran intercambiados en todas direcciones. Otro producto obtenido en las sierras en grandes cantidades durante el Período Chorrera es la obsidiana de la cual se hacían preciosos cuchillos desprendiendolos de un nucleo previamente preparado.

Las orejeras que nos recuerdan los carretes usados por los hombres de varias tribus de la selva tropical estaban presentes en el Ecuador costeño en epocas tan tempranas como las del Valdivia tardío, demostrándolo la cabeza de una figurilla de Chacras de gran tamaño. Fueron demostradas realísticamente en una urna grande de Chorrera en forma de hombre. Las orejeras más antiguas eran probablemente de madera, pero en Chorrera eran de cerámica pulida con paredes finas, o de concha y onix. Las figurillas grandes huecas sugieren que el cuerpo estaba sin ropa, pero pintado con diseños complicados. Sellos planos o cilíndricos de cerámica son comunes en Chorrera y algunos de ellos tienen diseños similares a las pinturas expuestas en las figurillas. La pintura del cuerpo y los sellos cilíndricos son similares a la pintura del cuerpo de los indios witotos del nordeste del Perú. Estos últimos usan estampadores de madera. No cabe duda de que muchos estampadores de madera fueron usados en Machalilla y Chorrera pero no han sido conservados.

Influencias del Ecuador Formativo en las Civilizaciones Nacientes de Mesoamérica y del Perú

Hay un número de características culturales comunes en el Ecuador, el Perú, y México que demuestran la influencia de las culturas Formativas del Ecuador costeño sobre Mesoamérica y el Perú. Las culturas Formativas de México Occidental compartieron con el Ecuador un complejo de rasgos de cerámica, incluyendo el barro rojo sobre café, botellas achatadas, botellas con asa de estribo, vasijas carenadas y vasijas simulando una pila de dos o tres ollas. Todo este complejo parece ser derivado del prototipo ecuatoriano como la fase de transición desde el final de Valdivia a Machalilla. Grove (manuscrito en prensa) ha sugerido que este complejo fue transmitido a México a través de una colonización directa por mar. Posiblemente estos colonizadores eran los antepasados de los tarascanos. Otro eslabon entre el Ecuador y Mesoamérica es la pintura iridiscente en la cerámica en Chorrera y la fase Ocós en la costa pacifico de Guatemala. Esta es producida aplicando un engobe diluido de barro que contiene óxido de hierro a una vasija antes de ser cocida. Después de la cocción inicial, la vasija es devuelta a un fuego a baja temperatura para el ahumado. Las

pequeñísimas partículas minerales en el engobe producen el efecto iridiscente y el óxido de hierro imparte el color rosáceo de la superficie. La pintura iridiscente de Chorrera representa el producto final de un milenio de experimentación con engobe rojo y ahumado negro que se remonta a Valdivia tardío. Ya que no existe un desarrollo anterior tan duradero en Guatemala, no cabe duda de que la técnica iridiscente llegó a esta del Ecuador. Orejeras en forma de aros de servilletas de cerámica también son compartidos por Chorrera y Ocós, así como Tlatilco en el valle de México. Esto se remonta a Valdivia terminal en el Ecuador y por lo tanto son más antiguos aquí que en Mesoamérica.

Entre 1200 y 1000 A.C. figurillas huecas cuidadosamente talladas aparecieron en el occidente de México y se extendieron a las sierras centrales mexicanas. Aproximadamente al mismo tiempo figurillas similares aparecieron en la costa central del Perú. Las figurillas huecas de México y del Perú comparten cierto número de características con las figurillas de Chorrera del Río Chico en Manabí. Estos incluyen el tratamiento de casquete en el pelo o cofia, el modelado de los rasgos de la cara, las extremidades cortas y rudimentarias, y el torso cuidadosamente modelado. Las grandes similitudes entre los tres grupos de figurillas nos hace preguntarnos cuál es la dirección del flujo de influencias. No existen figurillas huecas anteriores en México o el Perú, ni hay antecedente de ninguna clase. En el Ecuador las figurillas huecas se remontan a Valdivia terminal y hay una evolución continua en el estilo de las figurillas de Valdivia a Chorrera y las figurillas huecas de Río Chico. Claramente las figurillas huecas de México y del Perú fueron el producto de la influencia de la costa del Ecuador.

Chorrera fue contemporáneo con la cultura de Chavín en el Perú y Olmec en México. El arte de Chavín y el de Olmec estan basados en el mismo sistema religioso, cosmología, y mitos sobre el origen. El universo es imaginado como un caimán gigantesco flotando en un mar infinito, el cual es transformado en un caimán del cielo asociado con el águila arpía, y un caimán del agua y del averno asociado con la vegatación submarina, peces, y dos moluscos marinos — la ostra espinosa (*Spondylus*) y la concha (*Malea* o *Strombus*). Estos dos seres omnipotentes se comunican con el mundo humano a través del jaguar el cual es el mensajero entre los mundos sagrados y seculares.

El arte de Chorrera raramente contiene las combinaciones específicas iconográficas que son compartidas por Chavín y Olmec. Una excepción es el águila arpía la cual es mostrada en una forma abreviada en las vasijas policromadas de Chorrera. Chorrera también comparte con Chavín y con Tlatilco en México el estampado de zigzag en zonas sobre cerámica y las vasijas en forma de anillos. El Ecuador costeño fue la fuente física de dos conchas marinas que son básicas a la religión de Chavín, la concha *Malea* y la ostra espinosa mencionadas anteriormente. Estas fueron comunmente asociadas en pareja en el arte de Chavín, como en la representación tallada de una deidad en Chavín de Huantar quien sostiene una concha en la mano derecha y una ostra espinosa en la izquierda. Estas conchas no se producen al sur del Golfo de Guayaquil. Las numerosas conchas de estas dos especies encontradas en el Perú fueron recolectadas en la costa del Ecuador e intercambiadas hacia el sur. Este trueque empezó muy temprano debido a que hacia 800 A.C. estas dos conchas importadas habían sido completamente incorporadas a la iconografía religiosa de Chavín.

La escultura realista y animada de las botellas silbato de Chorrera es un climax en el arte de la cerámica del Nuevo Mundo. Esta tradición es ancestral a las figurillas huecas y formas zoológicas de Colima y Nayarít en México que datan de principios de la Era Cristiana y estimuló el modelado realista del estilo Mochica de la costa norte del Perú entre 200 y 500 D.C.

En resumen, la cerámica espectacular del Ecuador Formativo inspiró las tradiciones en formación de las cerámicas de Mesoamérica y del Perú. Esta influencia comenzó temprano en el segundo milenio A.C. y continuó por más de mil años. Sin embargo hacia 300 A.C. los pueblos del Ecuador habían perdido su posición de preeminentes innovadores culturales del Nuevo Mundo, los habitantes costeros continuaron dominando la comunicación marítima entre el Perú y Mesoamérica en una función similar a la de los fenicios en el Mediterraneo. Este comercio marítimo continuó hasta el siglo XVI cuando fue reportado por cronistas españoles de la época.

DONALD COLLIER

Bibliography

I. Selected Works

Bushnell, G.H.S. *The Archaeology of the Santa Elena Peninsula in Southwest Ecuador*. Cambridge: University of Cambridge Press, 1951.

Estrada, E. *Valdivia: un sitio arqueológico formativo en la costa de la provincia del Guayas, Ecuador*. (Pub. 1) Guayaquil: Museo Victor Emilio Estrada, 1956.

Evans, C., Meggers, B.J. and Estrada, E. *Cultura Valdivia*. (Pub. 6) Guayaquil: Museo Victor Emilio Estrada, 1959.

Meggers, Betty J. *Ecuador* (Ancient Peoples and Places). New York: Praeger, 1966.

Meggers, B. J., Evans, C. and Estrada, E. "The Early Formative Period of Coastal Ecuador: The Valdivia and Machalilla Phases," *Smithsonian Contributions to Anthropology*, I. Washington, D.C.: Smithsonian Institution, 1965.

II. Ecuador: The Environment

Chapman, Frank M. "The Distribution of Bird-Life in Ecuador," *Bulletin of the American Museum of Natural History*, LV. New York: American Museum of Natural History, 1926.

Ferdon, Edwin N., Jr. "Studies in Ecuadorian Geography," *Monographs of the School of American Research*, no. 15. Santa Fe: School of American Research and University of Southern California, 1950.

Murphy, Robert Cushman. "To the Chocó in the Schooner Askoy," *Natural History*, LIII (May 1944), 200 -209.

Richardson, James B. III. "The Preceramic Sequence and the Pleistocene and Post-Pleistocene Climate of Northwest Peru," *in* Lathrap, D. W. and Douglas, Jody, eds., *Variation in Anthropology: Essays in Honor of John C. McGregor*, pp. 199-211. Urbana: Illinois Archaeological Survey, 1973.

Sarma, Akkaraju V. N. "Holocene Paleoecology of South Coastal Ecuador," *Proceedings of the American Philosophical Society*, CXVIII (1974), no. 1, 93-134.

Svenson, Henry K. "Vegetation of the Coast of Ecuador and Peru and Its Relation to the Galapagos Islands. I. Geographical Relations of the Flora," *American Journal of Botany*, XXXIII (May 1946), 394-498.

Wolf, Theodore. *The Geography and Geology of Ecuador*. Translated by James W. Flanagan. Toronto, 1933 (Original Spanish edition, Leipzig, 1892).

III. Ecuador: The Formative Stage

Bischof, Henning. "Una investigación estratigráfica en Valdivia (Ecuador): Primeros resultados," *Indiana*, I (1973), 157-163, Berlin.

Bischof, Henning and Viteri Gamboa, Julio. "Pre-Valdivia Occupations on the Southwest Coast of Ecuador," *American Antiquity*, XXXVIII (Oct. 1972), no. 4, 548-551.

Braun, Robert. "Cerro Narrío Reanalyzed: The Formative as Seen from the Southern Ecuadorian Highlands," *Primer Simposio de Correlaciones Andino-Mesoamericano*, (Salinas, Ecuador, July 1971). Guayaquil, in press.

Collier, Donald and Murra, John V. "Survey and Excavations in Southern Ecuador," *Field Museum, Anthropological Series*, XXXV. Chicago: Field Museum of Natural History, 1943.

Estrada, E. *Las Culturas Pre-Clásicas, Formativas o Arcaicas del Ecuador*. (Pub. 5) Guayaquil: Museo Victor Emilio Estrada, 1958.

Evans, Clifford and Meggers, B. J. "Valdivia, An Early Formative Culture," *Archaeology*, XI (1958), no. 3, 175-182.

Hill, Betsy. "A New Chronology of the Valdivia Ceramic Complex," *Ñawpa Pacha*, in press.

Holm, Olaf. *La Pieza del Mes: La Cultura Chorrera*. Guayaquil: Exposición por la Sección de Antropología Cultural, Núcleo del Guayas de la Casa de la Cultura Ecuatoriana, 1974.

Lathrap, Donald W. "Possible Affiliations of the Machalilla Complex of Coastal Ecuador," *American Antiquity*, XXIX (1963), 239-241.

———. Review of: B. J. Meggers, C. Evans, and E. Estrada, "The Early Formative Period of Coastal Ecuador: The Valdivia and Machalilla Phases," in *American Anthropologist*, LXIX (1967), no. 1, 96-98.

Marcos, Jorge G. "Loomed Textiles in a Late Valdivia Context (Ecuador)." Unpublished mss., University of Illinois, Urbana, 1973.

Norton, Presley. "Early Valdivia Middens At Loma Alta, Ecuador." Paper presented at 37th annual meeting of the Society for American Archaeology, Bal Harbor, May 6, 1972.

———. "A Preliminary Report on Loma Alta and the Implications of Inland Valdivia 'A'," *Primer Simposio de Correlaciones Andino-Mesoamericano*, (Salinas, Ecuador, July 1971). Guayaquil, in press.

Paulsen, Allison C. and McDougle, Eugene J. "The Machalilla and Engoroy Occupations of the Santa Elena Peninsula in South Coastal Ecuador." Paper presented at the 39th annual meeting of the Society for American Archaeology, Washington, D.C., 1974.

Porras Garcés, Pedro I. *El Encanto, Isla de la Puná, Guayas*. Quito, 1973.

Zevallos Menéndez, Carlos and Holm, Olaf. *Excavaciones Arqueológicas en San Pablo: Informe preliminar*. Guayaquil, 1960.

IV. Origins of Agriculture In the New World

Beadle, George W. "The Mystery of Maize," *Field Museum Bulletin*, XLIII (1972), no. 10, 2-11.

Buge, David. "Maize in South America." Unpublished mss., University of Illinois, Urbana, 1973.

Flannery, Kent V. "The Origins of Agriculture," *Annual Review of Anthropology*, II (1973), 271-310.

Harris, D. R. "The Ecology of Swidden Cultivation in the Upper Orinoco Rain Forest, Venezuela," *The Geographical Review*, LXI (1971), 475-495.

———. "The Origins of Agriculture in the Tropics," *American Scientist*, LX (1972), 180-193.

Lathrap, Donald W. "Our Father the Cayman, Our Mother the Gourd: Spinden Revisited, or a Unitary Model for the Emergence of Agriculture In the New World." Paper presented at the 9th International Congress of Anthropological and Ethnological Sciences, Chicago, Ill., 1973, in press.

Mangelsdorf, Paul C., MacNeish, Richard S., and Galinat, Walton C. "Prehistoric Wild and Cultivated Maize," *in* Byers, Douglas S., ed., *The Prehistory of the Tehuacán Valley. I, Environment and Subsistence*, pp. 178-299. Austin: University of Texas Press, 1967.

Pickersgill, Barbara. "The Archaeological Record of Chili Peppers (*Capsicum* spp.) and the Sequence of Plant Domestication in Peru," *American Antiquity*, XXXIV (1969), 54-61.

Sauer, Carl O. *Agricultural Origins and Dispersals*. New York: The American Geographical Society, 1952.

Timothy, David H., Hatheway, William H., Grant, Ulysses J., Torregroza C., Manuel, Sarria V., Daniel, and Varela A., Daniel. *Races of Maize in Ecuador*. (Publication 975), Washington, D.C.: National Academy of Sciences - National Research Council, 1963.

Whitaker, T. W. "Endemism and Pre-Columbian Migration of the Bottle Gourd, *Lagenaria siceraria* (Mol.) Standl.," *in* Riley, C. L., Kelley, J. C., Pennington, C. W., and Rands, R. L., eds., *Man Across the Sea*, pp. 320-327. Austin: University of Texas Press, 1971.

Zevallos Menéndez, Carlos. *La Agricultura en el Formativo Temprano del Ecuador (Cultura Valdivia)*. Guayaquil: Casa de la Cultura Ecuatoriana, 1971.

V. Use of Hallucinogenic Drugs

Furst, P. T. (ed.). *Flesh of the Gods*. New York: Praeger, 1972.

Furst, P. T. "Hallucinogens In Precolumbian Art," *in* King, M. E. and Traylor, I. R., Jr., eds., *Art and Environment in North America*, pp. 11-101, (Special Publication no. 7). Texas Tech University Museum, 1974.

Harner, Michael J., (ed.). *Hallucinogens and Shamanism*. London: Oxford University Press, 1973.

Wassen, S. H. "The Use of Some Specific Kinds of South American Indian Snuff and Related Paraphernalia," *Etnologiska Studier*, XXVIII (1965), 1-116.

———. "Anthropological Survey of the Use of South American Snuffs," *in* Efron, D. H., ed., *Ethnopharmacologic Search for Psychoactive Drugs*, pp. 233-289. (Proceedings of symposium held in San Francisco, Calif., Jan. 28-30, 1967.) NIMH, no. 2, Health Service Publication no. 1645. Washington, D. C.

Zerries, O. "Die Vorstellung vom Zweiten Ich und die Rolle der Harpye in der Kultur der Naturvolker Sudamerikas," *Anthropos*, LIII (1962), 889-914.

———. "Bancos zoomorfos y asientos de los espíritus en la América del Sur," *Suplemento Antropologico*, V (1970), nos. 1-2, 289-314, Asunción.

Zerries, O., Lathrap, D. W., and Norton, P. "Shamen's Stools and the Time Depth of Tropical Forest Culture," *in* Hall, Edwin S. Jr. and Donnel, Robert C., eds., *Irving Rouse Fetschrift*, in press.

VI. Relation of Ecuador to Surrounding Areas

A. General

Estrada, Emilio and Meggers, B. J. "A Complex of Traits of Probable Transpacific Origin on the Coast of Ecuador," *American Anthropologist*, LXIII (1961), 913-939.

Lathrap, Donald W. "The Antiquity and Importance of Long-Distance Trade Relationships in the Moist Tropics of Pre-Columbian South America," *World Archaeology*, V (Oct. 1973), no. 2, 170-186.

_____ . "Summary or Model Building: How Does One Achieve a Meaningful Overview of a Continent's Prehistory?" review of Gordon R. Willey, *An Introduction to American Archaeology. II, South America*, in *American Anthropologist*, LXXV (1973), no. 6, 1755-1767.

_____ . "The Moist Tropics, the Arid Lands, and the Appearance of Great Art Styles In the New World," *in* King, M. E. and Traylor, I. R., Jr., eds., *Art and Environment In North America*, pp. 115-158. (Special Publication no. 7). Texas Tech University Museum, 1974.

Paulsen, Allison C. "The Thorny Oyster and the Voice of God: *Spondylus* and *Strombus* in Andean Prehistory," *American Antiquity*, in press.

_____ . "La sequencia de la cerámica de Guangala de la Peninsula de Santa Elena y sus implicaciones para un contacto prehistorico entre el Ecuador y América central," *Primer Simposio de Correlaciones Andino-Mesoamericano*, (Salinas, Ecuador, July 1971). Guayaquil, in press.

West, R. C. "Aboriginal Sea Navigation Between Middle and South America," *American Anthropologist*, LXIII (1961), 133-135.

Willey, G. R. "The Early Great Styles and the Rise of the Pre-Columbian Civilizations," *American Anthropologist*, LXIV (1962), 1-14.

B. Tropical Forest Culture

Barrett, S. A. *The Cayapa Indians of Ecuador*, Part I (Indian Notes and Monographs No. 40). New York: Museum of the American Indian, Heye Foundation, 1925.

Lathrap, Donald W. *The Upper Amazon* (Ancient Peoples and Places, Vol. 70). New York: Praeger, 1970.

_____ . "The Tropical Forest and the Cultural Context of Chavín," *in* Benson, E. P., ed., *Dumbarton Oaks Conference on Chavin*, pp. 73-100. Washington, D.C.: Dumbarton Oaks Research Library and Collections, 1971.

Lowie, R. H. "The Tropical Forests: An Introduction," *in* Steward, J. H., ed., *Handbook of South American Indians*, Vol. 3, pp. 1-56. Washington, D. C.: Bureau of American Ethnology, Bulletin 143, 1948.

C. Peru

Engel, Frederic. "Curayacu – a Chavinoid Site," *Archaeology*, IX (1956), no. 2, 98-105.

Izumi, Seiichi. Guculiza, Pedro, and Kano, Chiaki. *Excavations at Shillacoto, Huánuco, Peru*. (Bulletin no. 3). Tokyo: The University Museum, University of Tokyo, 1972.

Izumi, S. and Sono, T. *Andes 2: Excavations at Kotosh, Peru*. Tokyo: Kadokawa Publishing Co., 1960.

Kano, C. "Pre-Chavin Cultures In the Central Highlands of Peru: New Evidence from Shillacoto, Huánuco," *in* Benson, E. P., ed., *The Cult of the Feline*, pp. 139-152. Washington, D. C.: Dumbarton Oaks Research Library and Collections, 1972.

Lathrap, Donald W. "Origins of Central Andean Civilization: New Evidence," review of S. Izumi and T. Sono, *Andes 2: Excavations at Kotosh, Peru*, in *Science*, 148 (1965), 796-798.

_____ . "Relationships Between Mesoamerica and the Andean Areas," *in* Ekholm, Gordon F. and Willey, Gordon R., eds., *Handbook of Middle American Indians, Vol. 4, Archaeological Frontiers and External Connections*, pp. 265-275. Austin: University of Texas Press, 1966.

_____ . "Aboriginal Occupation and Changes In River Channel On the Central Ucayali, Peru," *American Antiquity*, XXXIII (Jan. 1968), no. 1, 62-79.

_____ . "Gifts of the Cayman: Some Thoughts On the Subsistence Basis of Chavin," *in* Lathrap, D. W., and Douglas, J., eds., *Variations in Anthropology*, pp. 91-105. Urbana: Illinois Archaeological Survey, 1973.

_____ . "Complex Iconographic Features Shared By Olmec and Chavin and Some Speculations On Their Possible Significance," *Primer Simposio de Correlaciones Andino-Mesoamericano* (Salinas, Ecuador, July 1971). Guayaquil, in press.

Menzel, Dorothy, Rowe, John H., and Dawson, Lawrence E. *The Paracas Pottery of Ica: A Study In Style and Time*. Berkeley and Los Angeles: University of California Press, 1964.

Rowe, John Howland. *Chavin Art: An Inquiry Into Its Form and Meaning*. New York: Museum of Primitive Art, 1962.

Sawyer, Alan R. *Ancient Peruvian Ceramics: The Nathan Cummings Collection*. New York: Metropolitan Museum of Art, 1966.

D. Mesoamerica

Coe, Michael D. "Archaeological Linkages with North and South America at La Victoria, Guatemala," *American Anthropologist*, LXII (1960), 363-393.

_____ . "La Victoria. An Early Site On the Pacific Coast of Guatemala," *Papers of the Peabody Museum of Archaeology and Ethnology*, LIII. Cambridge: Harvard University Press, 1961.

Evans, Clifford and Meggers, Betty J. "Mesoamerica and the Eastern Caribbean Area," *in* Ekholm, Gordon F. and Willey, Gordon R., eds., *Handbook of Middle American Indians, Vol. 4, Archaeological Frontiers and External Connections*, pp. 243-264. Austin: University of Texas Press, 1966.

Grove, D. C. "The Mesoamerican Formative and South American Influences," *Primer Simposio de Correlaciones Andino-Mesoamericano*, (Salinas, Ecuador, July 1971). Guayaquil, in press.

Lowe, Gareth W. and Green, Dee F. *Altamira and Padre Piedra, Early Preclassic Sites In Chiapas, Mexico*. (Papers of the New World Archaeological Foundation, no. 20). Provo, Utah; Brigham Young University, 1967.

MacNeish, Richard S., Peterson, Frederick A., Flannery, Kent V. *The Prehistory of the Tehuacán Valley. Vol. 3, Ceramics*. Austin: University of Texas Press, 1970.

E. Colombia

Reichel-Dolmatoff, Gerardo. *San Agustin, A Culture of Colombia* (Art and Civilization of Indian America). New York: Praeger, 1972.

Reichel-Dolmatoff, Gerardo and Dussan de Reichel, A. "Momil: excavaciones en el Sinú." *Revista Colombiana de Antropologia*, V (1956), 109-334.

Catalogue of the Exhibit

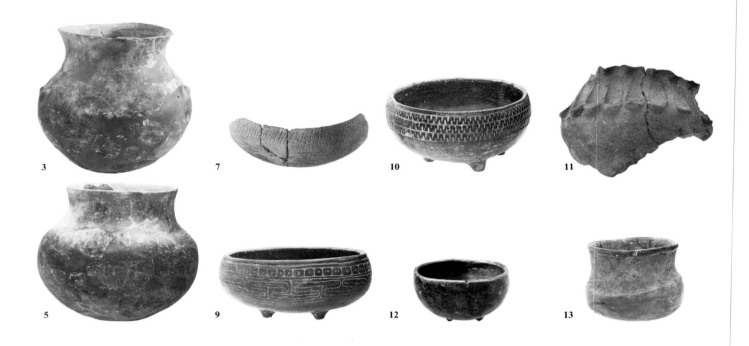

3 7 10 11

5 9 12 13

Note: Objects listed are part of the Pérez Collection of Guayaquil unless otherwise indicated. The number in parenthesis refers to the Pérez Collection number. The find spots of the material are all located in the province of Guayas, Ecuador, unless otherwise specified.

Figure references refer to those illustrated in the text. The abbreviation n.i. identifies those not illustrated.

Ecuadorian Formative: Valdivia Period

1 (Fig. 15)
Upper half of a restored jar with incised decoration.

Medio cuello de una vasija con decoración incisa.

Pre-Phase 1. Loma Alta, J-II. Ht. 19 cm. (V-207)

2 (Fig. 12)
Jar with incised decoration made by cross-brushing with a multiple tip stylus.

Vasija con decoración incisa hecha de brochazos entrecruzados marcados con un estilo de varias puntas.

Pre-Phase 1. Loma Alta, J-III. Ht. 22.5 cm. (V-162)

3
Restored jar with nodes pushed out from interior.

Vasija restaurada con nudos presionados hacia afuera desde el interior.

Pre-Phase 1. Loma Alta, J-III. Ht. 22 cm. (V-166)

4 (Fig. 13)
Pot with pie crust rim and nodes pushed out from interior.

Vasija globular con borde en forma de costra de pastel y nudos presionados hacia afuera desde el interior.

Pre-Phase 1. Loma Alta, J-III. Ht. 13 cm. (V-161)

5
Jar with incised decoration.

Vasija globular con decoración incisa.

Pre-Phase 1. Loma Alta, J-III. Ht. 25.5 cm. (V-164)

6 (Fig. 14)
Bowl with red slip. This may be one of the earliest examples of red slip yet known in the Western Hemisphere.

Cuenco con engobe rojo. Es posible que sea uno de los ejemplos más antiguos de engobe rojo conocidos hasta ahora en las Américas.

Pre-Phase 1. Cairns, Loma Alta, J-III. Ht. 8 cm. (V-155)

7
Bowl fragment with red slip and incised decoration.

Fragmento de un cuenco con engobe rojo y decoración incisa.

Phase 1. Loma Alta. L. 15.8 cm. (V-234)

8 (Fig. 19)
Tetrapod bowl with red slip and engraved decoration filled with white paint.

Cuenco tetrápodo con engobe rojo y decoración grabada rellena con pintura blanca.

Phase 2. Valdivia. Ht. 18 cm. (V-26)

9
Tetrapod bowl with red slip and incised decoration.

Cuenco tetrápodo con engobe rojo y decoración incisa.

Phase 2. Valdivia. Ht. 14 cm. (V-1)

10
Tetrapod bowl with red slip and carved or excised decoration filled with white paint.

Cuenco tetrápodo con engobe rojo y decoración tallada o excisa rellena con pintura blanca.

Phase 2. Valdivia. Ht. 14 cm. (V-37)

11
Bowl fragment with finger-trailed decoration.

Fragmento de una vasija con decoración trazada con los dedos.

Phase 2. Loma Alta. L. 14.2 cm. (V-331)

12
Tetrapod bowl.

Cuenco tetrápodo.

Phase 2-3. Valdivia. Ht. 10.5 cm. (V-52)

13
Jar with red slip and broad band of geometric incised designs below rim.

Vasija con engobe rojo y una banda ancha de diseños geométricos incisos debajo del borde.

Phase 3. Valdivia. Ht. 12 cm. (V-146)

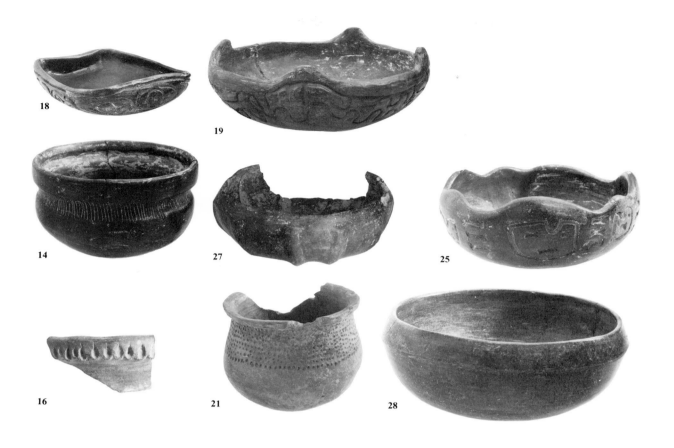

14
Jar with red slip on rim and incised design on neck; black smudging.

Vasija con engobe rojo en el borde y diseño inciso en el cuello; ahumado negro.

Phase 3. Clementina. Ht. 9.5 cm. (V-100)

15 (Fig. 3)
Jar fragment with corn-kernel impressions around rim.

Fragmento de una vasija con impresiones de granos de maíz alrededor del borde.

Phase 3. Real Alto. L. 4.5 cm. (Collection of D. Lathrap)

16
Jar fragment with corn-kernel impressions around rim.

Fragmento de una vasija con impresiones de granos de maíz alrededor del borde.

Phase 3. Real Alto. L. 7.8 cm. (Collection of D. Lathrap)

17 (n.i.)
Jar fragment with corn-kernel impressions around rim.

Fragmento de una vasija con impresiones de granos de maíz alrededor del borde.

Phase 3. Real Alto. W. 18.5 cm. (Collection of D. Lathrap)

18
Restored bowl with broad-line incisions, probably in imitation of a carved gourd.

Vasija restaurada con incisiones anchas, probablemente imitando a una calabaza tallada.

Phase 3. Valdivia. Ht. 4 cm. (V-86)

19
Deeply carved bowl with red slip, imitating in shape and decoration a carved gourd. The indentation on the bottom corresponds to the stem- or blossom-end of an actual bottle gourd.

Vasija profundamente tallada con engobe rojo, imitando la forma y la decoración de una calabaza tallada. La pequeña concavidad de la base corresponde al tallo o punto de inserción de la flor de la calabaza.

Phase 3. Valdivia. Diam. 17.7 cm. (V-14)

20 (Fig. 21)
Red slipped jar, with broad band of punctations below rim.

Vasija de engobe rojo, con banda ancha de punteados bajo el borde.

Phase 4. Clementina. Ht. 10 cm. (V-113)

21
Jar with punctations between rim and shoulder.

Vasija con punteado entre el borde y el hombro.

Phase 4. Clementina. Ht. 9 cm. (V-105)

22 (Fig. 20)
Restored bowl with incised designs, including human faces, in imitation of a carved gourd.

Vasija restaurada con diseños incisos, incluyendo rostros humanos, imitando a una calabaza tallada.

Phase 4. Site unknown. Diam. 17.2 cm. (V-9)

23 (Fig. 17)
Bowl with carved rim and incised faces in imitation of a carved gourd.

Cuenco con borde tallado y rostros incisos imitando a una calabaza tallada.

Phase 4. Valdivia. Diam. 14.5 cm. (V-15)

24 (Fig. 16)
Bowl fragment with undulating rim and incised faces in imitation of a decorated gourd; black smudging.

Fragmento de un cuenco con borde ondulado y rostros incisos imitando a una calabaza decorada; ahumado negro.

Phase 4. Valdivia. Diam. 18.6 cm. (V-74)

25
Bowl with carved rim and excised faces, in imitation of a carved gourd.

Cuenco con borde tallado y rostros excisos imitando a una calabaza tallada.

Phase 4. Valdivia. Ht. 8.5 cm. (V-41)

26 (Fig. 6)
Restored bowl fragment with red slip, probably representing a dugout canoe.

Fragmento de un cuenco restaurado con engobe rojo, probablemente representando una canoa.

Phase 4. Valdivia. Ht. 5 cm. (Collection of Richard Zeller)

27
Bowl fragment with modeled decoration in imitation of half a gourd.

Fragmento de un cuenco con decoración modelada imitando a una media calabaza.

Phase 5. Clementina. Ht. 5.5 cm. (V-106)

28
Bowl with cambered rim.

Cuenco con borde combado.

Phase 5. Valdivia. Ht. 8 cm. (V-81)

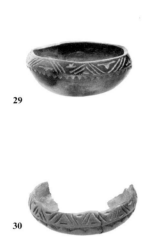

29

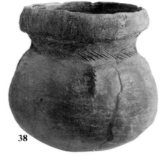

33

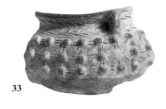

35

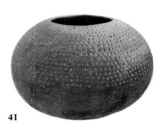

38

41

30

41

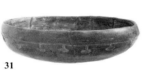

31

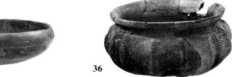

36

39

42

29
Restored bowl with excised design in imitation of a carved gourd.

Cuenco restaurado con diseño exciso imitando a una calabaza tallada.

Phase 5. Valdivia. Ht. 8.5 cm. (V-40)

30
Fragment of carved bowl with undulating rim, red slip, and excised design, probably in imitation of a carved gourd.

Fragmento de un cuenco tallado con borde ondulado, engobe rojo, diseño exciso, probablemente imitando a una calabaza tallada.

Phase 5. Valdivia. Ht. 5 cm. (V-197)

31
Bowl with red slip on the rim, broad excised design on the shoulder, and black smudging on shoulder and bottom.

Cuenco con engobe rojo en el borde, diseño exciso en el hombro, y ahumado negro en los hombros y la base.

Phase 5. Valdivia. Ht. 12.3 cm. (V-57)

32 (Fig. 77)
Jar with deeply concave neck and multiple loop handles; red slip on rim and black smudging on body.

Vasija con cuello cóncavo profundo y asas múltiples en forma de anillos; engobe rojo en el borde y ahumado negro en el cuerpo.

Phase 6. Valdivia. Ht. 7 cm. (V-21)

33
Jar fragment with deeply concave neck, loop handle, and appliqué and incised decoration.

Fragmento de una vasija con cuello cóncavo profundo, asa de anillo, y decoración aplicada e incisa.

Phase 6. Valdivia. Ht. 11.1 cm. (V-212)

34 (Fig. 22)
Jar with deeply concave neck, multiple loop handles, and incised designs on neck and shoulder.

Vasija con cuello cóncavo profundo, varias asas en forma de anillos, y diseños incisos en el cuello y hombro.

Phase 6. Clementina. Ht. 11 cm. (V-108)

35
Jar with deeply concave incised neck and appliqué and modeled ridge around shoulder.

Vasija con cuello cóncavo profundo inciso; aro aplicado y modelado alrededor del hombro.

Phase 6. Boca de San José, Manabí. Ht. 13.5 cm. (V-132)

36
Incomplete jar with incised and appliqué design representing ears of corn; red slip on rim and interior.

Vasija incompleta con diseño inciso y aplicado representando mazorcas de maíz; engobe rojo en el borde y el interior.

Phase 6. Buenavista. Ht. 10 cm. (V-135)

37 (Fig. 2)
Incomplete jar fragment with incised and modeled design representing ears of corn.

Vasija incompleta con diseño modelado e inciso representando mazorcas de maíz.

Phase 6. San Pablo. Ht. 16.2 cm. (Collection of Casa de la Cultura, Guayaquil)

38
Jar with cambered rim and incised and appliqué design representing ear of corn.

Vasija con borde combado y diseño aplicado e inciso representando una mazorca de maíz.

Phase 6. Buenavista. Ht. 19.5 cm. (V-127)

39
Spherical jar with red slip and coarse punctate surface created by applying seeds to the roughened surface of the pot, which were then burned off in the firing.

Vasija esférica con engobe rojo y superficie de punteado grueso obtenido aplicando semillas a la superficie áspera de la vasija, las cuales fueron luego quemadas en la cocción.

Phase 6. Coaque, Manabí. Ht. 19.6 cm. (V-20)

40 (n.i.)
Plate fragment with carbonized maize kernel imbedded in the bottom wall.

Tiesto de un plato con restos de un grano de maíz carbonizdo embebido en la pared inferior externa.

Phase 6. San Pablo. L. 11 cm. (Collection of Casa de la Cultura, Guayaquil)

41
Restored neckless, spherical jar with zoned red slip and fine punctate design.

Vasija restaurada esférica sin cuello, con engobe rojo en zonas y diseño punteado fino.

Phase 6. Perú, Manabí. Ht. 18 cm. (V-6)

42
Deep bowl with wide flaring rim, punctate and incised design; red slip on rim and interior, and black smudging on exterior.

Vasija profunda con borde saliente, diseño inciso y punteado; engobe rojo en el borde y el interior, y ahumado negro en el exterior.

Phase 6. Chacras, Manabí. Ht. 20 cm. (V-199)

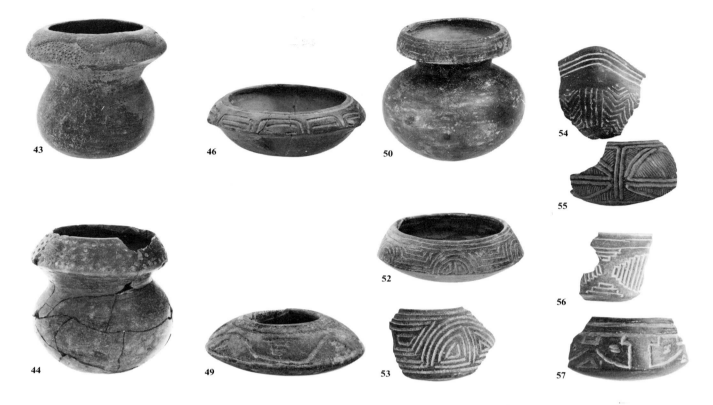

43

Jar with cambered rim, zoned red slip, and punctation in unslipped areas; the overall shape suggests a bottle gourd tied during the growth process.

Vasija con borde entrante; engobe rojo en zonas, y punteado en áreas sin engobe; la figura total sugiere a una calabaza que ha sido atada durante el crecimiento.

Phase 6. Chacras, Manabi. Ht. 17.5 cm. (V-149)

44

Restored jar with cambered rim, red slip, and punctate design.

Vasija restaurada con borde entrante, engobe rojo y diseño punteado.

Phase 6. Valdivia. Ht. 15.5 cm. (V-117)

45 (Fig. 18)

Bowl fragment with incised faces and rocker stamping in deeply incised grooves below rim; probably in imitation of a carved gourd. Black smudging.

Fragmento de una vasija con rostros incisos y estampado de zigzag en surcos hondos bajo el borde; probablemente imitando a una calabaza tallada. Ahumado negro.

Phase 6. Buenavista. Ht. 7 cm. (V-188)

46

Restored bowl with notching at the bottom of broad-line incisions on cambered rim.

Cuenco restaurado con muescas en la parte inferior de incisiones anchas en un borde combado.

Phase 6. Chacras, Manabi. Ht. 9.5 cm. (V-54)

47 (Fig. 23)

Jar with cambered rim, red slip, and deeply incised design.

Vasija con borde combado, engobe rojo, y diseño inciso profundo.

Phase 6. Chacras, Manabi. Ht. 13.5 cm. (V-124)

48 (Fig. 75)

Double pot, with appliqué and incised design representing ears of corn; red slip on interior of rim.

Vasija doble, con aplicación y diseño inciso representando mazorcas de maíz; engobe rojo en el interior del borde.

Transitional Phase 6. Clementina. Ht. 13.6 cm. (V-104)

49

Small carinated bowl with broad-line incisions above shoulder.

Pequeño cuenco carenado con incisos de línea ancha sobre el hombro.

Phase 7. Chacras, Manabi. Ht. 4.6 cm. (V-94)

50

Restored jar with flaring and cambered rim and incised decoration on the rim; black smudging.

Vasija restaurada con borde protuberante y combado y decoración incisa en el borde; ahumado negro.

Phase 7. Valdivia. Ht. 16.4 cm. (V-98)

51 (Fig. 24)

Deep bowl with markedly concave side, red slip, and zoned incised decoration.

Vasija profunda con lados marcadamente cóncavos, engobe rojo, y decoración incisa en zonas.

Phase 8. Valdivia. Ht. 9.5 cm. (V-56)

52

Carinated bowl with drag-and-jab incised design; red slip and black smudging.

Cuenco carenado con diseño inciso en forma de "drag-and-jab"; engobe rojo y ahumado negro.

Phase 8. Mejia, Manabi. Ht. 6.5 cm. (V-8)

53

Fragment of carinated bowl with black smudged surface and deeply incised grooves filled with rocker stamping and post-fired white pigment.

Fragmento de un cuenco carenado con superficie negra ahumada y surcos incisos profundos conteniendo estampado en zigzag y pigmento aplicado después de la cocción.

Phase 8. Valdivia. L. 8.7 cm. (V-213)

54

Bowl fragment with black smudged surface and fine line incision filled with white pigment.

Fragmento de un recipiente con la superficie negra ahumada e incisos de lineas finas rellenas con pigmento blanco.

Phase 8. Valdivia. L. 11.3 cm. (V-214)

55

Bowl fragment with black smudged surface; rocker stamping in deeply incised grooves and fine line incision filled with white pigment.

Fragmento de un recipiente con superficie ahumada negra; estampado en zig–zag en surcos profundos incisos y incisiones de lineas finas rellenas con pigmento blanco.

Phase 8. Valdivia. L. 7.2 cm. (V-215)

56

Bowl fragment with broad line incision.

Fragmento de un recipiente con incisión ancha.

Phase 8. Valdivia. L. 10.2 cm. (V-216)

57

Fragment of carinated bowl with black smudged surface and incised design filled with white pigment.

Fragmento de recipiente carenado con superficie ahumada negra y diseño inciso relleno con pigmento blanco.

Phase 8. Valdivia. L. 9 cm. (V-217)

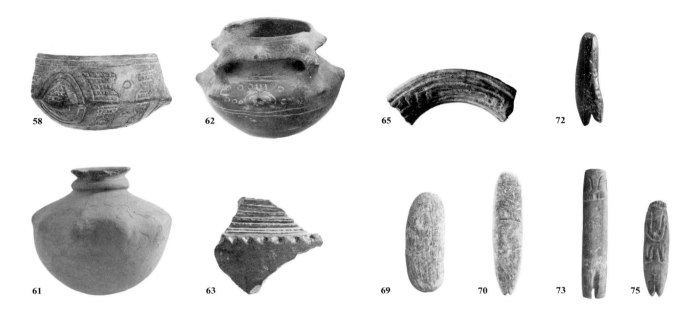

58

Bowl fragment with shoulder bosses and incised design.

Fragmento de una vasija con córcovas alrededor del hombro y diseño inciso.

Phase 8. Valdivia. Ht. 8.5 cm. (Collection of D. Lathrap)

59 (Fig. 25)

Bowl with zoned incised designs, burnished black smudging, and multi-colored, post-fired, resin-based paint on textured areas.

Cuenco con diseños incisos por zonas, ahumado negro pulido, y pintura polycromada de base resina aplicada después de la cocción en áreas de textura.

Phase 8. Valdivia. Ht. 6.5 cm. (V-31)

60 (Fig. 26)

Jar with red and white slip, zoned punctations, and a line of bosses around shoulder.

Vasija con engobe rojo y blanco, punteado en zona, y una linea con córcovas alrededor del hombro.

Terminal Valdivia. Chacras, Manabí. Ht. 10.9 cm. (V-147)

61

Jar with bosses on shoulder and a band of incisions between shoulder and neck.

Vasija con córcovas en el hombro y una banda de incisiones entre el hombro y el cuello.

Terminal Valdivia. Chacras, Manabí. Ht. 16.5 cm. (V-148)

62

Jar with cambered rim, bosses on shoulder and rim, multiple loop handles, and incised bands and punctations made with a reed or bone stamp; the bosses seem to relate to faces on the Valdivia 6 bowls and jars that imitate carved gourds.

Vasija con borde entrante, córcovas en el hombro y borde, varias asas de anillo, y bandas incisas y punteado hecho con un estampador de caña o hueso; las protuberancias parecen relacionarse con las caras en las vasijas de Valdivia 6 que imitan calabazas talladas.

Terminal Valdivia. Chacras, Manabí. Ht. 17.7 cm. (V-138)

63

Jar fragment with furrowed neck and nicked shoulder.

Fragmento de una vasija con cuello surcado y hombro con muescas.

Terminal Valdivia. Chacras, Manabí. L. 9 cm. (Collection of D. Lathrap)

64 (n.i.)

Rim sherd with incised design on interior.

Tiesto de un borde con diseño inciso en el interior.

Terminal Valdivia. Chacras, Manabí. L. 13.1 cm. (V-332)

65

Rim sherd with incised design on interior.

Tiesto de un borde con diseño inciso en el interior.

Terminal Valdivia. Chacras, Manabí. L. 12.4 cm. (V-333)

66 (Fig. 50)

Shaped stone figurine.

Figurilla de piedra tallada.

Phase 1. Loma Alta. L. 6.2 cm. (V-242)

67 (n.i.)

Shaped stone figurine.

Figurilla de piedra tallada.

Phase 1. Loma Alta. L. 5.5 cm. (V-243)

68 (n.i.)

Shaped stone figurine.

Figurilla de piedra tallada.

Phase 1. Loma Alta. L. 6.5 cm. (V-244)

69

Shaped stone figurine.

Figurilla de piedra tallada.

Phase 1. Loma Alta. L. 6.3 cm. (V-245)

70

Shaped stone figurine with notch at one end, the beginning of depiction of legs.

Figurilla de piedra tallada con hendidura a un extremo, el comienzo de la representación de las piernas.

Phase 1. Loma Alta. L. 9.1 cm. (V-238)

71 (Fig. 50)

Shaped stone figurine with notch at one end indicating legs.

Figurilla de piedra tallada con hendidura a un extremo indicando las piernas.

Phase 1. Loma Alta. L. 5.9 cm. (V-239)

72

Shaped bone figurine with notch at one end indicating legs.

Figurilla tallada de hueso con hendidura a un extremo indicando las piernas.

Phase 1. Loma Alta. L. 4.5 cm. (V-240)

73

Carved stone figurine with face and legs indicated.

Figurilla de piedra tallada con rostro y piernas indicados.

Phase 2. Loma Alta. L. 8.6 cm. (V-241)

74 (Fig. 16)

Carved stone figurine with face.

Figurilla de piedra tallada con rostro.

Phase 2. Clementina. L. 9.6 cm. (V-235)

75

Carved stone figurine with face, arms, and legs depicted.

Figurilla de piedra tallada con rostro, brazos, y piernas representados.

Phase 2. Clementina. L. 4.1 cm. (V-236)

76 (Fig. 50)

Carved stone figurine with face and legs indicated.

Figurilla de piedra tallada con rostro y piernas representados.

Phase 2. Valdivia. L. 5.5 cm. (V-237)

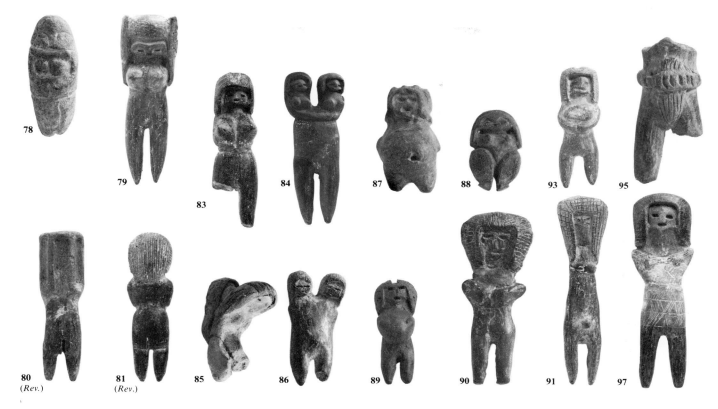

77 (Fig. 50)
Carved stone figurine with depiction of face, hair, arms, and legs.

Figurilla de piedra tallada con representación del rostro, cabello, brazos, y piernas.

Phase 2. Clementina. Ht. 8 cm. (V-328)

78
Carved stone figurine with face, breasts, arms, and legs depicted.

Figurilla de piedra tallada con rostro, pechos, brazos, y piernas representados.

Phase 2. Clementina. Ht. 5.5 cm. (V-329)

79
Ceramic figurine of woman; red slip.

Figurilla de cerámica de una mujer; engobe rojo.

Phase 3. Valdivia. Ht. 14 cm. (V-293)

80
Ceramic figurine of woman; red slip.

Figurilla de cerámica de una mujer; engobe rojo.

Phase 3. Valdivia. Ht. 8.3 cm. (V-307)

81
Ceramic figurine of woman; red slip.

Figurilla de cerámica de una mujer; engobe rojo.

Phase 3. Valdivia. Ht. 10.7 cm. (V-300)

82 (Fig. 51)
Ceramic figurine of woman.

Figurilla de cerámica de una mujer.

Phase 3. Valdivia. Ht. 11.1 cm. (V-298)

83
Ceramic figurine of woman; red slip.

Figurilla de cerámica de una mujer; engobe rojo.

Phase 3. Valdivia. Ht. 11.7 cm. (V-295)

84
Restored two-headed ceramic figurine of woman; red slip.

Figurilla restaurada de cerámica de una mujer con dos cabezas; engobe rojo.

Phase 3. Valdivia. Ht. 14.2 cm. (V-296)

85
Ceramic figurine of woman carrying a baby.

Figurilla de cerámica de una mujer llevando a un nene.

Phase 3. Valdivia. Ht. 6.1 cm. (V-310)

86
Two-headed ceramic figurine.

Figurilla de cerámica con dos cabezas.

Phase 3. Valdivia. Ht. 4.5 cm. (V-312)

87
Ceramic figurine of pregnant woman.

Figurilla de cerámica de una mujer embarazada.

Phase 3. Valdivia. Ht. 4 cm. (V-319)

88
Ceramic figurine of woman.

Figurilla de cerámica de una mujer.

Phase 3. Valdivia. Ht. 3.4 cm. (V-321)

89
Ceramic figurine of pregnant woman.

Figurilla de cerámica de una mujer embarazada.

Phase 3. Buenavista. Ht. 3.3 cm. (V-320)

90
Ceramic figurine of woman; red slip.

Figurilla de cerámica de una mujer; engobe rojo.

Phase 4. Valdivia. Ht. 6.8 cm. (V-306)

91
Ceramic figurine of man; red slip.

Figurilla de cerámica de un hombre; engobe rojo.

Phase 4. Valdivia. Ht. 12 cm. (V-301)

92 (Fig. 51)
Ceramic figurine; red slip.

Figurilla de cerámica; engobe rojo.

Phase 4. Valdivia. Ht. 8.5 cm. (V-305)

93
Ceramic figurine of man; red slip.

Figurilla de cerámica de un hombre; engobe rojo.

Phase 4. Valdivia. Ht. 7.7 cm. (V-302)

94 (Fig. 17)
Ceramic figurine; red slip.

Figurilla de cerámica; engobe rojo.

Phase 4. Site unknown. Ht. 12.3 cm. (V-299)

95
Ceramic figurine fragment of male wearing belt and loincloth.

Fragmento de una figurilla de cerámica masculina usando cinturón y taparrabo.

Phase 4. Site unknown. H. 5.5 cm. (V-309)

96 (Fig.64)
Ceramic figurine of a pregnant woman carrying a snuff tablet on her head; the figurine is hollow and contains a rattle.

Figurilla de cerámica de una mujer embarazada llevando una tableta de aspirar en la cabeza; la figurilla es hueca y contiene un cascabel.

Phase 4. Valdivia. Ht. 4.4 cm. (V-313)

97
Ceramic figurine of woman; red slip.

Figurilla de cerámica de una mujer; engobe rojo.

Phase 5. Valdivia. Ht. 13.9 cm. (V-294)

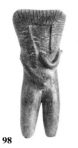
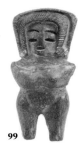
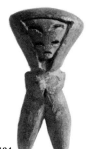
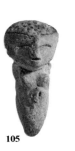
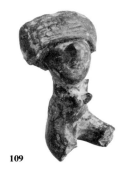

98 **99** **104** **105** **109** **100**

101 **106** **107** **110** **111**

98
Ceramic figurine; red slip.

Figurilla de cerámica; engobe rojo.

Phase 5. Buenavista. Ht. 6.8 cm. (V-303)

99
Ceramic figurine of man; red slip.

Figurilla de cerámica de un hombre; engobe rojo.

Phase 5. Valdivia. Ht. 9.8 cm. (V-297)

100
Fragment of the breasts from a ceramic figurine.

Fragmento de los pechos de una figurilla de cerámica.

Phase 5. Valdivia. Ht. 2.7 cm. (V-224)

101
Torso fragment of a ceramic figurine of pregnant woman.

Fragmento del torso de una figurilla de cerámica de una mujer embarazada.

Phase 5. Valdivia. Ht. 5.5 cm. (V-315)

102 (Fig. 51)
Ceramic figurine of man; red slip.

Figurilla de cerámica de un hombre; engobe rojo.

Phase 6. Buenavista. Ht. 14.5 cm. (V-292)

103 (Fig. 18)
Ceramic figurine of woman.

Figurilla de cerámica de una mujer.

San Pablo type, Phase 6. Buenavista. Ht. 4.5 cm. (V-311)

104
Ceramic figurine of woman.

Figurilla de cerámica de una mujer.

San Pablo type, Phase 6. Buenavista. Ht. 5.8 cm. (V-308)

105
Ceramic figurine of seated woman.

Figurilla de cerámica de una mujer sentada.

Transitional San Pablo - Chacras style, Phase 8. Sta. Marta, Manabí. Ht. 5.7 cm. (V-317)

106
Ceramic figurine.

Figurilla de cerámica.

Transitional San Pablo - Chacras style, Phase 8. Site unknown. Ht. 4.6 cm. (V-314)

107
Ceramic figurine fragment.

Fragmento de una figurilla de cerámica.

Terminal Valdivia. Chacras, Manabí. Ht. 3.2 cm. (V-218)

108 (Fig. 66)
Fragment of ceramic figurine. The bulging cheek represents a cud of coca.

Fragmento de una figurilla de cerámica. La protuberancia en el cachete representa una bocado de coca.

Chacras style, Terminal Valdivia. Valdivia. Ht. 7.2 cm. (V-219)

109
Ceramic figurine fragment of seated woman.

Figurilla de cerámica fragmentada de una mujer sentada.

Terminal Valdivia. Chacras, Manabí. Ht. 8.7 cm. (V-220)

110
Ceramic figurine fragment.

Fragmento de una figurilla de cerámica.

Terminal Valdivia. Chacras, Manabí. Ht. 5.4 cm. (V-221)

111
Ceramic figurine fragment.

Fragmento de una figurilla de cerámica.

Chacras style, Terminal Valdivia. Miguelillo, Manabí. Ht. 6.5 cm. (V-222)

112 (n.i.)
Ceramic figurine fragment.

Fragmento de una figurilla de cerámica.

Terminal Valdivia. Chacras, Manabí. Ht. 5 cm. (V-223)

113 (Fig. 53)
Ceramic figurine of seated woman; red slip.

Figurilla de cerámica de una mujer sentada; engobe rojo.

Chacras style, Terminal Valdivia. Valdivia. Ht. 14.1 cm. (V-291)

114 (Fig. 68)
Head of ceramic figurine with incised depiction of large ear spools; occipital head deformation is clearly shown.

Cabeza de una figurilla de cerámica con representación incisa de grandes orejeras, mostrando claramente una deformación occipital de la cabeza.

Chacras style, Terminal Valdivia. Site unknown. Ht. 12.5 cm. (V-330)

115 (n.i.)
Ceramic figurine of seated person.

Figurilla de cerámica de una persona sentada.

Chacras style, Terminal Valdivia. Valdivia. Ht. 3.9 cm. (V-318)

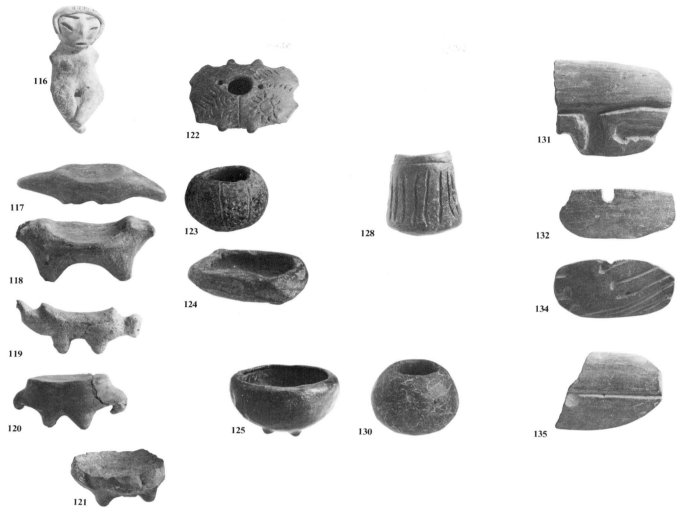

116
Ceramic figurine of seated woman.

Figurilla de cerámica de una mujer sentada.

Chacras style, Terminal Valdivia. Site unknown. Ht. 4.4 cm. (V-316)

117
Ceramic miniature of shaman's stool.

Miniatura de cerámica del banquillo de un shaman (brujo-adivino).

Valdivia. L. 9.3 cm. (V-322)

118
Ceramic miniature of shaman's stool, probably representing a jaguar.

Miniatura de cerámica del banquillo de un shaman (brujo-adivino), probablemente representando un jaguar.

Valdivia. L. 5.9 cm. (V-325)

119
Ceramic miniature of shaman's stool probably in the form of a jaguar.

Miniatura de cerámica del banquillo de un shaman (brujo-adivino), probablemente en la forma de un jaguar.

Valdivia. L. 6.9 cm. (V-323)

120
Ceramic miniature of shaman's stool probably in the form of an anteater.

Miniatura de cerámica del banquillo de un shaman (brujo-adivino), probablemente en la forma de un oso hormiguero.

Valdivia. L. 5.8 cm. (V-324)

121
Ceramic tetrapod fragment, possibly a child's or beginning potter's first attempt.

Fragmento tetrápodo de cerámica, posiblemente el primer intento de un niño o de un aprendiz alfarero.

Phase 2. Loma Alta. Diam. 4.7 cm. (V-228)

122
Ceramic tetrapod lime pot; feet missing.

Olla tetrápoda de cerámica para la cal; los pies perdidos.

Phase 3 or 4. Buenavista. L. 7.8 cm. (V-226)

123
Ceramic lime pot with zoned punctations.

Olla de cerámica para la cal con punteado por zonas.

Probably Phase 4. Valdivia. Ht. 2.1 cm. (V-327)

124
Ceramic lime pot.

Olla de cerámica para la cal.

Possibly Phase 4. Valdivia. L. 4.2 cm. (V-229)

125
Ceramic tetrapod lime pot.

Olla tetrápoda de cerámica para la cal.

Phase 4. Valdivia. Ht. 3.6 cm. (V-227)

126 (Fig. 62)
Ceramic lime pot with incised and excised design.

Olla de cerámica para la cal con diseño inciso y exciso.

Phases 4-5. Valdivia. Ht. 2.2 cm. (V-326)

127 (n.i.)
Ceramic lime pot.

Olla de cerámica para la cal.

Site unknown. Ht. 3.3 cm. (V-230)

128
Ceramic lime pot.

Olla de cerámica para la cal.

Buenavista. Ht. 3.6 cm. (V-233)

129 (n.i.)
Ceramic lime pot.

Olla de cerámica para la cal.

Site unknown. Ht. 2.4 cm. (V-232)

130
Ceramic lime pot.

Olla de cerámica para la cal.

Site unknown. Ht. 2.6 cm. (V-231)

131-135 (133 n.i.)
Five potting tools made from Phase 5 pottery sherds.

Cinco instrumentos de alfarería hechos con tiestos de cerámica de la Fase 5.

San Pablo. L. of 131: 5.5 cm. (Collection of Casa de la Cultura, Guayaquil)

136

137

139

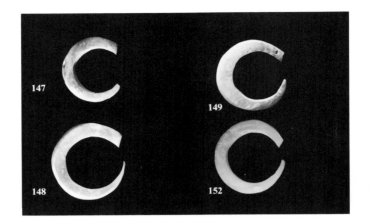

147

149

148

152

163

140

159

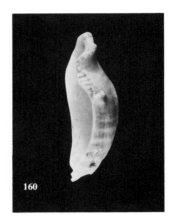

160

165

166

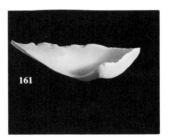

161

167

136-139 (138 n.i.)
Four spindle whorls made from pottery sherds.

Cuatro torteras hechas con tiestos de cerámica.

San Pablo. Diam. of 136: 4.2 cm. (Collection of Casa de la Cultura, Guayaquil)

140
Lump of fired clay with two distinct textile impressions, one showing a plain weave with single warp and weft and the other a plain weave with double warp and double weft.

Pedazo de barro cocido con dos impresiones textiles distintivas, una mostrando un tejido sencillo con urdimbre y trama singulares, y el otro un tejido sencillo con doble urdimbre y doble trama.

Phases 6-7. Real Alto, Chanduy Valley. L. 4 cm. (Collection of J. Marcos)

141-145 (Fig. 5; 142 n.i.)
Five shell fishhooks showing various stages in their manufacture.

Cinco anzuelos hechos de conchas mostrando varias fases de su manufactura.

142, Loma Alta, (V-273); others, sites unknown. Diam. of 141: 3.5 cm. (V-272-275, 277)

146-153 (146, 150, 151, 153 n.i.)
Eight shell fishhooks.

Ocho anzuelos de concha.

Sites unknown. Diam. of 146: 6.8 cm. (V-271; 147-152, no coll. numbers; V-279)

154-157 (n.i.)
Four shell fishhooks.

Cuatro anzuelos de concha.

Valdivia-Machalilla. 156 and 157, Ayangue, (V-276, 278); others, sites unknown. Diam. of 154: 5.1 cm. (V-276, 278, 280, 281)

158-159 (158 n.i.)
Two shell spoons.

Dos cucharas de concha.

San Pablo. L. of 159: 14 cm. (Collection of Casa de la Cultura, Guayaquil)

160
Spoon made from shell of *Malea ringens*.

Cuchara de concha hecha de *Malea ringens*.

Real Alto. L. 8.9 cm. (Collection of J. Marcos)

161
Draw knife made from shell of *Melongena patula*.

Navaja hecha de una concha de *Melongena patula*.

Real Alto. L. 13.2 cm. (Collection of J. Marcos)

162 a-i (n.i.)
Nine shells: **162 a-h**, *Anadara tuberculosa*; **162i**, *Anadara grandis*.

Nueve conchas: **162 a-h**, *Anadara tuberculosa*; **162i**, *Anadara grandis*.

Real Alto. L. of 162a: 7.2 cm.; L. of 162i: 10.2 cm. (Collected by D. Collier)

163-167 (164 n.i.)
Five shell potting tools.

Cinco instrumentos de concha para la alfarería.

San Pablo. L. of 163: 4.1 cm. (Collection of Casa de la Cultura, Guayaquil)

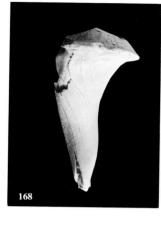

168

173

180

182

184

185

169

174

175

176

177

196

191

187

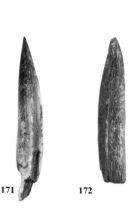

171

172

193

195

168

Pick made from the columella of a very large specimen of shell *(Melongena patula)*.

Pico hecho de la columela de un espécimen grande de concha *(Melongena patula)*.

San Pablo. L. 13.8 cm. (collection of Casa de la Cultura, Guayaquil)

169

Spondylus shell.

Concha de *Spondylus*.

Site unknown. L. 17 cm. (Collection of O. Holm)

170 (n.i.)

Broken shell of *Hexaplex brassica*.

Concha rota de un *Hexaplex brassica*.

San Pablo. L. 11.4 cm. (Collection of Casa de la Cultura, Guayaquil)

171-173

Three projectile points, formed from the teeth of a sawfish, *Pristis*.

Tres puntas de proyectiles hechos de dientes del pescado priste *(Pristis)*.

171, Buenavista. L. 8.1 cm. (V-251); 172, Punta Concepción. (V-253); 173, Loma Alta. (V-250)

174-179 (178, 179 n.i.)

Six chert drills.

Seis taladros de pedernal.

San Pablo. Aver. L. 2.6 cm. (Collection of Casa de la Cultura, Guayaquil)

180-185 (181, 183 n.i.)

Six stone reamers.

Seis escariadores de piedra.

180, Los Hornos. (V-265); 181, La Ponga. (V-266); others, sites unknown. L. of 180: 5.9 cm. (V-265 - 270)

186 (n.i.)

Bifacially worked stone implement, possibly used as an adze.

Implemento de piedra trabajada en ambas superficies, posiblemente una azuela.

Loma Alta. L. 8 cm. (V-258)

187-196 (188, 189, 190, 192, 194 n.i.)

Ten flint flakes, possibly waste from making stone implements; some (eg., nos. **187, 191, 195**) were used as knives.

Diez láminas de pedernal, posiblemente desperdicios de la fábrica de utensilios; algunas servían como cuchillos.

Loma Alta. L. of 187: 6.2 cm. (V-254-257; 259-264)

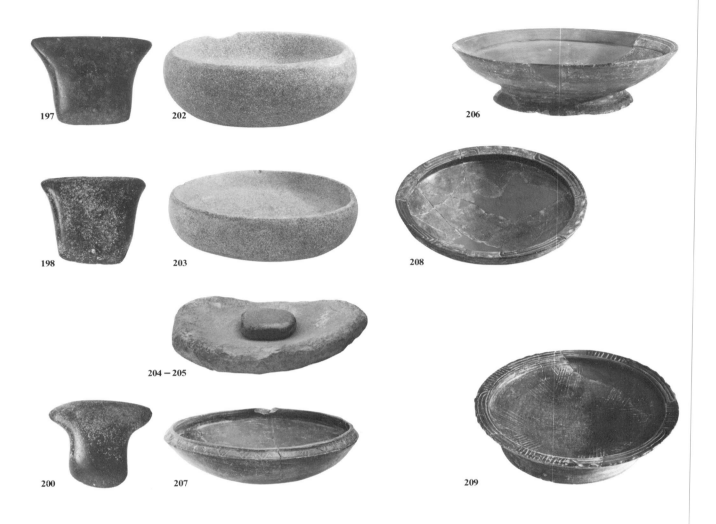

197 198 200

197-201 (199, n.i.; 201, Fig. 4)
Five ground stone axes.

Cinco hachas afiladas de piedra.

197 and 198, Cerro Verde. (V-287, 289); others, sites unknown. L. of 197: 14.1 cm. (V-286-290)

202
Stone bowl.

Vasija de piedra.

Site unknown. Diam. 25.7 cm. (V-168)

203
Stone bowl.

Site unknown. Diam. 34 cm. (V-171)

204-205
Grinding slab (metate) and handstone (manos).

Metate y manos.

San Pablo. L. of metate, 36.8 cm.; L. of manos, 15 cm. (Collection of Casa de la Cultura, Guayaquil)

Ecuadorian Formative: Machalilla Period

206
Restored bowl with "double line break" on rim similar to Olmec-associated pottery in Mesoamerica, where the "double line break" probably represents the mouth of the cayman deity. Contrastive use of red-slip rim and black-smudged interior.

Vasija restaurada con "double line break" en el borde similar a la cerámica relacionada a Olmec en Mesoamérica, donde la "double line break" representa probablemente la boca de la deidad caimán. Uso contrastante de engobe rojo en el borde y ahumado negro en el interior.

La Ponga. Diam. 31 cm. (Mch-3)

207
Carinated bowl with engraved decoration.

Vasija carenada con decoración grabada.

La Ponga. Diam. 22.4 cm. (Mch-6)

208
Restored bowl with everted rim, contrastive red panels on rim, and harpy eagle crest design on panels between the red zones.

Vasija restaurada con borde evertido, paneles contrastantes rojos en el borde, y un diseño de la cresta de un águila arpía en paneles entre las zonas rojas.

La Ponga. Diam. 24 cm. (Mch-22)

209
Restored bowl with everted rim, pedestal base, and interior patterned burnishing; the whole interior is deliberately smudged, with contrastive panels on rim and incised harpy eagle crest design on panels between the red zones.

Vasija restaurada con borde evertido, base en forma de pedestal, e interior pulido en zonas; todo el interior está deliberadamente ahumado, con paneles contrastantes en el borde y diseño inciso de la cresta de un águila arpía en paneles entre las zonas rajas.

La Ponga. Diam. 26 cm. (Mch-14)

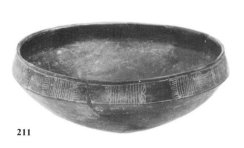

211

222

215

219

223

214

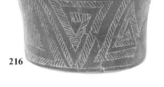

216

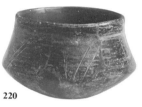

220

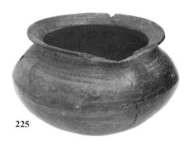

225

210 (Fig. 30)
Restored jar with marked carination and engraved design filled with white pigment; highly burnished.

Vasija restaurada con carenación marcada y diseño grabado relleno con pigmento blanco; muy pulido.

La Ponga. Ht. 12 cm. (Mch-15)

211
Carinated bowl with engraved design filled with white pigment; heavy allover black smudging.

Vasija carenada con diseño grabado relleno con pigmento blanco; ahumado denso y negro en toda la superficie.

Clementina. Ht. 10.5 cm. (Mch-18)

212 (Fig. 32)
Restored pedestal bowl with red slip and engraved design filled with white pigment.

Vasija restaurada con pedestal y engobe rojo y diseño grabado relleno con pigmento blanco.

La Ponga. Ht. 11 cm. (Mch-20)

213 (n.i.)
Restored pedestal bowl with everted rim and incised design of harpy eagle crest; patterned burnishing on interior.

Vasija de pedestal restaurada con borde evertido y diseño inciso de la cresta de un águila arpía; interior pulido en zonas.

La Ponga. Ht. 7 cm. (Mch-7)

214
Sharply carinated bowl with engraved design filled with white pigment.

Vasija con carenación aguda con diseño grabado relleno con pigmento blanco.

La Ponga. Ht. 8.3 cm. (Mch-8)

215
Carinated bowl with engraved design.

Vasija carenada con diseño grabado.

La Ponga. Diam. 25.5 cm. (Mch-21)

216
Restored deep bowl with concave side and flaring rim, red slip, and engraved design filled with white pigment.

Vasija profunda restaurada con lados cóncavos y borde saliente, engobe rojo, y diseño grabado relleno de pigmento blanco.

La Ponga. Ht. 9.5 cm. (Mch-24)

217 (Fig. 27)
Black smudged jar with engraved design filled with white pigment.

Vasija ahumada negra con diseño grabado relleno con pigmento blanco.

Rio Blanco, Manabí. Ht. 15.4 cm. (Mch-1)

218 (Fig. 31)
Black burnished sherd with engraved design.

Tiesto negro pulido con diseño grabado.

La Ponga. L. 7.4 cm. (Mch-33)

219
Black sherd from bowl with engraved design filled with white pigment.

Tiesto negro de un cuenco con diseño grabado relleno con pigmento blanco.

La Ponga. L. 7.3 cm. (Mch-156)

220
Restored jar with red-on-tan zoned painting, subsequently smudged.

Vasija restaurada con pintura en zonas roja sobre café, más tarde ahumada.

La Ponga. Ht. 8 cm. (Mch-25)

221 (Fig. 33)
Restored bottle with red-on-tan painted design.

Botella restaurada con diseño de pintura roja sobre café.

La Ponga. Ht. 13 cm. (Mch-9)

222
Bottle with red-on-tan painted design.

Botella con diseño pintado rojo sobre café.

Buenavista. Ht. 15 cm. (Mch-23)

223
Restored carinated bowl with red-on-tan painted design and appliqué bumps around shoulder.

Cuenco carenado restaurado con diseño pintado en rojo sobre café y botones aplicados alrededor del hombro.

Buenavista. Ht. 12 cm. (Mch-16)

224 (Fig. 28)
Carinated jar with red-on-tan painted design and minute notches around shoulder.

Vasija carenada con diseño pintado en rojo sobre café y muescas diminutas alrededor del hombro.

La Ponga. Ht. 5.7 cm. (Mch-29)

225
Jar with red-on-tan painted design.

Vasija con diseño pintado en rojo sobre café.

Machalilla, Manabí. Ht. 16 cm. (Mch-30)

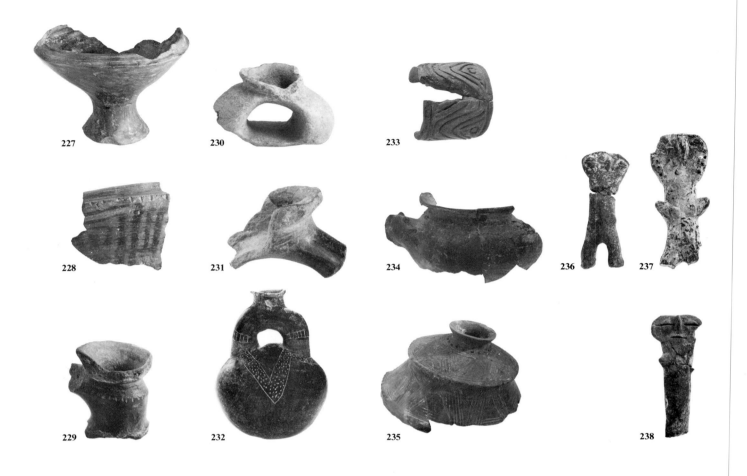

227 230 233

228 231 234 236 237

229 232 235 238

226 (Fig. 29)
Spherical jar with red painted band below rim.

Vasija esférica con franja pintada en rojo bajo el borde.

Loma Alta, J-II. Ht. 24.5 cm. (Mch-31)

227
Incomplete pedestal vase ("compotera").

Vaso de pedestal (compotera), incompleto.

Loma Alta, J-II. Ht. 16 cm. (Mch-12)

228
Red painted and smudged sherd.

Tiesto rojo pintado y ahumado.

La Ponga. L. 6.5 cm. (Collection of D. Lathrap)

229 (cf. Fig. 34 for reconstructed drawing)
Double spout and bridge fragment.

Fragmento de un doble pico con puente.

La Ponga. Ht. 5 cm. (Collection of D. Lathrap)

230 (cf. Fig. 34 for reconstructed drawing)
Stirrup-spout fragment.

Fragmento de un asa de estribo.

La Ponga. Ht. 4.5 cm. (Collection of D. Lathrap)

231
Stirrup-spout fragment.

Fragmento de un asa de estribo.

La Ponga. Ht. 4 cm. (Collection of D. Lathrap)

232
Black smudged stirrup-spout jar with engraved design.

Vasija de asa de estribo ahumada en negro con diseño grabado.

Machalilla-Chorrera transition. Chacras, Manabí. Ht. 16.7 cm. (Mch-127)

233
Ceramic roller stamp.

Sello cilíndrico de cerámica.

La Ponga. W. 5.1 cm. (Mch-31.5)

234
Bowl fragment with bird's head on shoulder; the bird's head has been pushed out from the interior in the manner of some Cerro Narrío ceramics.

Fragmento de una vasija con la cabeza de un ave en el hombro; la cabeza de ave ha sido empujada desde el interior a la manera de algunas cerámicas de Cerro Narrío.

La Ponga. Ht. 6.5 cm. (Mch-34)

235
Fragmentary double-tier jar with incised and pattern-burnished design, and appliqué shoulder bumps.

Vasija de doble forma fragmentada, con diseño inciso y pulido en zonas, y botones aplicadas en el hombro.

La Ponga. Ht. 18.7 cm. (Mch-35)

236
Ceramic figurine with ear perforations.

Figurilla de cerámica con perforaciones en las orejas.

Barcelona. Ht. 10.3 cm. (Mch-144)

237
Ceramic figurine.

Figurilla de cerámica.

Barcelona. Ht. 8.5 cm. (Mch-145)

238
Ceramic figurine.

Figurilla de cerámica.

Barcelona. Ht. 10 cm. (Mch-146)

239 (Fig. 52)
Ceramic figurine with ear perforations.

Figurilla de cerámica con perforaciones en las orejas.

La Ponga. Ht. 11.3 cm. (Mch-147)

240 (n.i.)
Fragment of ceramic figurine with ear perforations.

Fragmento de una figurilla de cerámica con perforaciones en las orejas.

La Ponga. Ht. 5.4 cm. (Mch-141)

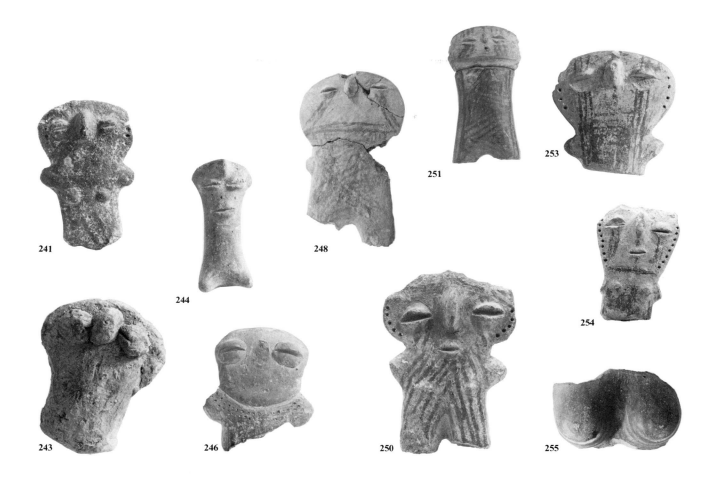

241
Fragment of ceramic figurine.
Fragmento de una figurilla de cerámica.
La Ponga. Ht. 7.8 cm. (Mch-143)

242 (Fig. 52)
Fragment of ceramic figurine with ear perforations.
Fragmento de una figurilla de cerámica con perforaciones en las orejas.
La Ponga. Ht. 4.6 cm. (Mch-142)

243
Fragment of ceramic figurine.
Fragmento de una figurilla de cerámica.
Machalilla, Manabí. Ht. 6.3 cm. (Mch-137)

244
Ceramic figurine.
Figurilla de cerámica.
Machalilla, Manabí. Ht. 5.9 cm. (Mch-138)

245 (n.i.)
Ceramic figurine.
Figurilla de cerámica.
Chacras, Manabí. Ht. 5.2 cm. (Mch-139)

246
Fragment of ceramic figurine.
Fragmento de una figurilla de cerámica.
La Ponga. Ht. 4.5 cm. (Mch-140)

247 (Fig. 52)
Ceramic figurine with red-on-tan painted design.
Figurilla de cerámica con diseño pintado en rojo sobre café.
Barcelona. Ht. 13 cm. (Mch-130)

248
Fragmentary ceramic figurine with red-on-tan painted design.
Figurilla de cerámica fragmentada con diseño pintado en rojo sobre café.
Barcelona. Ht. 14.6 cm. (Mch-131)

249 (Fig. 52)
Fragment of ceramic figurine with red-on-tan painted design and ear perforations.
Fragmento de una figurilla de cerámica con diseño pintado en rojo sobre café y perforaciones en las orejas.
Barcelona. Ht. 10.8 cm. (Mch-132)

250
Fragment of ceramic figurine with red-on-tan painted design and ear perforations.
Fragmento de una figurilla de cerámica con diseño pintado en rojo sobre café y perforaciones en las orejas.
Barcelona. Ht. 10.2 cm. (Mch-133)

251
Ceramic figurine with red-on-tan painted design.
Figurilla de cerámica con diseño pintado en rojo sobre café.
Barcelona. Ht. 13.2 cm. (Mch-134)

252 (n.i.)
Head fragment of ceramic figurine with red-on-tan painted design.
Fragmento de la cabeza de una figurilla de cerámica con diseño pintado en rojo sobre café.
Clementina. Ht. 8 cm. (Mch-135)

253
Head fragment of ceramic figurine with red-on-tan painted design and ear perforations.
Fragmento de la cabeza de una figurilla de cerámica con diseño pintado en rojo sobre café, y perforaciones en las orejas.
Clementina. Ht. 7.6 cm. (Mch-135.5)

254
Ceramic figurine fragment with red-on-tan painted design and ear perforations.
Fragmento de una figurilla de cerámica con diseño pintado en rojo sobre café y perforaciones en las orejas.
Clementina. Ht. 9.3 cm. (Mch-136)

255
Breast fragment from a hollow figurine; red slip and black smudging, approaching iridescent effect.
Fragmento de los pechos de una figurilla hueca; engobe rojo y ahumado negro, con un efecto casi-iridiscente.
Loma Baja. Ht. 4.5 cm. (Mch-32)

256 (Fig. 54)
Hollow figurine with perforations along ear and beneath lower lip; red slip on natural buff paste.
Figurilla hueca con perforaciones a lo largo de la oreja y bajo el labio inferior; engobe rojo sobre pasta amarillenta natural.
Muisne, Esmeraldas. Ht. 20 cm. (Mch-125)

257 (Fig. 36)
Human effigy vessel with red painted design on light colored paste.
Vasija en forma de efigie humana con diseño pintado en rojo sobre pasta de color claro.
Calderón, Manabí. Ht. 18.6 cm. (Mch-124)

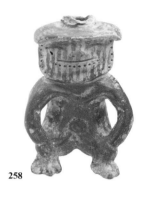

258

262

263

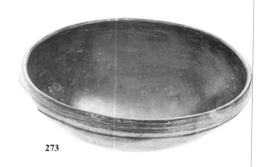

273

260

266

267

269

270

272

260

264 265

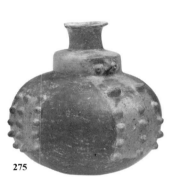

275

261

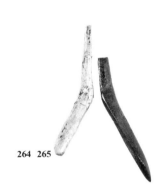

258
Hollow figurine of seated male with red slip, red-on-tan painted design, and perforations along ear and below lower lip.

Figurilla hueca de un hombre sentado con engobe rojo, diseño pintado en rojo sobre café, y perforaciones a lo largo de la oreja y bajo el labio inferior.

Muisne, Esmeraldas. Ht. 12 cm. (Mch-126)

259 (Fig. 62)
Ceramic lime pot in the shape of a reclining woman (?), with perforations along ears and below the lower lip, and punctions on the sides and back.

Olla de cerámica para la cal en forma de una mujer (?) reclinándose, con perforaciones a lo largo de las orejas y bajo el labio inferior, y punteaduras en los lados y espalda.

La Horma. Ht. 7 cm. (Mch-121)

260
Ring-base ceramic lime pot with four faces formed by appliqué and incisions.

Olla de cerámica para la cal con base anillada con cuatro caras formadas por aplicaciones e incisiones.

Guabito, Manabi. Ht. 4 cm. (Mch-122)

261
Ceramic lime pot with near-iridescent design on the interior.

Olla de cerámica para la cal con diseño casi-iridiscente en el interior.

Barcelona. Ht. 3.6 cm. (Mch-123)

262
Eight ceramic beads.

Ocho cuentas de cerámica.

Machalilla, Manabi. Diam. of bead, 1.7 cm. (Mch-148)

263
Shell ornament depicting an animal.

Ornamento de concha representando a un animal.

La Ponga, probably manufactured in Cerro Narrío. L. 2.8 cm. (Mch-128)

264-265
Two harpoon barbs of bone.

Dos púas de arpón de hueso.

Site unknown. L. of 264: 6.3 cm. (Ch-780, 784)

266-272 (268, 271 n.i.)
Seven stone saws.

Siete serruchos de piedra.

Nos. 266-271, La Ponga; 272, site unknown. L. of 266: 7.9 cm. (Mch-149-155)

Ecuadorian Formative: Chorrera Period

273
Bowl with interior iridescent painted designs under imperfectly smudged black ground.

Vasija con diseños pintados iridiscentes en el interior bajo fondo de ahumado negro imperfecto.

Machalilla-Chorrera transition. Miguelillo, Manabi. Diam. 23 cm. (Ch-518)

274 (Fig. 48)
Ceramic neckrest in the shape of an armadillo; black smudging and engraved decoration around rim.

Descanso para la nuca en la forma de un armadillo; ahumado negro y decoración grabada alrededor del borde.

Machalilla-Chorrera transition. Calderón, Manabí. Ht. 9.4 cm. (Ch-42)

275
Effigy jar with modeled face, feet, and bosses, possibly representing an owl; red slip on buff.

Vasija efigie con cara modelada, piés, y protuberancias, posiblemente representando a una lechuza; engobe rojo sobre color amarillento.

Machalilla-Chorrera transition. La Horma, Manabí. Ht. 16.2 cm. (Ch-303)

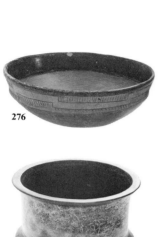

276

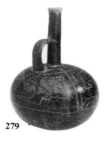

279

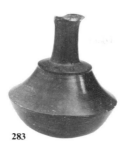

283

277

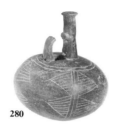

280

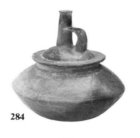

284

286

278

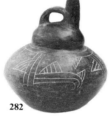

282

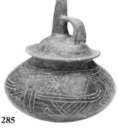

285

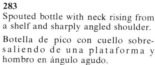

287

276
Bowl with red slip and incised decoration on natural band under rim.

Cuenco con engobe rojo y decoración incisa sobre franja de color natural bajo el borde.

Charapotó, Manabí. Diam. 30 cm. (Ch-543)

277
Deep bowl with flaring base and red bands around rim and base and black resist on intermediary panel.

Cuenco profundo con base saliente y franjas rojas alrededor del borde y base, y pintura negra por resistencia en panel intermediario.

Perú, Manabí. Ht. 12 cm. (Ch-511)

278
Bowl with pedestal base and scalloped rim; red slipped interior and smudged exterior.

Cuenco con base de pedestal y borde ondulando; engobe rojo en el interior y exterior ahumado.

Calderón, Manabí. Diam. 19.5 cm. (Ch-617)

279
Bottle with two whistles, spout and handle, and engraved design; burnished red slip with extensive fire clouds.

Botella con dos silbatos, pico y asa, y diseño grabado; engobe rojo pulido con numerosas manchas de fuego.

Charapotó, Manabí. Ht. 20.5 cm. (Ch-275)

280
Bottle with two whistles, spout and handle, and engraved design filled with white pigment.

Botella con dos silbatos, pico y asa, y diseño grabado relleno de pigmento blanco.

Chacras, Manabí. Ht. 19 cm. (Ch-267)

281 (Fig. 35)
Bottle with two whistles, single spout and handle, red slip, and engraved design filled with white pigment.

Botella con dos silbatos, pico y asa simples, engobe rojo, y diseño grabado relleno con pigmento blanco.

Perú, Manabí. Ht. 29 cm. (Ch-263)

282
Bottle with two whistles and spout and handle rising from a dome-like protuberance; design of engraved lines filled with white pigment includes the harpy eagle crest and claw.

Botella con dos silbatos y pico y asa sobresaliendo de una protuberancia en forma de cúpula; el diseño de lineas grabadas rellenas con pigmento blanco incluye la cresta y garra del. águila arpía.

La Balsita, Manabí. Ht. 19.5 cm. (Ch-252)

283
Spouted bottle with neck rising from a shelf and sharply angled shoulder.

Botella de pico con cuello sobresaliendo de una plataforma y hombro en ángulo agudo.

San Vincente, Manabí. Ht. 20.6 cm. (Ch-283)

284
Whistling vessel with spout and handle rising from a dome-like protuberance on top of a shelf; highly burnished surface with accidental fire clouds and engraved design filled with white pigment.

Botella silbato con pico y asa saliendo de una protuberancia en forma de cúpula sobre una plataforma; superficie muy pulida con manchas de fuego accidentales y diseño grabado relleno de pigmento blanco.

Calderón, Manabí. Ht. 18 cm. (Ch-255)

285
Bottle with two whistles and spout and handle rising from a dome-like protuberance on top of a shelf; burnished surface; the engraved design filled with white pigment includes the harpy eagle crest and claw.

Botella con dos silbatos y pico y asa sobresaliendo de una protuberancia en forma de cúpula sobre una plataforma; superficie muy pulida; el diseño grabado relleno de pigmento blanco incluye la cresta y garra de un águila arpía.

Barranco Blanco, Manabí. Ht. 22.5 cm. (Ch-240)

286
Bowl with red slipped interior; gouged surface decoration on the exterior possibly used as a grater.

Cuenco con interior de engobe rojo; decoración de muescas en la superficie exterior posiblemente usada como un rallador.

Verde, Manabí. Ht. 10 cm. (Ch-552)

287
Bottle with red slip on the spout and all-over fingernail gouging on the body.

Botella con engobe rojo en el pico y muescas hechas con las uñas sobre todo el cuerpo.

María San Plácido, Manabí. Ht. 16.5 cm. (Ch-666)

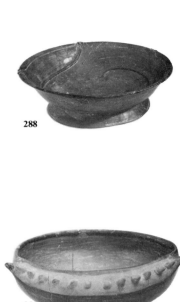

288

291

294

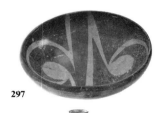

297

289

292

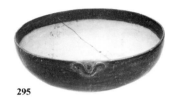

295

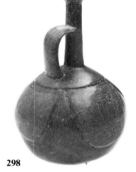

298

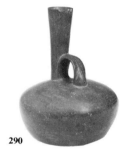

290

293

296

299

288

Bowl with modeled design of snake on interior; central rosette and diamond pattern suggesting a pit viper in iridescent painting.

Plato con diseño modelado de una serpiente en el interior. Motivo central de roseta y diamante que sugiere una víbora en pintura iridiscente.

Chacras, Manabí. Diam. 26 cm. (Ch-546)

289

Bowl with red slip and knobs projecting in a line just below the rim in an unslipped zone.

Cuenco con engobe rojo y protuberancias proyectadas en una linea justamente bajo el borde en una zona sin engobe.

Charapotó, Manabí. Ht. 7 cm. (Ch-474)

290

Whistling bottle with flaring spout and handle and highly polished red slip.

Botella silbato con asa y pico dilatado hacia el borde y con engobe rojo muy pulido.

Perú, Manabí. Ht. 21.4 cm. (Ch-231)

291

Jar with inturned shoulder and flaring rim ("spitoon-shaped"); red and cream slip on exterior.

Vasija con hombro entrante y borde saliente ("forma de escupidera"); engobe rojo crema en el exterior.

Perú, Manabí. Ht. 10.5 cm. (Ch-423)

292

Oval bowl with wide rim flanges at either end and red slip on interior.

Cuenco ovalado con rebordes anchos como asas a cada extremo y engobe rojo en el interior.

Manabí province. L. 27.5 cm. (Ch-356)

293

Shallow pedestal bowl; burnished surface and red-slip disc on interior; stylized bat-wing-and-claw design placed around red disc by shallow incising and rocker stamping; smudging on interior of bowl.

Cuenco llano con pedestal; superficie pulida y disco de engobe rojo en el interior; ala y garras de un murciélago estilizado colocadas alrededor del disco por incisiones ligeras y estampado en zig-zag; ahumado en el interior de la vasija.

Cerro Verde, Manabí. Diam. 32 cm. (Ch-519)

294

Pedestal bowl; dark tan paste with cream horizontal band. The smudged surface of the interior carries a lightly incised spiral design of stylized bat's wings.

Vasija con pedestal; pasta color café oscuro con franja horizontal crema. La superficie ahumada del interior lleva un diseño en espiral ligeramente inciso de las alas de un murciélago estilizado.

Charapotó, Manabí. Diam. 23 cm. (Ch-520)

295

Bowl in the form of a half gourd with red slip and red painted discs on cream paste.

Vasija en forma de la mitad de una calabaza con engobe rojo y discos pintados en rojo sobre pasta crema.

Manabí province. Diam. 17 cm. (Ch-644)

296

Shallow bowl with red and black on buff painting on interior.

Vasija llana con interior pintado en rojo y negro sobre amarillento.

La Balsita, Manabí. Diam. 26.5 cm. (Ch-469)

297

Shallow bowl with red-on-buff painted interior; an exterior dimple below the rim represents the stem attachment of a gourd.

Vasija llana con el interior pintado de rojo sobre amarillento; el hoyuelo exterior bajo el borde representa el punto de inserción del pedúnculo de una calabaza.

La Balsita, Manabí. Diam. 27 cm. (Ch-475)

298

Bottle with two whistles and single spout and handle probably representing a tropical fruit; red-on-buff surface.

Botella con dos silbatos y un solo pico y un asa; rojo sobre superficie amarillenta; probablemente representando una fruta tropical.

La Balsita, Manabí. Ht. 20.5 cm. (Ch-557)

299

Jar with red slip on buff paste with engraved paint-filled design bounding the unslipped zones.

Vasija con engobe rojo sobre pasta amarillenta con diseño grabado relleno de pintura rodeando las zonas sin engobe.

Rio Chico, Manabí. Ht. 12.2 cm. (Ch-433)

300

305

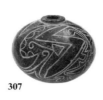

307

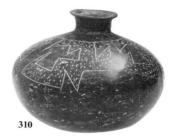

310

301

306

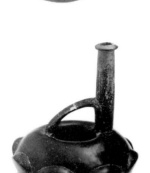

306

304

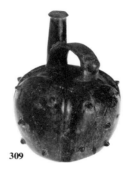

308

309

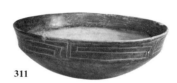

311

300
Bowl with red slip and interior red design on a buff ground with resist decoration.

Vasija con engobe rojo y diseño rojo sobre base amarillenta en el interior con decoración en negativo.

La Irene, Manabí. Diam. 27 cm. (Ch-499)

301
Bowl with interior red and resist-painted black designs on a buff ground.

Vasija con diseños rojos y diseños negros en negativo pintados en el interior sobre una base amarillenta.

Transitional to Bahía. La Balsita, Manabí. Diam. 26.5 cm. (Ch-586)

302 (Fig. 39)
Square vase with overall red slip, white slip painting, and allover smudged resist designs.

Vaso cúbico con engobe rojo total, engobe blanco pintado, diseños ahumados en negativo sobre toda la superficie exterior.

El Limón, Manabí. Ht. 15 cm. (Ch-318)

303 (Fig. 38)
Bowl with red slip and black-resist painting on interior, depicting two lesser anteaters (*Tamandua*) standing on a honeycomb-like base that may represent a beehive or anthill.

Vasija con engobe rojo y diseños negros en negativo en el interior representando dos osos hormigueros (*Tamandua*) parados sobre una base semejante a un panal que posiblemente es un hormiguero o una colmena.

Perú, Manabí. Diam. 19.6 cm. (Ch-539)

304
Jar with sharply carinated shoulder, red slip, and black-organic painted design on shoulder

Vasija con hombro carenado agudamente, engobe rojo, diseño negro-organico pintado sobre el hombro.

Calderón, Manabí. Ht. 9.9 cm. (Ch-386)

305
Square vase with zoned red slip within engraved design.

Vaso cuadrado con engobe rojo en zonas dentro del diseño grabado.

Cerro Verde, Manabí. Ht. 14 cm. (Ch-319)

306
Small jar with red slip and black smudged designs bordered by engraved lines filled with white pigment.

Pequeña vasija con engobe rojo y diseños negros ahumados rodeados por lineas grabadas rellenas con pigmento blanco.

Rio Chico, Manabí. Ht. 5.3 cm. (Ch-308)

307
Miniature jar with red slip and black smudged designs bordered by engraved lines filled with white pigment.

Vasija en miniatura con engobe rojo y diseños negros ahumados rodeados por lineas grabadas rellenas con pigmento blanco.

Manabí province. Ht. 6.7 cm. (Ch-401)

308
Doughnut-shaped whistling vessel with spout and handle, black smudged surface, and red slip.

Vasija silbato de forma anular con pico y asa, superficie ahumada negra, y engobe rojo.

Calderón, Manabí. Ht. 20 cm. (Ch-237)

309
Four-lobed whistling bottle with spout and handle, and modeled lugs, possibly representing a fruit or vegetable; black smudged surface with engraved zones, possibly including iridescent painting.

Botella silbato con cuatro lóbulos, pico y asa y protuberancias modeladas, posiblemente representando a una fruta o vegetal; superficie negra ahumada con zonas grabadas, posiblemente incluyendo pintura iridiscente.

Carrizal, Manabí. Ht. 17.5 cm. (Ch-660)

310
Bottle with red-slipped rim, black-smudged body, and design of engraved lines filled with white pigment.

Botella con engobe rojo en el borde, cuerpo ahumado negro, y diseño de lineas grabadas rellenas de pigmento blanco.

Pinpiquasi, Manabí. Ht. 13.5 cm. (Ch-294)

311
Bowl with geometric incised design on shoulder; reddish tan slip over light tan paste.

Cuenco con diseño geométrico inciso en el hombro; engobe rojizo-café sobre pasta café claro.

El Junco, Manabí. Ht. 10.2 cm. (Ch-364)

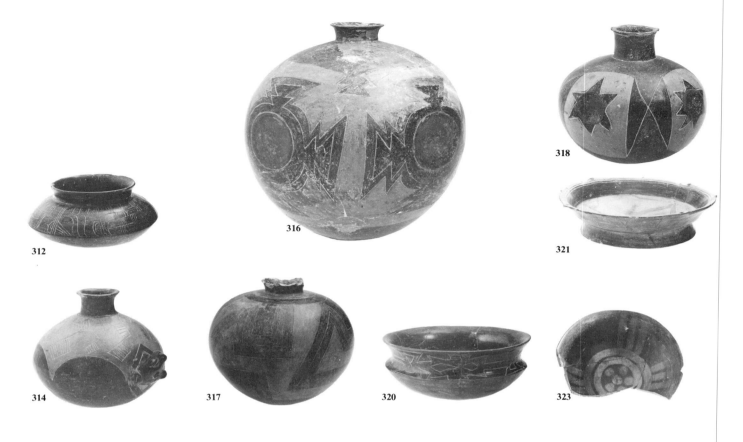

312

316

318

312

314

317

320

321

323

312
Jar with red slip and engraved design filled with white pigment on shoulder.

Vasija con engobe rojo y en el hombro un diseño grabado relleno de pigmento blanco.

Chacras, Manabí. Ht. 6.5 cm. (Ch-405)

313 (Fig. 37)
Whistling bottle with spout and handle, red slip, and smudged resist design on the unslipped surface.

Botella silbato con pico y asa, engobe rojo, y diseño ahumado en negativo en la superficie sin engobe.

Alhajuela, Manabí. Ht. 18.5 cm. (Ch-668)

314
Jar with red slip, low bosses around the shoulder, and engraved geometric designs filled with white pigment on the unslipped buff surface of the upper shoulder; the animal head on the shoulder of the pot is a coati, probably a red coati *(Nasua nasua).*

Vasija con engobe rojo, una representación modelada de un coatí *(Nasua nasua)* en el hombro, y diseños geométricos grabados rellenos con pigmento blanco en la superficie amarillenta sin engobe en la parte superior del hombro.

Chacras, Manabí. Ht. 15.5 cm. (Ch-85)

315 (Fig. 40)
Bottle with two whistles, spout and handle, red slip, and zoned organic black painting bordered by engraved lines.

Botella con dos silbatos, pico y asa, engobe rojo, y pintura negra orgánica en zonas bordeada de líneas grabadas.

Manabí province. Ht. 18.6 cm. (Ch-247)

316
Jar with red and smudged black designs bordered by engraved lines on a buff surface.

Vasija con diseños rojos y negros ahumados rodeados por líneas grabadas en una superficie amarillenta.

La Balsita, Manabí. Ht. 35.5 cm. (Ch-189)

317
Jar with broken rim and red and smudged black designs bordered by engraved lines on a buff surface.

Vasija con borde roto y diseños rojos y negros ahumados rodeados por líneas grabadas en una superficie amarillenta.

Resbalón, Manabí. Ht. 17 cm. (Ch-285)

318
Jar with red slip on light paste with areas of smudging bordered by engraved lines.

Vasija con engobe rojo sobre pasta clara con areas ahumadas rodeadas por líneas grabadas.

La Balsita, Manabí. Ht. 14.6 cm. (Ch-640)

319 (Fig. 41)
Jar with modeled and incised representations of bats on the shoulder; each bat is shown both from the front and in profile, apparently in flight. Bats are smudged black on a red-slipped ground.

Vasija con representaciones modeladas e incisas de murciélagos en el hombro; cada murciélago esta mostrado de frente y de perfil, aparentemente en vuelo. Los murciélagos son de ahumado negro sobre una superficie de engobe rojo.

Alhajuela, Manabí. Ht. 12.5 cm. (Ch-661)

320
Red-slipped bowl with sharply carinated shoulder; a black smudged geometric design bordered with engraved lines circles the vessel between shoulder and rim.

Vasija de engobe rojo con hombros agudamente carenados; un diseño geométrico en ahumado negro bordeado con líneas grabadas rodea la vasija entre el hombro y el borde.

Charapotó, Manabí. Ht. 7.5 cm. (Ch-340)

321
Restored bowl with modeled rim; red slip on exterior and interior of rim, and red on buff surface with engraved borders in interior.

Vasija restaurada con borde modelado; engobe rojo en el exterior e interior del borde, y rojo sobre superficie amarillenta con bordes grabados en el interior.

Miguelillo, Manabí. Diam. 30.5 cm. (Ch-487)

322 (Fig. 76)
Whistling bottle with spout and handle and iridescent painting under black smudging.

Botella silbato con pico y asa y pintura iridiscente bajo ahumado negro.

Manabí province. Ht. 23.5 cm. (Ch-224)

323
Bowl fragment with iridescent painting under black smudging on interior.

Fragmento de una vasija con pintura iridiscente bajo ahumado negro en el interior.

La Ponga. Diam. 19.2 cm. (Ch-671)

324 (Fig. 11)
Bowl with iridescent painting under black smudging on interior and thicker red slip on exterior.

Vasija con pintura iridiscente bajo ahumado negro en el interior y engobe rojo más denso en el exterior.

Manabí province. Diam. 27.5 cm. (Ch-355)

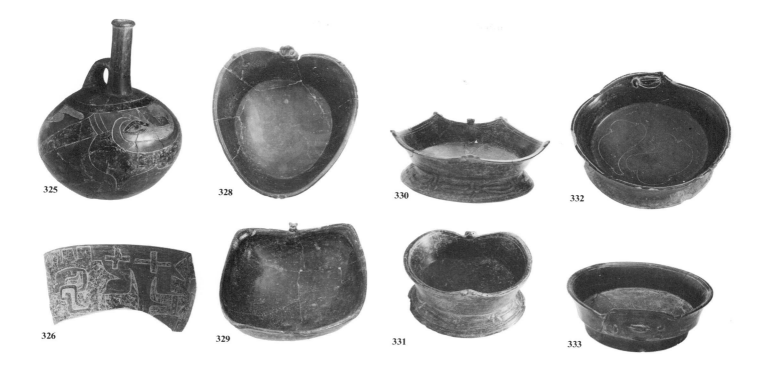

325

Whistling bottle with spout and handle, red slip, and repeat motif of an inverted harpy eagle *(Harpia harpyja)* in red, smudged black, cream slip, and unslipped buff around the shoulders; the colors are bordered by engraved lines filled with white pigment.

Botella silbato con pico y asa, engobe rojo, y motivo repetido de un águila arpía *(Harpia harpyja)* invertida en rojo, negro ahumado, engobe crema, y superficie amarillenta sin engobe alrededor de los hombros; los colores estan rodeados de lineas grabadas rellenas de pigmento blanco.

Chacras, Manabí. Ht. 21.9 cm. (Ch-219)

326 (cf. Fig. 80 for drawing)

Fragment of large jar with two polychrome designs (unslipped buff, red, and smudged black outlined by engraved lines) of stylized harpy eagles *(Harpia harpyja)*.

Fragmento de una vasija grande con dos diseños policromos (amarillento sin engobe, rojo y ahumado negro bordeado por lineas grabadas) de águilas arpías *(Harpia harpyja)* estilizadas.

Ojo de Agua, Manabí. Ht. 12.5 cm. (Ch-655)

327 (Fig. 47)

Bowl with bat's head modeled on rim; the undulating rim and the bowl body represent the bat's outstretched wings. Red slip on exterior and smudged interior with a perforation through the wall of the vessel.

Vasija con la cabeza de un murciélago modelada en el borde; el borde ondulado y el cuerpo de la vasija representan las alas abiertas del murciélago. Engobe rojo en el exterior e interior ahumado; una perforación a través de la pared de la vasija.

La Balsita, Manabí. L. 20 cm. (Ch-357)

328

Heart-shaped bowl depicting a bat, with iridescence under a black smudged surface on the interior. The entire vessel represents the outstretched wings; the rim lugs on each side of the head, the bat's thumbs; and the lug opposite the head, the creature's tail.

Vasija en forma de corazón representando a un murciélago, con pintura iridiscente bajo la superficie ahumada negra en el interior. La vasija completa representa las alas abiertas; los dos lóbulos en el borde a cada lado de la cabeza, los pulgares del murciélago; y lo que está enfrente de la cabeza, la cola del animal.

Cuatro Esquinas, Manabí. L. 26.5 cm. (Ch-353)

329

Bowl with red slip covered by black smudging. The whole vessel depicts a bat: the two rim angles near the head represent the angles (wrists) of the bat's wings; the lug opposite the head, its tail. The modeled body of the bat is perforated through the wall of the vessel.

Vasija con engobe rojo cubierta con ahumado negro. La vasija completa representa a un murciélago; los dos ángulos del borde cerca de la cabeza representan los ángulos de las alas del murciélago; el lóbulo opuesto a la cabeza, su cola. El cuerpo modelado del murciélago esta perforado en la pared de la vasija.

La Irene, Manabí. L. 24 cm. (Ch-485)

330

Red-slipped bowl with incised pedestal base. The bowl depicts a bat with the five-pointed rim representing the bat in flight: starting from the head the first two bumps are the thumbs, the second pair the feet, and the single bump opposite the head is the tail. The broad-line incisions on the pedestal are the harpy eagle crest design.

Vasija de engobe rojo con base de pedestal incisa. La vasija representa a un murciélago con el borde de cinco puntas representando al murciélago en vuelo; comenzando en la cabeza las dos primeras córcovas son los pulgares, el segundo par, los pies, y la córcova única opuesta a la cabeza su cola. Las anchas incisiónes en el pedestal tienen el diseño de la cresta del águila arpía.

Calderón, Manabí. L. 26.5 cm. (Ch-489)

331

Bowl with incised pedestal base; the rim and interior depict a bat; smudged interior and natural exterior.

Vasija con base de pedestal incisa; el borde e interior representan a un murciélago; interior ahumado y exterior natural.

Chacras, Manabí. L. 15.8 cm. (Ch-490)

332

Bowl with modeled bat's face in profile on interior rim and engraved design of bat's wings and claws on interior; the rim represents the bat's wings.

Vasija con el perfil de la cara de un murciélago modelada en el borde interior y diseño grabado de las alas y garras de un murciélago en el interior; el borde representa las alas del murciélago.

La Balsita, Manabí. Diam. 23 cm. (Ch-341)

333

Bowl with modeled bat's head on shoulder, and engraved design of bat's wings and claws on interior.

Vasija con la cabeza de un murciélago modelada en el hombro, y diseño grabado de las alas y garras de un murciélago en el interior.

Chacras, Manabí. Diam. 15 cm. (Ch-352)

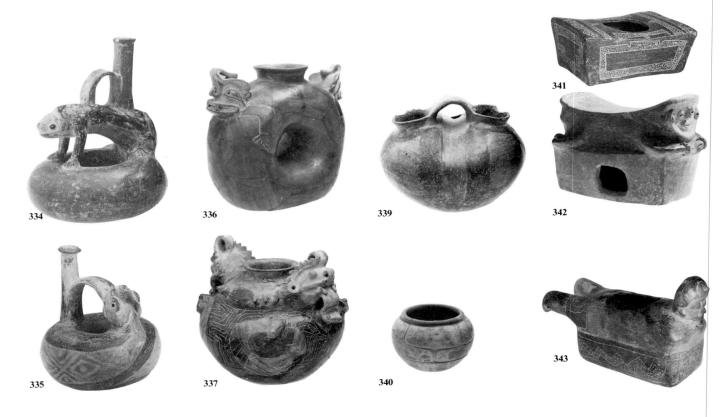

334
335

336
337

339

340

341

342

343

334
Doughnut-shaped bottle with two whistles. The spout and handle rise from the back of an animal, possibly a rodent, which stands on the doughnut; red slip and black organic paint.

Botella de forma anular con dos silbatos. El pico y el asa sobresalen del lomo de un animal, posiblemente un roedor, que está parado sobre el anillo; engobe rojo y pintura negra orgánica.

Chacras, Manabí. Ht. 21 cm. (Ch-13)

335
Spouted bottle with two whistles and doughnut-shaped base; the body depicts a coiled snake, probably a fer-de-lance (*Bothrops*). The snake holds the handle in its mouth; red slip delineates the snake's body, resist painting on natural depicts its back markings, and inlaid bits of obsidian show its eyes.

Botella de pico con dos silbatos y base de forma anular; el cuerpo representa a una serpiente enroscada, probablemente una equis (manapare, jaraca, *Bothrops*). La serpiente sostiene el asa con la boca; engobe rojo delinéa el cuerpo de la serpiente, pintura en negativo sobre el natural representa las marcas del cuerpo, y pedacitos de obsidiana incrustados los ojos.

Manabí province. Ht. 18.5 cm. (Ch-14)

336
Vertical doughnut-shaped jar with red-on-buff slip, resist-painted decoration, and a pair of modeled "Bahía monster" heads and arms.

Vasija de forma de anillo vertical con engobe rojo sobre superficie amarillenta, decoración de pintura en negativo, y un par de cabezas y brazos de "monstruos de Bahía."

Transitional to Bahía. Resbalón, Manabí. Ht. 24.5 cm. (Ch-246)

337
Jar with red and smudged black painting on buff and pair of modeled "Bahía monster" heads, similar to **336**. On the shoulder are designs in red, smudged black (resist) and engraved lines suggesting water swirling about four modeled serpents. Similar serpents are emerging from the mouths of the monsters.

Vasija con pintura roja y ahumado negro sobre pulido y un par de cabezas modeladas de "monstruos Bahía," similar a **336**. Sobre el hombro hay diseños en rojo, ahumado negro (en negativo) y lineas grabadas que sugieren remolinos de agua girando alrededor de cuatro serpientes modeladas. Serpientes similares salen de las bocas de los monstruos.

Transitional to Bahia. Manabí province. Ht. 29.4 cm. (Ch-200)

338 (Fig. 79)
Whistling bottle with spout and bridge attached to a modeled and incised head of a man wearing a turban and nose plug. Stripes of iridescent painting are evident on the body of the pot and post-fired, resin-based crusting is on the head of the effigy. Three air stops produce at least three tones, including a third and a fifth.

Botella silbato con pico y puente unido a una cabeza modelada e incisa de un hombre usando un turbante y un tapón en la nariz. Franjas de pintura iridiscente son evidentes en el cuerpo de la botella y hay una capa post-cocida de base de resina sobre la cabeza de la efigie. Tres agujeros producen por lo menos tres tonos, incluyendo un tercio y un quinto.

Transitional to Bahia. Salaite, Manabí. Ht. 20.7 cm. (Ch-702)

339
Jar with two openings and connecting handle; tan slip on light colored paste in broad-band design.

Vasija con dos aberturas y asa conectante; engobe café y pasta de color claro en el diseño de franja ancha.

La Balsita, Manabí. Ht. 16 cm. (Ch-326)

340
Small jar with incised modeling, red slip, and black smudged rim.

Pequeña vasija con modelado inciso, engobe rojo y borde de ahumado negro.

Transitional to Bahia. Atacames, Esmeraldas. Ht. 6.1 cm. (V-225)

341
Ceramic rectangular neckrest with red slip and engraved design filled with white pigment.

Descanso para el cuello de cerámica rectangular con diseño grabado relleno de pigmento blanco.

Calderón, Manabí. Ht. 6 cm. (Ch-215)

342
Rectangular ceramic neckrest with modeled representations of human faces and arms at either end; red slip.

Descanso para el cuello rectangular de cerámica con representaciones modeladas de rostros y brazos humanos a cada extremo; engobe rojo.

Pueblo Nuevo, Manabí. Ht. 13.6 cm. (Ch-216)

343
Ceramic representation of a man lying on his stomach, with red slip and engraved designs; possibly intended as a neckrest.

Representación en cerámica de un hombre tendido boca abajo, con engobe rojo y diseños grabados; posiblemente destinado como descanso para el cuello.

Chacras, Manabí. Ht. 14 cm. (Ch-179)

344

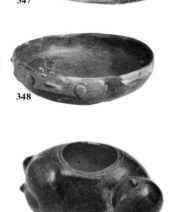

347

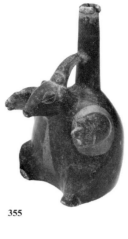

351

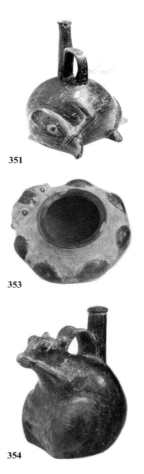

355

345

348

353

350

346

354

356

344

Ceramic representation of a man lying on his stomach, with red slip; possibly intended as a neckrest.

Representación en cerámica de un hombre tendido boca abajo, con engobe rojo; posiblemente destinado como descanso para el cuello.

Manabí province. Ht. 12 cm. (Ch-171.5)

345

Ceramic representation of a man reclining on his back, with red slip and engraved design on base and smudged black on head; possibly intended as a neckrest.

Representación en cerámica de un hombre tendido de espaldas, con engobe rojo y diseño grabado en la base y ahumado negro en la cabeza; posiblemente destinado como descanso para el cuello.

Chacras, Manabí. Ht. 7 cm. (Ch-178)

346

Effigy vessel in the shape of an oval house with thatched roof and log-runged stairway; red slip.

Vasija efigie en la forma de una casa ovalada con techo de paja y escalera formada por escalones de leños; engobe rojo.

Site unknown. Ht. 18.9 cm. (Ch-678)

347

Pedestal bowl with a modeled face, possibly that of an owl; red slip on exterior and black smudging on interior.

Vasija de pedestal con una cara modelada, posiblemente de una lechuza; engobe rojo en el exterior y ahumado negro en el interior.

Chacras, Manabí. Ht. 12 cm. (Ch-347)

348

Bowl with a modeled face, fins, and tail of a fish, the puffer (family Tetraodontidae), below rim; red slip and three pairs of mend holes on bottom indicating ancient repair.

Vasija con una cara modelada, aletas y cola de un pez, el puercoespín (familia Tetraodontidae), bajo el borde; engobe rojo y tres pares de huecos remendados indicando una reparación hecha por los Chorreras.

La Balsita, Manabí. Ht. 6.5 cm. (Ch-338)

349 (Fig. 7)

Whistling bottle in the shape of a dog (possibly Mexican hairless) with spout and bridge attached to head and two whistles; red and white slip and black smudging.

Botella silbato en la forma de un perro (posiblemente el Mexicano sin pelo) con pico y puente unidos a la cabeza y dos silbatos; engobe rojo y blanco y ahumado negro.

Chacras, Manabí. Ht. 27.5 cm. (Ch-11)

350

Effigy vessel probably representing a young coati; black smudged surface.

Vasija efigie probablemente representando un coatí joven; superificie ahumada negra.

Resbalón, Manabí. Ht. 7.5 cm. (Ch-83)

351

Whistling bottle in the shape of a coati, probably the red coati (*Nasua nasua*); with spout and handle, red slip.

Botella silbato en la forma de un coatí (*Nasua nasua*); pico y asa, engobe rojo.

Chacras, Manabí. Ht. 17.5 cm. (Ch-15)

352 (Fig. 87)

Whistling bottle probably representing a kinkajou (the head is that of an opossum and the tail of a kinkajou); spout and handle, and engraved design delineating zones of uncolored iridescent painting.

Botella silbato probablemente representando a un kinkajou (la cabeza es la de una zarigüella y el rabo de un kinkajou); pico y asa, y diseño grabado delineando zonas de pintura iridiscente incolora .

La Horma, Manabí. Ht. 18.5 cm. (Ch-5)

353

Effigy vessel in the shape of a sloth; red slip on mat white. The head and other bosses are pushed out from the interior of the vessel.

Vasija efigie en la forma de un perezoso; engobe rojo sobre blanco mate. La cabeza y otras córcovas fueron empujadas hacia afuera desde el interior de la vasija.

Manabí province. Diam. 13.3 cm. (Ch-79)

354

Whistling bottle probably representing an agouti (*Dasyprocta*), with spout and handle.

Botella silbato en la forma de un agutí (*Dasyprocta*), con pico y asa.

Chacras, Manabí. Ht. 18.5 cm. (Ch-21)

355

Whistling bottle in the shape of the lesser anteater (*Tamandua*), with red slip on tan.

Botella silbato en la forma de un oso homiguero (*Tamandua*), con engobe rojo sobre café.

La Irene, Manabí. Ht. 25 cm. (Ch-7)

356

Whistling bottle in the shape of a screaming spider monkey (*Ateles paniscus*), with spout and handle; red slip.

Botella silbato en la forma de un mono araña (*Ateles paniscus*) chillando, con pico y asa; engobe rojo.

Calderón, Manabí. Ht. 23 cm. (Ch-10)

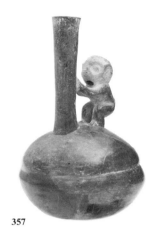

357

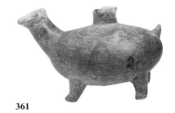

361

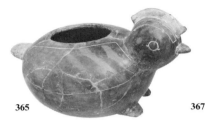

365

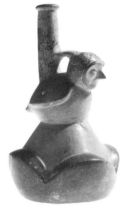

367

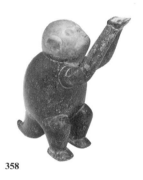

358

364

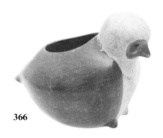

366

357
Effigy bottle in the shape of a young *Cebus* monkey *(Cebus albifrons)* climbing a tree, represented by the spout; the monkey forms the handle of the vessel; red slip.

Botella efigie en la forma de un mono capuchino joven *(Cebus albifrons)* escalando un árbol, representado por el pico; el mono forma el asa de la vasija; engobe rojo.

Resbalón, Manabí. Ht. 28.5 cm. (Ch-9)

358
Whistling bottle in the shape of a wooly monkey *(Lagothrix lagothricha)*; the joined and outstretched hands of the monkey form the spout of the vessel; red slip on body with buff head showing traces of black smudging.

Botella silbato en la forma de un mono lanudo *(Lagothrix lagothricha)*; las manos unidas y alzadas del mono forman el pico de la vasija; engobe rojo con la cabeza amarillenta y mostrando trazas de ahumado negro.

Calderón, Manabí. Ht. 23 cm. (Ch-23)

359 (Fig. 45)
Three-toned whistling bottle in the shape of a spider monkey, with single spout and handle attached to monkey's head; red slip on body and traces of black smudging on face.

Botella silbato de tres tonos musicales en la forma de un mono araña, con simple pico y asa unidos a la cabeza del mono; engobe rojo en el cuerpo y trazas de ahumado negro en la cara.

La Balsita, Manabí. Ht. 17 cm. (Ch-8)

360 (Fig. 58)
Effigy vessel in the form of a reclining *Cebus* monkey scratching itself; white slip.

Vasija efigie en forma de un mono capuchino reclinado, rascándose; engobe blanco.

Calderón, Manabí. Ht. 9 cm. (Ch-3)

361
Effigy vessel, possibly intended to be in the shape of a llama; red on buff with black organic paint outlining buff areas.

Vasija efigie, posiblemente intentando tener la forma de una llama; rojo sobre color amarillento con pintura negra orgánica delineando las áreas amarillentas.

Pinpiquasi, Manabí. Ht. 14 cm. (Ch-24)

362 (Fig. 67)
Spouted effigy vessel in the shape of a fantastic animal, with the head of a toad; the legs terminate in heads of raptorial birds (birds of prey) or, more probably, sea lions; buff slip and black organic paint.

Vasija efigie con pico en la forma de un animal fantástico, con la cabeza de un sapo; las patas terminadas en cabezas de aves de rapiña o, aún más probablemente, lobos marinos; engobe amarillento con pintura negra orgánica.

Rio Chico, Manabí. Ht. 16 cm. (Ch-555)

363 (Fig. 83)
Effigy vessel in the form of a grotesque animal with bloated body and menacing teeth, possibly representing a jaguar; buff body and red slip on mouth and rim.

Vasija efigie en la forma de un animal grotesco con cuerpo hinchado y dientes amenazadores, posiblemente representando a un jaguar; rojo sobre amarillento.

Chacras, Manabí. Ht. 16.5 cm. (Ch-96)

364
Whistling bottle in the shape of a freetail bat (family Molossidae); spout and handle; red on buff.

Botella silbato en la forma de un murciélago con la cola libre (familia Molossidae); pico y asa; rojo sobre amarillenta.

La Horma, Manabí. Ht. 26 cm. (Ch-88)

365
Effigy vessel in the shape of a bird, probably a wood quail *(Odontophorus)* ; red slip and resist painted designs on body and head.

Vasija efigie en la forma de un ave, probablemente un gallito *(Odontophorus)*; engobe rojo y diseño de pintura en negativo sobre la cabeza y el cuerpo.

Manabí province. Ht. 14.5 cm. (Ch-17)

366
Effigy vessel in the shape of a spectacled owl *(Pulsatrix perspicillata)*; white and red slip.

Vasija efigie en la forma de un buho de anteojos *(Pulsatrix perspicillata)*; blanco sobre engobe rojo.

La Balsita, Manabí. Ht. 14.5 cm. (Ch-629)

367
Whistling bottle in the shape of a barn owl *(Tyto alba)*, possibly sitting on a hilltop; spout and handle; red and buff painted surface.

Botella silbato en la forma de una lechuza *(Tyto alba)*, posiblemente sentada sobre la cima de una colina; pico y asa y superficie pintada en rojo sobre color amarillento.

La Horma, Manabí. Ht. 24 cm. (Ch-22)

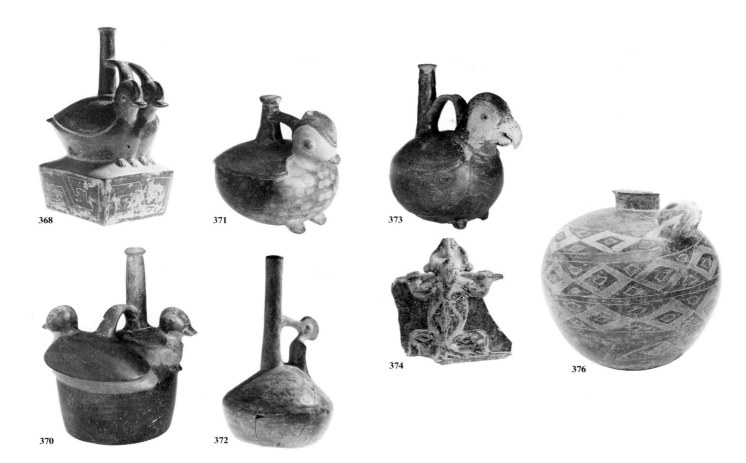

368

371

373

370

372

374

376

368

Bottle with two whistles, a spout, and handles attached to the heads of two birds, probably wood quail (*Odontophorus*), sitting on a rectangular base; red and white slip, geometric engraved design on the base cutting through to underlying white slip.

Botella con dos silbatos, un pico, y asas unidas a las cabezas de dos aves, probablemente gallitos (*Odontophorus*) sentados en una base rectangular; engobe rojo y blanco, diseño geométrico grabado en la base cortando hasta la capa anterior de engobe blanco.

La Balsita, Manabí. Ht. 26.5 cm. (Ch-86)

369 (Fig. 59)

Bottle with two whistles, spout and handle; the body of the vessel in the shape of a macaw sitting on top of a tri-lobed base formed of pods of a *guabo* tree of the genus *Inga* (probably *Inga balaensis* or *Inga eggersii*); red slip and black smudging.

Botella con dos silbatos, pico y asa; el cuerpo de la vasija en forma de un guacamayo sentado sobre el tope de una base de tres lóbulos formados por vainas de guabo, árbol del género *Inga* (probablemente *Inga balaensis* o *Inga eggersii*); engobe rojo y ahumado negro.

Resbalón, Manabí. Ht. 20.5 cm. (Ch-6)

370

Bottle with two whistles, spout and handle; the body of the pot in the shape of two ducks; red and buff painted surface.

Botella con dos silbatos, pico y asa; el cuerpo de la vasija en la forma de dos patos; superficie roja y amarillenta pintada.

La Horma, Manabí. Ht. 26.5 cm. (Ch-90)

371

Whistling bottle with spout and handle in the shape of a bird, probably a wood quail (*Odontophorus*); buff, red slip, and black smudging with resist design on breast.

Botella silbato con pico y asa en la forma de un ave, probablemente un gallito (*Odontophorus*); amarillento, engobe rojo, y ahumado negro con diseño en negativo en el pecho.

Manabí province. Ht. 12.3 cm. (Ch-92)

372

Whistling bottle; the spout represents a tree and a woodpecker forms the handle; red slip.

Botella silbato; el pico representa a un árbol y un pájaro carpintero forma el asa; engobe rojo.

La Balsita, Manabí. Ht. 26 cm. (Ch-16)

373

Whistling bottle with spout and handle in the shape of a macaw; overall red slip and white slip with punctations on face.

Botella silbato con pico y asa en la forma de un guacamayo; engobe rojo total con engobe blanco y puntaciones en rostro.

La Horma, Manabí. Ht. 21 cm. (Ch-4)

374

Fragment of the neck of a large jar; a lizard-like creature with the head of the "Bahía monster" is climbing up the outside of the rim and looking into the jar. Overall red slip and organic black paint on natural surface of the creature.

Fragmento del cuello de una vasija grande; un animal parecido a un lagarto con una cabeza de un "monstruo Bahía" está trepando por la parte exterior del borde y mirando hacia adentro de la vasija. Engobe rojo total y pintura orgánica negra sobre la superficie natural del animal.

Ojo de Agua, Manabí. Ht. 13 cm. (Ch-656)

375 (Figs. 74 and 88)

Effigy jar with a modeled representation of a laughing falcon (*Herpetotheres cachinnans*) holding in its beak and claws a snake, probably a fer-de-lance (*Bothrops*); red slip, smudged black on buff and engraved lines; the snake's eyes are inlaid with obsidian.

Vasija efigie con representación modelada de un halcón vaquero (*Herpetotheres cachinnans*) sosteniendo una serpiente con su pico y garras, probablemente una serpiente equis (manapare, jaraca, *Bothrops*); engobe rojo, ahumado negro sobre color amarillento y líneas grabadas; los ojos de la serpiente estan incrustados con obsidiana.

Manabí province. Ht. 27.5 cm. (Ch-197)

376

Effigy jar with a modeled and painted snake, probably a fer-de-lance (*Bothrops*), coiled around the body of the pot; red slip and smudged black on buff and engraved lines; the snake's eyes are inlaid with obsidian.

Vasija efigie con serpiente modelada y pintada, probablemente una serpiente equis (manapare, jaraca, *Bothrops*), enrollada alrededor del cuerpo de la vasija; engobe rojo y ahumado negro sobre color amarillento y lineas grabadas; los ojos de la serpiente estan incrustados con obsidiana.

Calderón, Manabí. Ht. 29.9 cm. (Ch-192)

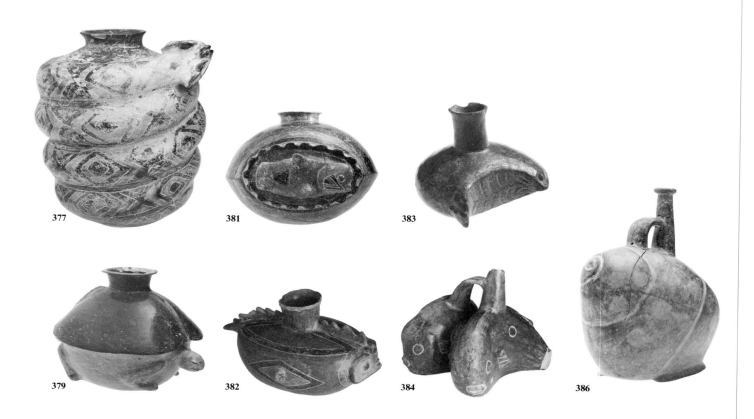

377

379

381

383

382

384

386

377
Effigy jar with a modeled and painted snake, possibly a bushmaster *(Lachesis)*, encircling the body of the pot; red slip and smudged black on buff, engraved lines.

Vasija efigie con una serpiente modelada y pintada, posiblemente una cascabela muda (cuaima, suracucu, *Lachesis)*, rodeando el cuerpo de la vasija; engobe rojo y ahumado negro sobre color amarillento, lineas grabadas.

Chacras, Manabí. Ht. 30 cm. (Ch-187)

378 (Fig. 42)
Restored effigy vessel in the shape of a land turtle; black smudged surface with engraving filled with white pigment. The left rear claw fragment is unsmudged, the result of an accidental refiring of that portion after the vessel had been broken.

Vasija efigie restaurada en la forma de una tortuga terrestre; superficie ahumada negra con grabados rellenos con pigmento blanco. El fragmento donde se encuentra la garra posterior izquierda no está ahumada, como resultado de una recocción accidental de este pedazo de la vasija después de rota.

La Ponga. Ht. 6.7 cm. (Ch-604)

379
One of a pair (with **380**) of nearly identical effigy vessels in the shape of marine turtles found in the same grave; red slip on buff. This is the only example of duplicate forms that has been noted as yet among the Chorrera effigy vessels.

Parte de una pareja (con **380**) de vasijas efigie casi idénticas en la forma de tortugas marinas encontradas en la misma tumba; engobe rojo sobre color amarillento. Este es el único ejemplo de formas duplicadas que sabemos ha sido encontrado hasta ahora entre las vasijas efigies de Chorrera.

Chacras, Manabí. Ht. 18 cm. (Ch-97)

380 (Fig. 10)
Turtle effigy vessel, mate to **379**; red slip on buff.

Vasija efigie de una tortuga, compañera de **379**; engobe rojo sobre color amarillento.

Chacras, Manabí. Ht. 16 cm. (Ch-98)

381
Effigy jar with a modeled and painted representation of a fish, the bumphead wrasse *(Bodianus eclancheri)*, on either side of the vessel; red slip with black organic paint bounded by engraved lines.

Vasija efigie con representación modelada y pintada de un pez, loberos o vieja *(Bodianus eclancheri)*, en ambos lados de la vasija; engobe rojo con pintura negra orgánica rodeada de lineas grabadas.

Calderón, Manabí. L. 34.6 cm. (Ch-191)

382
Effigy jar in the form of a puffer or burr fish (family *Tetraodontidae)*; red slip and black smudge on buff; engraved lines.

Vasija efigie en la forma de un pez, puercoespín (familia *Tetraodontidae)*; engobe rojo y ahumado negro sobre el pez; lineas grabadas.

Miguelillo, Manabí. Ht. 9.5 cm. (Ch-58)

383
Effigy jar in the shape of a shrimp-like creature; spout, red slip.

Vasija efigie en la forma de ser de forma de camarón; pico, engobe rojo.

Calderón, Manabí. Ht. 9 cm. (Ch-78)

384
Whistling bottle with spout and handle, modeled to represent a pair of cichlid fish *(Aequidens)*; burnished surface and deeply engraved lines.

Botella silbato con pico y asa, modelado representando un par de peces, sarra o chusco *(Aequidens)*; superficie pulida y lineas grabadas profundamente.

Bejuco de Junín, Manabí. Ht. 14 cm. (Ch-65)

385 (Fig. 1)
Effigy jar with modeled crab at the top and painted and incised designs on the body representing the eye, crest and claw of the harpy eagle *(Harpia harpyja)*; red and white on natural and smudged black.

Vasija efigie con cangrejo modelado en el tope y un diseño inciso pintado repetido dos veces en el cuerpo representando el ojo, cresta y garra del águila harpía *(Harpia harpyja)*; colores rojo y blanco sobre natural y negro ahumado.

Alhajuela, Manabí. Ht. 30.5 cm. (Ch-564)

386
Whistling bottle with spout and handle representing a snail, possibly inspired by a marine snail similar to *Polinices*; black resist on buff.

Botella silbato con pico y asa representando a un caracol, posiblemente inspirado por una caracol marino similar a *Polinices*; negativo negro sobre amarillento.

Loma Rita, Manabí. Ht. 23.5 cm. (Ch-232)

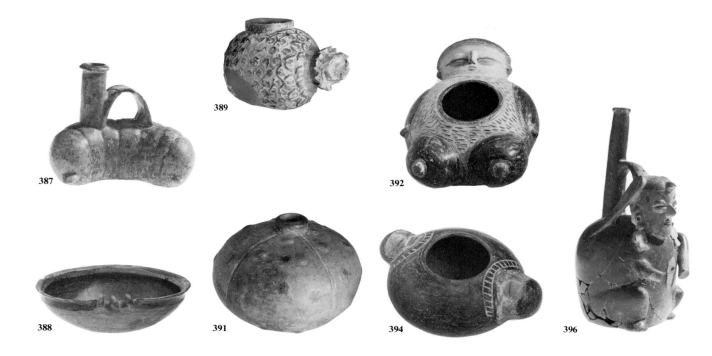

387

Bottle with two whistles, single spout and handle, red slip, and body in the shape of a palm grub. The grub is the larva of the snout beetle (*Rhynchophorus*) that lays its eggs in the rotting trunks of certain palm trees. These grubs reach a maximum length of 7 cm.

Botella con dos silbatos, simple pico y asa, y engobe rojo; el cuerpo de la vasija es en forma de una larva. Esta es la larva de un escarabajo del género *Rhynchophorus* que deposita sus huevos en los troncos en descomposición de ciertas palmas. Estas larvas alcanzan un largo máximo de 7 cm.

Cuatro Esquinas, Manabí. L. 17.5 cm. (Ch-1)

388

Effigy bowl, the shape possibly inspired by a *Spondylus* shell; red slip on buff.

Cuenco efigie, la forma posiblemente inspirada por una concha *Spondylus*; engobe rojo sobre color amarillento.

Cerro Verde, Manabí. Ht. 7.5 cm. (Ch-468)

389

Restored effigy jar in the shape of a pineapple; red slip on buff.

Vasija efigie restaurada en la forma de una piña; engobe rojo sobre color amarillento.

La Ponga. Ht. 10.8 cm. (Ch-677)

390 (Fig. 44)

Restored bottle with two whistles, spout and handle, the body of the pot in the shape of a bottle gourd (*Lagenaria siceraria*); black smudging over zoned iridescence and engraved design filled with white pigment.

Botella restaurada con dos silbatos, pico y asa, el cuerpo de la vasija en la forma de una calabaza (*Lagenaria siceraria*); ahumado negro sobre pintura iridiscente en zonas y diseño grabado relleno con pigmento blanco.

La Balsita, Manabí. Ht. 24 cm. (Ch-229)

391

Effigy jar in the form of a winter squash (*Cucurbita maxima*); red slip on buff.

Vasija efigie en la forma de un calabaza (*Cucurbita maxima*); engobe rojo sobre color amarillento.

La Irene, Manabí. Ht. 11.5 cm. (Ch-322)

392

Effigy vessel in the shape of a human reclining on its back with head and mammiform legs pushed out from the interior; red slip and smudging on light mat background.

Vasija efigie en la forma de un humano tendido de espaldas con cabeza y piernas mamiformes presionadas hacia afuera desde el interior; engobe rojo y ahumado sobre fondo mate.

Resbalón, Manabí. Ht. 10 cm. (Ch-174)

393 (Fig. 43)

Effigy jar depicting a man reclining on his back, with white slip on the face and body; head and legs are punched out from the interior.

Vasija efigie representando a un hombre tendido de espaldas, con engobe blanco en la cara y el cuerpo; la cabeza y las piernas fueron presionadas hacia afuera desde el interior.

La Balsita, Manabí. Ht. 9 cm. (Ch-195)

394

Effigy bowl with a human head represented at opposite sides of the bowl; red slip, black smudging on buff, engraved lines filled in with white pigment, and postfired, resin-based limonite paint on the faces.

Vasija efigie con una cabeza humana representada en lados opuestos de la vasija; engobe rojo, ahumado negro sobre color amarillento, lineas grabadas rellenas con pigmento blanco, y post-cocción, pintura limonita con base de resina en las caras.

Manabí province. Ht. 7.5 cm. (Ch-151)

395 (Fig. 8)

Whistling bottle with spout and handle (broken) and body in the shape of a man seated in a reed boat (*balsita*); red slip and black smudging on buff and incised lines filled with white pigment.

Botella silbato con pico y asa (rota), el cuerpo de la vasija en la forma de una balsita de juncos (totora); engobe rojo y ahumado negro sobre color amarillento y lineas incisas rellenas con pigmento blanco.

Charapotó, Manabí. Ht. 24.5 cm. (Ch-165)

396

Whistling bottle in the shape of a seated man wearing elaborate ear spools from which hang pendants; red slip and smudging on buff.

Botella silbato en la forma de un hombre sentado llevando orejeras elaboradas de donde cuelgan pendientes; engobe rojo y ahumado en color amarillento.

El Junco, Manabí. Ht. 27 cm. (Ch-149)

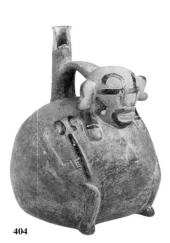

403

397

400

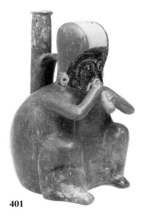

401

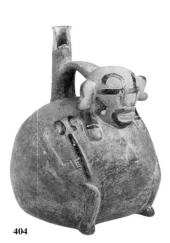

404

397
Whistling bottle in the shape of a seated man carrying on his back a burden, out of which rise the spout and handle, supported by means of a tumpline slung from his forehead; two whistles, red slip and black organic paint on buff.

Botella silbato en la forma de un hombre sentado llevando una carga en la espalda, de la cual salen el pico y el asa, sujetada por medio de una faja a través a su frente; dos silbatos, engobe rojo y pintura negra orgánica sobre color amarillento.

La Balsita, Manabí. Ht. 31.6 cm. (Ch-605)

398 (Fig. 86)
Whistling bottle in the form of a seated man with hands bound behind his back; two whistles, red slip on buff.

Botella silbato en la forma de un hombre sentado con las manos atadas detrás de la espalda; dos silbatos, engobe rojo sobre color amarillento.

Resbalón, Manabí. Ht. 26.5 cm. (Ch-173)

399 (Fig. 60)
Effigy vessel in the shape of a seated human with a tumpline with textile design carried across the head and on the pack; red on brown with white slip and resist black on cream.

Vasija efigie en la forma de un humano sentado con una faja de cargar con diseños de tejidos llevandolo sobre la frente y en la carga; rojo sobre café con engobe blanco y negativo negro sobre crema.

Chacras, Manabí. Ht. 13 cm. (Ch-160)

400
Whistling bottle in the shape of a man playing a flageolet; two whistles; red slip except on face and flageolet.

Botella silbato en la forma de un hombre tocando un octavín; dos silbatos; engobe rojo a excepción de la cara y el octavín.

Chacras, Manabí. Ht. 17.5 cm. (Ch-162)

401
Whistling bottle in the shape of a man playing a flageolet; red on buff with a thick black organic paint.

Botella silbato en la forma de un hombre tocando un octavín; rojo sobre color amarillento con una densa pintura orgánica negra.

Calderón, Manabí. Ht. 22 cm. (Ch-159)

402 (Fig. 55)
Whistling bottle with spout and handle in the shape of a seated man; red slip and black smudging on buff with overall rocker stamping possibly intended to suggest a skin disease. The unfortunate man also has a split lip, which may represent a harelip or an ulcer caused by the disease leishmaniasis *(uta)*; one eye missing; a torn ear; a clubfoot; a withered arm possibly from a birth injury; an umbilical hernia; and a humpback. His "sabre shins" are a common manifestation of syphilis. His numerous wart-like nodules may indicate the presence of the disease verruga peruana, or possibly leishmaniasis, mentioned above; both these diseases are transmitted by the bite of sandflies.

Botella silbato con pico y asa en la forma de un hombre sentado; engobe rojo y ahumado negro sobre amarillento con estampado en zigzag en toda la superficie, posiblemente intentando sugerir una enfermedad de la piel. Este desafortunado hombre además tiene un labio partido, que puede representar que es labihendido o tiene una úlcera causada por la enfermedad leishmaniasis *(uta)*; le falta un ojo; una oreja desgarrada; un pie torcido; un brazo atrofiado posiblemente debido a un daño causado al nacer; una hernia umbilical; y una joroba. Sus espinillas agudas son una típica manifestación de sífilis. Sus numerosas verrugas indican la presencia de la enfermedad verruga peruana, o posiblemente leishmaniasis, mencionada anteriormente; ambas enfermedades son transmitidas por la picada de dos diferentes moscas de los arenales.

Calderón, Manabí. Ht. 26 cm. (Ch-167)

403
Bowl with bold rocker stamping and red slip on buff.

Cuenco con audaz estampado en zigzag y engobe rojo sobre color amarillento.

La Balsita, Manabí. Diam. 20 cm. (Ch-603)

404
Whistling bottle with spout and handle in the shape of a seated male who holds a mace-like staff; he is shown with face painting, ear ornaments with long tassels, and a pendant; two whistles, red slip, and black organic paint.

Botella silbato con pico y asa en la forma de un hombre sentado quien sostiene una vara en forma de maza; él está presentado con pinturas en la cara, ornamentos en las orejas con largas borlas, y un pendiente; dos silbatos, engobe rojo, y pintura negra orgánica.

Perú, Manabí. Ht. 18.5 cm. (Ch-161)

405 (Fig. 84)
Effigy vessel in the shape of an acrobat performing a back-bend; he wears an ornament in his nose; zoned red slip on buff.

Vasija efigie en la forma de un acróbata haciendo una arqueadura de espaldas; lleva un ornamento en la nariz; engobe rojo en zonas sobre color amarillento.

Chacras, Manabí. Ht. 13.5 cm. (Ch-172)

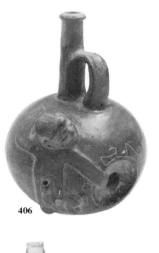

406

408

413

414

415

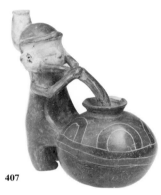

407

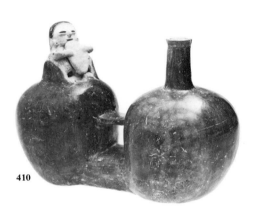

410

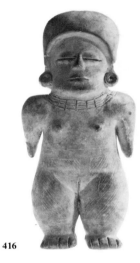

416

406
Whistling bottle with spout and handle, and a modeled and engraved representation of a man on the shoulder of the bottle.

Botella silbato con pico y asa, y una representación modelada y grabada de un hombre en el hombro de la botella.

Calderón, Manabí. Ht. 17 cm. (Ch-12)

407
Whistling bottle in the shape of a man, with spout attached to the back of his head; he apparently is drawing a liquid or a vapor out of a pot; the curious manner in which the tubes seem to extend to the ears may possibly indicate the use of medicinal herbs or drugs; two whistles, red slip and black smudging on buff.

Botella silbato en la forma de un hombre, con pico unido a la parte trasera de su cabeza; aparentemente esta sorbiendo un líquido o vapor de una vasija; la manera curiosa en la que los tubos parecen extenderse hasta las orejas puede indicar posiblemente el uso de hierbas medicinales o drogas; dos silbatos, engobe rojo y ahumado negro sobre color amarillento.

Río Verde, Manabí. Ht. 22.5 cm. (Ch-166)

408
Fragment of a whistling vessel containing the whistle, in the shape of a man playing panpipes; red slip with black smudging.

Fragmento de una vasija silbato conteniendo el silbato, en la forma de un hombre tocando flautas de Pan (rondador); engobe rojo con ahumado negro.

Playa Prieta, Manabí. Ht. 6.5 cm. (Ch-680)

409 (Fig. 46)
Whistling vessel (similar to **410**) consisting of two bottles joined by a bridge at the top and a hollow tube at the bottom with a spout on top of one bottle and a man playing panpipes on top of the other; two whistles and two additional stops; red slip and black smudging on buff.

Vasija silbato (similar a **410**) que consiste de dos botellas unidas por un puente cerca del tope y un tubo hueco cerca de la base con un pico en el tope de una de las botellas y un hombre tocando flautas de Pan (rondador) en el tope de la otra; dos silbatos y dos agujeros adicionales para modular los tonos; engobe rojo y ahumado negro sobre superficie amarillenta.

Manabí province. Ht. 18.4 cm. (Ch-209)

410
Double-toned whistling vessel (similar to **409**) consisting of two bottles joined by a bridge at the top and a hollow tube at the bottom with a spout on top of one bottle and a man playing panpipes on top of the other; two whistles differently pitched; red slip and black resist smudging on buff.

Vasija silbato de doble-tono (similar a **409**) consistiendo de dos botellas unidas por un puente cerca del tope y un tubo hueco cerca de la base con un pico en el tope de una de las botellas y un hombre tocando flautas de Pan (rondador) en el tope de la otra; dos silbatos de diferente tono; engobe rojo con ahumado negro en negativo sobre amarillo.

Manabí province. Ht. 19.5 cm. (Ch-612)

411 (Fig. 69)
Effigy jar in the shape of a man wearing large napkin-ring ear spools; red slip and black smudging on buff.

Vasija efigie en la forma de un hombre llevando grandes orejeras en forma de aros de servilletas; engobe rojo y ahumado negro sobre superficie amarillenta.

Resbalón, Manabí. Ht. 25.6 cm. (Ch-158)

412 (Fig. 71)
Fragment of the head and neck of a hollow figurine; red and cream slip and black paint (?) with ground-out circles inlaid with white paint. The painted designs represent body painting.

Fragmento de una cabeza y cuello de una figurilla hueca; engobe rojo y crema y pintura negra (?) con círculos raspados e incrustados con pintura blanca. Los diseños pintados representan pinturas del cuerpo.

La Ponga. L. 9.8 cm. (Ch-679)

413-415
Three potting tools made from potsherds.

Tres instrumentos usados en alfarería hechos de tiestos.

*La Ponga. L. of **413**: 6.5 cm. (Mch-36a,b,c)*

416
Hollow figurine of standing nude woman wearing ear spools and neck ornament; red slip with black smudging, and engraved designs representing body painting.

Figurilla hueca de una mujer parada desnuda llevando orejeras y ornamento en el cuello; engobe rojo con ahumado negro, diseños grabados representando pintura en el cuerpo.

Junín, Manabí. Ht. 33.5 cm. (Ch-245)

423

425

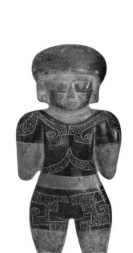

419

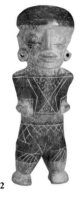

421

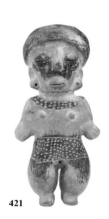

422

424

426

417 (Fig. 78)
Hollow figurine of a standing nude woman with ear spools; red and cream slip with black smudging and engraved designs.

Figurilla hueca de una mujer parada desnuda con orejeras; engobe rojo y crema con ahumado negro y diseños grabados.

Pinpiquasi, Manabí. Ht. 41.5 cm. (Ch-115)

418 (Fig. 72)
Hollow figurine of a standing woman with ear spools and painted and engraved designs representing face and body painting, or possibly a patterned textile; red slip on buff with engraved design filled with white pigment.

Figurilla hueca de una mujer parada con orejeras y diseños pintados y grabados representando pinturas en la cara y el cuerpo, o posiblemente tejidos con diseños; engobe rojo sobre amarillo con diseño grabado relleno con pigmento blanco.

La Balsita, Manabí. Ht. 34.5 cm. (Ch-112)

419
Hollow figurine of a standing woman with ear spools and painted and engraved designs representing face and body painting, or possibly a patterned textile costume; red slip and smudged black with engraved designs filled with white pigment.

Figurilla hueca de una mujer parada con orejeras y diseños pintados y grabados representando pinturas en la cara y el cuerpo, o posiblemente un traje de un tejido adornado; engobe rojo y ahumado negro con diseños grabados rellenos con pigmento blanco.

Chacras, Manabí. Ht. 32 cm. (Ch-113)

420 (Fig. 49)
Hollow figurine of a standing nude man with large, circular ear spools, face painting and body painting; red slip with black smudging on buff and engraved design filled with white pigment.

Figurilla hueca de un hombre parado desnudo con grandes orejeras circulares, pintura en la cara y el cuerpo; engobe rojo con ahumado negro sobre superficie amarillenta y diseño grabado relleno con pigmento blanco.

Cerro Verde, Manabí. Ht. 29.5 cm. (Ch-116)

421
Hollow figurine of a standing nude woman with large, circular ear spools, face and body painting; red slip with black smudging on buff and engraved designs filled with white pigment.

Figurilla hueca de una mujer parada desnuda con grandes orejeras circulares, pintura en la cara y el cuerpo; engobe rojo con ahumado negro sobre superficie amarillenta y diseños grabados rellenos de pigmento blanco.

Chacras, Manabí. Ht. 22.4 cm. (Ch-122)

422
Hollow figurine of standing nude woman with large ear spools and body painting; red slip on buff with engraved designs filled with white pigment.

Figurilla hueca de una mujer parada desnuda con grandes orejeras circulares y pintura en el cuerpo; engobe rojo sobre superficie amarillenta con diseños grabados rellenos con pigmento blanco.

Chacras, Manabí. Ht. 22 cm. (Ch-103)

423
Solid figurine of seated nude person; red slip on buff.

Figurilla maciza de una persona sentada desnuda; engobe rojo sobre superficie amarillenta.

Miguelillo, Manabí. Ht. 14.9 cm. (Ch-131)

424
Solid figurine of seated nude person; red post-fired crusting with black smudging on buff.

Figurilla maciza de una persona sentada desnuda; capa roja post-cocida con ahumado negro sobre superficie amarillenta.

Resbalón, Manabí. Ht. 9.5 cm. (Ch-106)

425
Solid figurine of a standing nude person with braided hair, holding a small animal, probably a guinea pig; unslipped.

Figurilla maciza de una persona parada desnuda con cabello trenzado, sujetando un pequeño animal probablemente un conejillo de Indias (cui); sin engobe.

San Isidro, Manabí. Ht. 13.9 cm. (Ch-134)

426
Incomplete solid figurine of standing nude person; unslipped.

Figurilla maciza incompleta de una persona parada desnuda; sin engobe.

San Isidro, Manabí. Ht. 8 cm. (Ch-143)

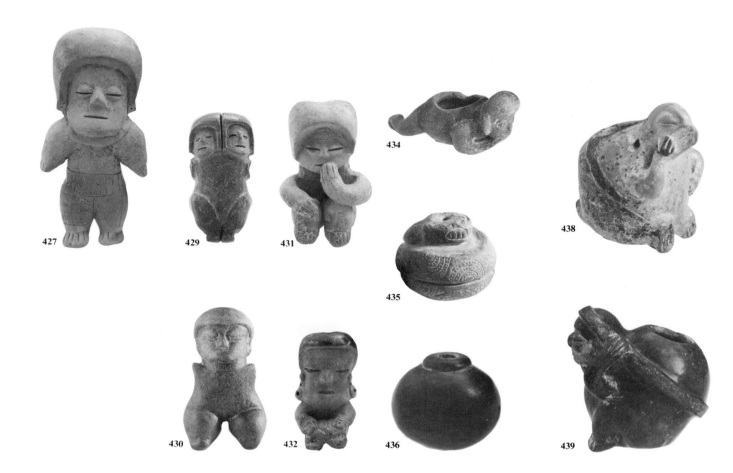

427
434
429
431
435
438
430
432
436
439

427
Solid figurine of standing nude female, with body painting indicated by engraving; smudging badly eroded.

Figurilla maciza de una mujer parada desnuda, con pintura en el cuerpo indicada por grabados; ahumado muy corroído.

San Isidro, Manabí. Ht. 19 cm. (Ch-132)

428 (n.i.)
Solid figurine of standing nude person; traces of red slip.

Figurilla maciza de una persona parada desnuda; trazas de engobe rojo.

Resbalón, Manabí. Ht. 17 cm. (Ch-104)

429
Double-headed solid ceramic figurine, arms missing; differential burnishing.

Figurilla maciza de cerámica con dos cabezas, le faltan los brazos; ahumado diferencial.

Bejuco, Manabí. Ht. 6.6 cm. (Ch-146)

430
Solid ceramic figurine without arms.

Figurilla maciza de cerámica sin brazos.

Site unknown. Ht. 9.2 cm. (Ch-109)

431
Seated solid ceramic figurine with hand over its mouth; post-fired, resin-based crusting with limonite pigment.

Figurilla de cerámica maciza sentada con una mano sobre la boca; post-cocida capa de base de resina con pigmento de limonita.

San Isidro, Manabí. Ht. 7.1 cm. (Ch-136)

432
Seated solid ceramic figurine; burnishing and black smudging on helmet.

Figurilla maciza de cerámica sentada; pulido y ahumado negro sobre el casquete.

Calderón, Manabí. Ht. 7.3 cm. (Ch-135)

433 (n.i.)
Seated solid ceramic figurine with hand over its mouth.

Figurilla sentada de cerámica maciza con una mano sobre la boca.

La Saiba, Manabí. Ht. 6.4 cm. (Ch-121)

434
Ceramic lime pot in the shape of a fat man or pregnant woman with the opening in its back and both hands over its mouth.

Vasija para la cal de cerámica en la forma de un hombre grueso o una mujer embarazada con una abertura en la espalda y ambas manos sobre la boca.

Site unknown. Ht. 3.5 cm. (Ch-695)

435
Perforated stone sphere possibly serving as a spindle whorl; the stone is carved as a snake, probably an anaconda.

Esfera de piedra perforada posiblemente usada como tortero; la piedra está tallada formando una serpiente, probablemente una anaconda.

Resbalón, Manabí. Ht. 5.1 cm. (Ch-692)

436
Ceramic lime pot in the shape of a gourd.

Cuenco para la cal de cerámica en la forma de una calabaza.

Site unknown. Ht. 4.2 cm. (Ch-691)

437 (Fig. 61)
Ceramic lime pot in the shape of a seated figure wearing a tumpline; red slip and black smudging.

Cuenco de cerámica para la cal en la forma de una figura sentada llevando una faja a través de su frente para cargar; engobe rojo y ahumado negro.

Chacras, Manabí. Ht. 7.4 cm. (Ch-633)

438
Ceramic lime pot in the shape of a seated animal holding its chin in its hand; red slip.

Vasija de cerámica para la cal en la forma de un animal sentado sosteniedo su barbilla con la mano; engobe rojo.

Resbalón, Manabí. Ht. 5.7 cm. (Ch-596)

439
Ceramic lime pot in the shape of a seated figure carrying a load by means of a tumpline; black smudged surface.

Vasija de cerámica para la cal en la forma de una figura sentada llevando una carga por medio de una faja a través a su frente; superficie ahumada negra.

La Balsita, Manabí. Ht. 6.2 cm. (Ch-599)

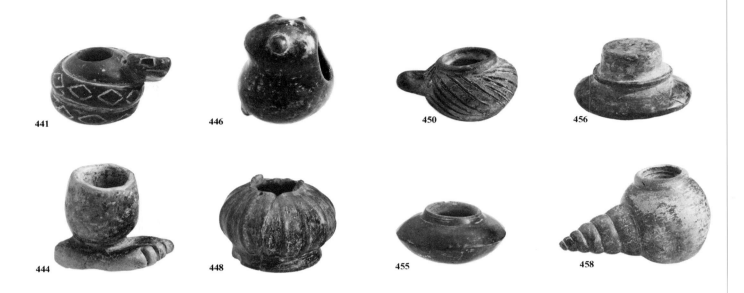

441 446 450 456

444 448 455 458

440 (n.i.)
Ceramic lime pot in the shape of a figure with arms held behind its neck, perhaps fastening a burden.

Vasija de cerámica para la cal en la forma de una figura con los brazos unidos tras el cuello, quizás atando una carga.

La Horma, Manabí. Ht. 5.1 cm. (Ch-601)

441
Ceramic lime pot in the shape of a coiled pit viper *(Bothrops* or *Lachesis)*; black smudged surface and engraved design filled in with white pigment; obsidian eyes.

Vasija de cerámica para la cal en la forma de una víbora *(Bothrops* o *Lachesis)* enrollada; superficie ahumada negra y diseño grabado relleno con pigmento blanco; ojos de obsidiana.

Pinpiquasi, Manabí. Ht. 3.8 cm. (Ch-295)

442 (n.i.)
Ceramic lime pot in the shape of a coiled pit viper *(Bothrops* or *Lachesis)*; black smudged surface with engraved design filled in with white pigment.

Vasija de cerámica para la cal en la forma de una víbora *(Bothrops* o *Lachesis)* enrollada; superficie ahumada negra con diseño grabado relleno de pigmento blanco.

Resbalón, Manabí. Ht. 3.4 cm. (Ch-391)

443 (Fig. 62)
Ceramic lime pot in the shape of a coiled snake, possibly a boa; creamy buff surface with traces of black smudging on head.

Vasija de cerámica para la cal en la forma de una serpiente enrollada, posiblemente una boa; superficie cremosa amarillenta con restos de ahumado negro en la cabeza.

Zozote, Manabí. Ht. 5 cm. (Ch-594)

444
Ceramic lime pot in the shape of a human foot; traces of black smudging on buff surface.

Vasija de cerámica para la cal en la forma de un pie humano; restos de ahumado negro sobre superficie amarillenta.

Chacras, Manabí. Ht. 4.1 cm. (Ch-684)

445 (n.i.)
Ceramic lime pot in the shape of a human figure; black smudged surface.

Vasija de cerámica para la cal en la forma de una figura humana; superficie ahumada negra.

La Balsita, Manabí. Ht. 3.1 cm. (Ch-683)

446
Ceramic lime pot in the shape of a seated animal, possibly a guinea pig or other rodent; red slip.

Vasija de cerámica para la cal en la forma de un animal sentado, posiblemente un conejillo de Indias (cui) u otro roedor; engobe rojo.

La Balsita, Manabí. Ht. 4.8 cm. (Ch-598)

447 (n.i.)
Ceramic lime pot with a modeled face on the shoulder of the pot.

Vasija de cerámica para la cal con una cara modelada en el hombro del recipiente.

Chacras, Manabí. Ht. 2.3 cm. (Ch-696)

448
Ceramic lime pot, ring-based, in the shape of a gourd; overall red slip.

Vasija de cerámica para la cal, con base de anillo, en la forma de una calabaza; engobe rojo total.

La Horma. Ht. 4.7 cm. (Ch-517)

449 (Fig. 61)
Ceramic lime pot, ring-based, in the shape of a gourd; smudged black surface.

Vasija de cerámica para la cal, base de anillo, en la forma de una calabaza; superficie ahumada negra.

Site unknown. Ht. 4.3 cm. (Ch-682)

450
Ceramic lime pot with handle on shoulder; diagonal incised lines around shoulder.

Vasija de cerámica para la cal con agarradera en el hombro; lineas incisas diagonales alrededor del hombro.

Chacras, Manabí. Ht. 3.6 cm. (Ch-687)

451 (Fig. 61)
Ceramic lime pot in the shape of a carved gourd; engraved designs; red slip and traces of black smudging.

Vasija de cerámica para la cal en la forma de una calabaza tallada; diseños grabados; engobe rojo y restos de ahumado negro.

Chacras, Manabí. Ht. 3.5 cm. (Ch-686)

452 (n.i.)
Ceramic lime pot in the form of a carinated jar; incised designs and black smudging.

Vasija de cerámica para la cal en la forma de un recipiente carenado; diseños incisos y ahumado negro.

Site unknown. Ht. 2.6 cm. (Ch-685)

453 (Fig. 61)
Restored ceramic lime pot; black smudging.

Vasija restaurada de cerámica para la cal; ahumado negro.

La Ponga. Ht. 5 cm. (Ch-681)

454 (n.i.)
Restored ceramic lime pot; red slip.

Vasija restaurada de cerámica para la cal; engobe rojo.

La Ponga. Ht. 3.7 cm. (Ch-690)

455
Ceramic lime pot; black smudging over red slip.

Vasija de cerámica para la cal; ahumado negro sobre engobe rojo.

Zozote, Manabí. Ht. 3.5 cm. (Ch-689)

456
Ceramic circular lid for lime pot; black smudging.

Tapa circular de cerámica para una vasija para la cal; ahumado negro.

Site unknown. Diam. 4.4 cm. (Ch-697)

457 (n.i.)
Ceramic lime pot with boss on shoulder; incised designs and black smudging.

Vasija de cerámica para la cal con combadura en el hombro; diseños incisos y ahumado negro.

La Ponga. Ht. 3.7 cm. (Ch-688)

458
Ceramic lime pot in the shape of a snail; red slip.

Vasija de cerámica para la cal en la forma de un caracol; engobe rojo.

La Horma, Manabí. Ht. 5.5 cm. (Ch-590)

459 (n.i.)
Ceramic lime pot; smudged black surface.

Vasija de cerámica para la cal; superficie ahumada negra.

Chacras, Manabí. Ht. 3.3 cm. (Ch-648)

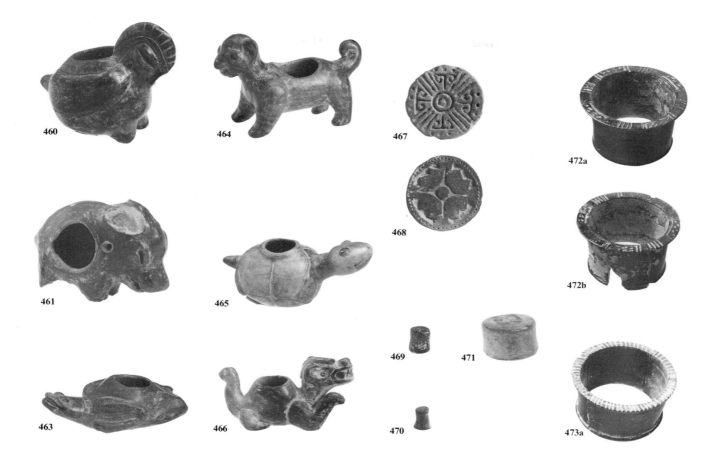

460
Ceramic lime pot in the shape of a bird, probably a curassow *(Crax)*; black smudging over red slip.

Vasija de cerámica para la cal en la forma de un ave, probablemente un pavón *(Crax)*; ahumado negro sobre engobe rojo.

Chacras, Manabí. Ht. 3.5 cm. (Ch-602)

461
Ceramic lime pot in the shape of a peccary.

Vasija de cerámica para la cal en la forma de un pecarí.

Guabito, Manabí. Ht. 2.7 cm. (Ch-597)

462 (Fig. 62)
Ceramic lime pot shaped like the shell of *Anadara grandis*.

Vasija de cerámica para la cal en la forma de la concha de la *Anadara grandis*.

Site unknown. Ht. 4.8 cm. (Ch-600)

463
Ceramic lime pot in the shape of a frog or toad; red slip.

Vasija de cerámica para la cal en la forma de una rana o sapo; engobe rojo.

La Balsita, Manabí. Ht. 4.2 cm. (Ch-595)

464
Ceramic lime pot in the shape of a jaguar; red slip and resist painting; stripes on legs and spotted rosette-like discs on body.

Vasija de cerámica para la cal en la forma de un jaguar; engobe rojo y pintura en negativo; franjas en las piernas y rosetas con manchas en el cuerpo.

Chacras, Manabí. Ht. 6.6 cm. (Ch-592)

465
Ceramic lime pot in the shape of a land turtle; smudged areas.

Vasija de cerámica para la cal en la forma de una tortuga terrestre; áreas ahumadas.

Negrital de Majia, Manabí. Ht. 4.6 cm. (Ch-589)

466
Ceramic lime pot in the shape of a jaguar with a somewhat fantastic head; red slip and black smudging.

Vasija de cerámica para la cal en la forma de un jaguar con una cabeza algo fantástica; engobe rojo y ahumado negro.

Calderón, Manabí. Ht. 6.4 cm. (Ch-593)

467
Solid ceramic ear plugs; excised design on face and black smudging.

Orejeras macizos de cerámica; diseño exciso en la superficie y ahumado negro.

Site unknown. Diam. 2.9 cm. (Ch-712a)

468
Solid ceramic ear plug; excised design on face and black smudging.

Orejera maciza de cerámica; diseño exciso en la superficie y ahumado negro.

Site unknown. Diam. 3.3 cm. (Ch-712b)

469
Solid ceramic ear plug.

Orejera maciza de cerámica.

Colonche, Manabí. Diam. 1.1 cm. (Ch-709b)

470
Solid ceramic ear plug.

Orejera maciza de cerámica.

Colonche, Manabí. Diam. 1 cm. (Ch-709a)

471
Solid ceramic ear plug.

Orejera maciza de cerámica.

Chacras, Manabí. Diam. 2.1 cm. (Ch-713)

472a-b
Pair of ceramic ear spools in the form of napkin rings; black smudging.

Par de orejeras de cerámica de forma de aro de servilleta; ahumado negro.

Site unknown. Diam. 5.8 cm. (Ch-703a-b)

473a-b (473b n.i.)
Pair of ceramic ear spools in the form of napkin rings; black smudging.

Par de orejeras de cerámica en forma de aro de servilleta; ahumado negro.

Calderón, Manabí. Diam. 4.8 cm. (Ch-704a-b)

474 (Fig. 70)
Ceramic ear spool in the form of napkin ring; black smudging over red slip.

Orejera de cerámica en forma de aro de servilleta; ahumado negro sobre engobe rojo.

Calderón, Manabí. Diam. 4.2 cm. (Ch-708a)

475a

479a

482

476

480a

486

489

490

484

478

481

485

475a-b (475b n.i.)
Pair of partially broken ceramic ear spools in the form of napkin rings; allover black smudging.

Par de orejeras de cerámica en forma de aro de servilleta parcialmente rotas; ahumado negro total.

Site unknown. Diam. 5.6 cm. (Ch-732; Ch-733)

476
Napkin-ring ear spool of shell (probably *Melongena*).

Orejera en forma de aro de servilleta hecha de concha (probablemente *Melongena*).

Miguelillo, Manabí. Diam. 5.3 cm. (Ch-706a)

477 (n.i.)
Napkin-ring ear spool of shell (probably *Melongena*).

Orejera en forma de aro de servilleta hecha de concha (probablemente *Melongena*).

Cerro Verde, Manabí. Diam. 5.3 cm. (Ch-706b)

478
Solid ear plug made from a shark vertebra.

Orejera maciza hecha de una vertebra de un tiburón.

Site unknown. Diam. 3.9 cm. (Ch-710)

479a-b (479b n.i.)
Pair of napkin-ring ear spools of shell (probably *Melongena*).

Par de orejeras en forma de aro de servilleta hechas de concha (probablemente *Melongena*).

Site unknown. Diam. 3.9 cm. (Ch-705a-b)

480a-b (480b n.i.)
Pair of napkin-ring ear spools of shell (probably *Melongena*).

Par de orejeras en forma de aro de servilleta hechas de concha (probablemente *Melongena*).

Site unknown. Diam. 1.9 cm. (Ch-707a-b).

481
Thin napkin-ring ear spool of shell (probably *Melongena*).

Orejera delgada de forma de aro de servilleta hecha de concha (probablemente *Melongena*).

Site unknown. Diam. 4.4 cm. (Ch-711)

482
Ceramic snuffing tube for inhaling snuff, with a series of three overlapping faces modeled on one end, each face sharing an eye with the face next to it; black smudging.

Tubo de cerámica para inhalar drogas en polvo, con una serie de tres caras sobrepuestas modeladas en un extremo, cada rostro compartiendo un ojo con el rostro siguiente; ahumado negro.

Miguelillo, Manabí. L. 5 cm. (Ch-716)

483 (Fig. 65)
Ceramic snuffing tube for inhaling snuff, with a crocodilian head, possibly a cayman.

Tubo de cerámica para inhalar drogas en polvo, con una cabeza cocodriliana, posiblemente de un caimán.

Chacras, Manabí. L. 4.9 cm. (Ch-693)

484
Miniature ceramic whistle in the form of a *Cebus* monkey; black smudging.

Silbato de cerámica en miniatura en la forma de un mono capuchino; ahumado negro.

Site unknown. Ht. 4.8 cm. (Ch-694)

485
Ceramic pendant in the shape of a fish, the lookdown (*Selene*, family Carangidae); red slip.

Pendiente de cerámica en forma de un pez, el reloj o corcovado (*Selene*, familia Carangidae); engobe rojo.

Calderón, Manabí. L. 7.8 cm. (Ch-714)

486
Shell figurine pendant.

Pendiente de concha en forma de figurilla.

Site unknown. L. 5.5 cm. (V-282, Ch-732)

487 (n.i.)
Shell figurine pendant.

Pendiente de concha en forma de figurilla.

Site unknown. L. 5.9 cm. (V-283, Ch-733)

488 (n.i.)
Shell figurine pendant. This figurine is similar to figurines from Cerro Narrío, and on a stylistic basis might possibly be dated to early Machalilla or late Valdivia.

Pendiente de concha en forma de figurilla. Esta figurilla es similar a las figurillas de Cerro Narrío, y basándose en su estile puede ser fechada en Machalillla temprano o Valdivia tardío.

Site unknown. L. 2.6 cm. (V-284, Ch-734)

489
Shell figurine pendant.

Pendiente de concha en forma de figurilla.

Esteros, Manabí. L. 5 cm. (V-285, Ch-735)

490
Shell figurine pendant in the shape of a man.

Pendiente de concha en la forma de un hombre.

Mejia, Manabí. L. 9.3 cm. (Ch-715)

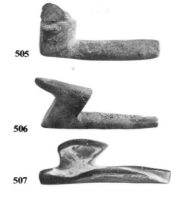
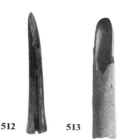

491
494

492
493

500

505

506

507

512
513

501
503

508
509

495°
496
499
498

502
504

510
511

514

491
Bone figurine in the shape of a man.

Figurilla de hueso en forma de un hombre.

Barcelona. Ht. 4.2 cm. (Ch-719)

492
Shell figurine pendant.

Pendiente de concha en forma de figurilla.

Site unknown. Ht. 3.8 cm. (Ch-717)

493
Shell figurine pendant.

Pendiente de concha en forma de figurilla.

Site unknown. Ht. 4.3 cm. (Ch-718)

494
Stone bust of lapis lazuli, with a flat-topped head and a triangular face. A hole is drilled vertically from the top of the head to the chest for suspension as a bead.

Busto de piedra de lapislázuli, con cabeza achatada y cara triangular. Un hueco ha sido taladrado verticalmente desde el tope de la cabeza hasta el pecho para ser usado como cuenta.

Calderón, Manabí. L. 3 cm. (Ch-720)

495-499 (497 n.i.)
Five bone tools, possibly used for weaving.

Cinco instrumentos de hueso, posiblemente usados para tejer.

Site unknown. L. of **495**: 11.5 cm. *(Ch-775-779)*

500
Bone tool, possibly used as a basketry awl.

Instrumento de hueso, posiblemente usado como lesna para fabricar cestos.

Site unknown. L. 8 cm. (Ch-774)

501-504
Four flutes made of bird bones.

Cuatro flautas hechas de huesos de ave.

*La Ponga. L. of **501**: 8.3 cm. (Ch-770-773)*

505
Bone spearthrower hook.

Gancho de hueso de un propulsor (estólica).

La Ponga. L. 4.9 cm. (Ch-783)

506
Bone spearthrower hook.

Gancho de hueso de un propulsor (estólica).

Buenavista. L. 5.3 cm. (Ch-781)

507
Shell spearthrower hook.

Gancho de concha de un propulsor (estólica).

Site unknown. L. 5.7 cm. (Ch-782)

508-511
Four awls. No. **508** is fashioned from the femur of a carnivore, perhaps the shortear dog, *Atelocynus*; **509** is possibly made of the penis bone of a sea mammal; **510** and **511** are parts of deer horns, most likely *Hippocamelus*.

Cuatro lesnas. No. **508** esta formada del femur de un carnivoro, quizás del perro silvestre *Atelocynus*; no. **509** posiblemente está hecho del hueso del pene de un mamífero acuático; no. **510** y **511** son partes de los cuernos de un venado, probablemente *Hippocamelus*.

*La Ponga. L. of **508**: 11.1 cm. (Ch-766, 764, 768, 769)*

512
Spearhead formed from the metatarsal (foot) bone of a deer, either *Odocoileus* or *Hippocamelus*.

Punta de lanza hecha del hueso metatarso de un venado, *Odocoileus* o *Hippocamelus*.

La Ponga. Ht. 14.7 cm. (Ch-763)

513
Bone projectile point, made possibly from the femur of a carnivore such as the shortear dog *Atelocynus*.

Punta de un proyectil hecha de hueso, posiblemente del fémur de un carnívoro como el perro silvestre *Atelocynus*.

La Ponga. Ht. 6.5 cm. (Ch-765)

514
Tool for stone napping, formed from a deer horn, probably *Hippocamelus*.

Instrumento para picar piedras, formado del cuerno de un venado, probablemente *Hippocamelus*.

La Ponga. Ht. 8 cm. (Ch-767)

515
Ceramic roller stamp.
Sello cilíndrico de cerámica.
Site unknown. L. 5.5 cm. (Ch-744)

516
Ceramic roller stamp.
Sello cilíndrico de cerámica.
Pedernales, Manabí. L. 5 cm. (Ch-743)

517
Ceramic roller stamp.
Sello cilíndrico de cerámica.
Site unknown. L. 3.9 cm. (Ch-752)

518 (Fig 73)
Ceramic roller stamp.
Sello cilíndrico de cerámica.
Loma Alta. L. 5.5 cm. (Ch-745)

519
Half a ceramic roller stamp.
La mitad de un sello cilíndrico de cerámica.
Loma Alta. L. 7.2 cm. (Ch-748)

520
Ceramic flat stamp.
Sello plano de cerámica.
Chacras, Manabí. L. 10.3 cm. (Ch-739)

521 (Fig. 73)
Ceramic flat stamp.
Sello plano de cerámica.
Pedernales, Manabí. L. 11.7 cm. (Ch-741)

522
Ceramic flat stamp.
Sello plano de cerámica.
Crucitas, Manabí. L. 5.1 cm. (Ch-738)

523
Ceramic flat stamp.
Sello plano de cerámica.
Tambillo, Manabí. L. 4.3 cm. (Ch-753)

524
Ceramic flat stamp with a figure 8 design.
Sello plano de cerámica con diseño formando un 8.
Site unknown. L. 9.5 cm. (Ch-741)

525
Ceramic flat stamp.
Sello plano de cerámica.
Site unknown. L. 6 cm. (Ch-740)

526
Ceramic flat stamp with the design of a face from which extend rays.
Sello plano de cerámica con diseño de una cara de la que salen rayos.
Site unknown. L. 6.8 cm. (Ch-749)

527
Ceramic roller stamp.
Sello cilíndrico de cerámica.
Site unknown. L. 9.8 cm. (Ch-736)

528-530 (**528** n.i.)
Three ceramic flat stamps.
Tres sellos planos de cerámica.
*Site unknown. L. of **529**: 5.8 cm. (Ch-754, 737, 747)*

531
Ceramic flat stamp incised with five human figures.
Sello plano con cinco figuras humanas incisas.
Site unknown. L. 4 cm. (Ch-757)

532 (n.i.)
Ceramic flat stamp.
Sello plano de cerámica.
Site unknown. L. 3 cm. (Ch-756)

533
Ceramic flat stamp.
Sello plano de cerámica.
Site unknown. L. 7 cm. (Ch-742)

534
Ceramic flat stamp.
Sello plano de cerámica.
Zozote, Manabí. L. 6.4 cm. (Ch-750)

535 (n.i.)
Ceramic flat stamp.
Sello plano de cerámica.
Site unknown. L. 5.5 cm. (Ch-751)

536
Ceramic flat stamp.
Sello plano de cerámica.
Loma Alta. L. 5.6 cm. (Ch-746)

537
Ceramic flat stamp with fish or bird.
Sello plano de cerámica con un pez o ave.
Chacras, Manabí. L. 4.2 cm. (Ch-755)

538

539

540

544

546

543

547

548

549

550

552

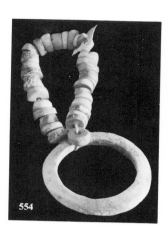

554

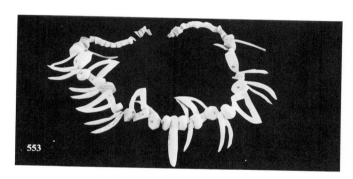

553

538-548 (541, 542, 545, n.i.)
Eleven ceramic spindle whorls; red slip and engraved design filled with white pigment, except for **544**, which has black smudging.

Once torteras de cerámica; engobe rojo y diseño grabado relleno de pigmento blanco, excepto **544**, que tiene ahumado negro.

538-540 and 544, 547, 548, Zozote, Manabí. (Ch-785, 788, 789, 792-794); 541-543 and 545, 546, Calderón, Manabí. (Ch-786, 787, 790, 791, 795). Average diam. 2.5 cm.

549
Sherd showing the impression of a textile with paired warp and paired weft.

Tiesto mostrando la impresión de un tejido con urdimbre pareada y trama pareada.

Site unknown. L. 3.3 cm. (Ch-796)

550
Carved bone inlaid with shell; probably a shaman's ritual implement. The bone is the thoracic vertebra of a deer, *Odocoileus* or *Hippocamelus*.

Hueso tallado incrustado con conchas; probablemente un implemento ritual de un shaman (brujo-adivino). El hueso es una vertebra toráxica de un venado, *Odocoileus* o *Hippocamelus*.

Site unknown. L. 10.9 cm. (Ch-736)

551 (Fig. 63)
Human figure carved from a human arm bone (left humerus). The figure is sitting on a four-legged stool with carved ends depicting an animal, probably a jaguar. The man represents a shaman on his stool during a curing ceremony. This object is probably a shaman's sucking tube used to suck disease objects from the bodies of his patients, or possibly a snuffing tube for inhaling narcotic snuff.

Figura humana tallada de un hueso de un brazo humano (húmero izquierdo). La figura esta sentada en un banquillo de cuatro patas con extremos tallados representando a un animal, probablemente a un jaguar; el hombre representa a un shaman (brujo-adivino) en su banquillo durante una ceremonia curandera. Este objeto es probablemente el tubo chupador del shaman usado para chupar los objetos causantes de la enfermedad del cuerpo de sus pacientes, o posiblemente para aspirar narcóticos.

Buenavista. L. 12.6 cm. (Ch-737)

552
Shell of *Malea ringens* with the border and internal structure cut away; probably used as a bowl.

Concha *Malea ringens* con el borde cortado y la estructura interna removida; probablemente usada como recipiente.

Site unknown. L. 19.5 cm. (Ch-701)

553
Necklace of *Spondylus* and other marine shells.

Collar de la concha *Spondylus* y otras conchas marinas.

Site unknown. Total l. 74.5 cm. (Ch-726)

554
Bangle of *Spondylus* shell with attached shell beads.

Brazalete de la concha *Spondylus* con cuentas de conchas añadidas.

Chacras, Manabí. Diam. of bangle 6.2 cm. (Ch-728)

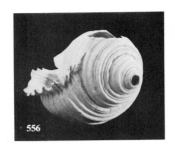

556

561

562

566

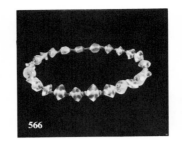

567

557

568

571

558

569

573

562

563

570

574

575

560

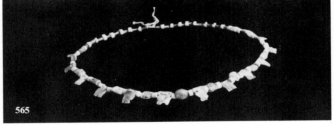

565

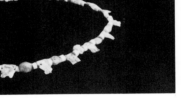

564

555 (n.i.)
Shell of *Anadara grandis*.

Concha *Anadara grandis*.

Calderón, Manabí. L. 15.6 cm. (Ch-698)

556
Shell of *Malea ringens* (Tun family), fashioned into a trumpet.

Concha *Malea ringens* (familia Tun), formando una trompeta.

La Irene, Manabí. L. 23.5 cm. (Ch-700)

557
Pectoral of shell of *Melongena patula*.

Pectoral de concha *Melongena patula*.

La Horma, Manabí. L. 10.2 cm. (Ch-723)

558
Pectoral of shell of *Spondylus calcifer*.

Pectoral de concha *Spondylus calcifer*.

Site unknown. L. 12.3 cm. (V-246)

559 (n.i.)
Pectoral of *Spondylus* shell.

Pectoral de concha *Spondylus*.

Site unknown. L. 11.2 cm. (V-247)

560
Pectoral of shell of *Melongena patula*.

Pectoral de concha *Melongena patula*.

La Saiba, Manabí. L. 7.6 cm. (Ch-721)

561
Pectoral of shell of *Melongena patula*.

Pectoral concha *Melongena patula*.

Charapotó, Manabí. L. 14.7 cm. (Ch-725)

562
Pectoral of shell *(Conus)*.

Pectoral de concha *(Conus)*.

La Saiba, Manabí. L. 12.2 cm. (Ch-724)

563
Shell necklace.

Collar de conchas.

Chacras, Manabí. Total l. 128 cm. (Ch-727)

564
Shell disc, probably pearl oyster *(Pinctada)*, perhaps intended as a pendant.

Disco de concha, probablemente de madreperla *(Pinctada)*, quizás destinado como pendiente.

Chacras, Manabí. Diam. 15.5 cm. (Ch-722)

565
Shell necklace with small human figures carved from the red rim of the *Spondylus* shell.

Collar de conchas con pequeñas figuras humanas talladas del borde rojo de la concha *Spondylus*.

Site unknown. Total l. 47.6 cm. (Ch-731)

566
Quartz crystal and shell necklace.

Collar de cristales de cuarzo y conchas.

Site unknown. Total l. 52.4 cm. (Ch-730)

567
Necklace of quartz crystal, lapis lazuli, and beads of mixed lapis and quartz.

Collar de crystales de cuarzo lapislázuli, y cuentas de lapislázuli y cuarzo mezclados.

Site unknown. Total l. 59 cm. (Ch-729)

568-570
Three stone projectile points.

Tres puntas de proyectiles de piedra.

568, 569, La Balsita, Manabí; 570, site unknown. Ht. of 568; 6 cm. (V-248, 249, 252)

571-575 (572 n.i.)
Five obsidian blades.

Cinco cuchillas de obsidiana.

Chorrera-Bahía transition. Joa, Manabí. L. of 571: 7.2 cm. (Collection of O. Holm)

108

576

578

580

581 582

583

584

585

586

587

588

589

590

591

592

Related Material

576

Jar with modelled bird on shoulder.

Vasija con un ave modelada en el hombro.

Early Cerro Narrío phase, ca. 1600 B.C. Cerro Narrío, Ecuador. Ht. 10.7 cm. (Collection of O. Holm)

577 (Fig. 30)
Red engraved sherd.

Tiesto rojo con grabados.

Early Cerro Narrío phase, ca. 1400 B.C. Cerro Narrío, Ecuador. L. 6.5 cm. (Collection of Field Museum, no. 240008)

578
Black engraved sherd.

Tiesto negro con grabados.

Early Cerro Narrío phase, ca. 1400 B.C. Cerro Narrío, Ecuador. L. 7.5 cm. (Collection of Field Museum, no. 240132)

579-580 (**579** n.i.)
Two worked *Spondylus* shells.

Dos conchas *Spondylus* trabajadas.

Early Cerro Narrío phase, ca. 1500 B.C. Cerro Narrío, Ecuador. L. of 580: 8.5 cm. (Collection of O. Holm)

581-583
Three pendants of *Spondylus* shell.

Tres pendientes de conchas *Spondylus.*

Early Cerro Narrío phase, ca. 1500 B.C. Cerro Narrío, Ecuador. L. of 581: 8.6 cm. (Collection of O. Holm)

584-586
Three sherds with incised designs.

Tres tiestos con diseños incisos.

1800-1400 B.C. Río Pastaza, Ecuador. L. of 584: 4.5 cm. (Collection of P. I. Porras Garcés)

587
Carved wooden shaman's stool, with the head of a turtle carved at one end.

Banquillo de un shaman (brujo-adivino) tallado en madera, con la cabeza de una tortuga reproducida a un extremo.

20th century. Jivaro Indians, Ecuador. Ht. 37.5 cm. (Collection of N. E. Whitten)

588-592

Five incised bowl fragments.

Cinco fragmentos de cuencos con incisiones.

Late Tutishcainyo, ca. 1500 B.C. Tutishcainyo site, Perú. L. of 588: 6.5 cm. (Collection of D. Lathrap)

603

593

596

597

598

604

593 (cf. Fig. 16 for drawing)
Replica of a gourd carved with human faces. The gourd was found with another carved gourd at the 2000 B.C. level at Huaca Prieta, Perú. The style is that of Valdivia 4. This gourd was carved in Ecuador in ca. 2100 B.C. and traded to Huaca Prieta.

Reproducción de una calabaza tallada con rostros humanos. La calabaza fue encontrada con otra calabaza tallada al nivel de 2000 A.C. en Huaca Prieta, Perú. El estilo es él de Valdivia 4. Esta calabaza fue tallada en el Ecuador en c. 2100 A.C. y llegó a Huaca Prieta por intercambio.

Ht. 4.5 cm. (Collection of The American Museum of Natural History)

594 (Fig. 81)
Rubbing of a stone relief on the temple at Chavín de Huantar, Perú.

Calcado de un relieve de piedra en el templo en Chavín de Huantar, Perú.

1200-900 B.C. 53 × 57.7 cm. (Rubbing from the collection of The American Museum of Natural History)

595 (Fig. 79)
Bottle with spout and handle. The turbaned head of a man is modeled on the bottle front; human figures enclosed in an arc are incised on each side; resin-based painting.

Botella con pico y asa. Un hombre con turbante en la cabeza modelado en el frente de la botella; figuras humanas encerradas en un arco incisas a cada lado; pintura de base de resina.

Late Paracas, ca. 300 B.C. Cerro Blanco, Perú. Ht. 15.4 cm. (Collection of The Metropolitan Museum of Art, Nathan Cummings Collection, no. 63.232.80)

596-598
Three fragments of ear spools in the form of napkin rings.

Tres fragmentos de orejeras en forma de aro de servilleta.

Ocos phase, ca. 1500 B.C. La Victoria, Guatemala. L. of 596: 3.3 cm. (Collection of the Peabody Museum of Archaeology and Ethnology, Harvard University, nos. 58-6520/20139 K-33d, K-34H, K-35H)

599-602 (Fig. 61)
Four small ceramic pots.

Cuatro vasijas pequeñas de cerámica.

800-500 B.C. Playa de los Muertos, Honduras. L. of 599: 4.1 cm. (Collection of the Peabody Museum of Archaeology and Ethnology, Harvard University, nos. c/10935, 10944, 10947, 10973)

603
Effigy vessel in the shape of a dog.

Recipiente efigie en la forma de un perro.

A.D. 100-300. Colima, Mexico. Ht. 20.5 cm. (Collection of Field Museum, no. 241253)

604
Bottle with tall neck, shelf below neck and concave walls; red-slip designs on buff.

Botella de cuello alto, plataforma bajo el cuello y paredes cóncavas: diseños de engobe rojo sobre superficie amarillenta.

1000-800 B.C. Tlatilco, Valley of Mexico. Ht. 29.5 cm. (Collection of Field Museum, no. 240689)

Nos. **15-17, 58, 63, 140, 160-162, 228-231, 577-578, 584-604**: not exhibited in Ecuador.